The Most
MALIGNED
WOMEN
in History

For Matt

The Most
MALIGNED
WOMEN
in History

SAMANTHA MORRIS

AN IMPRINT OF PEN & SWORD BOOKS LTD.
YORKSHIRE – PHILADELPHIA

First published in Great Britain in 2024 by
PEN AND SWORD HISTORY
An imprint of
Pen & Sword Books Ltd
Yorkshire – Philadelphia

Copyright © Samantha Morris, 2024

ISBN 978 1 39900 533 3

The right of Samantha Morris to be identified as Author of this work has been asserted by her in accordance with the Copyright, Designs and Patents Act 1988.

A CIP catalogue record for this book is available from the British Library.

All rights reserved. No part of this book may be reproduced or transmitted in any form or by any means, electronic or mechanical including photocopying, recording or by any information storage and retrieval system, without permission from the Publisher in writing.

Typeset in Times New Roman 12/16 by
SJmagic DESIGN SERVICES, India.
Printed and bound in the UK by CPI Group (UK) Ltd.

Pen & Sword Books Limited incorporates the imprints of Atlas, Archaeology, Aviation, Discovery, Family History, Fiction, History, Maritime, Military, Military Classics, Politics, Select, Transport, True Crime, Air World, Frontline Publishing, Leo Cooper, Remember When, Seaforth Publishing, The Praetorian Press, Wharncliffe Local History, Wharncliffe Transport, Wharncliffe True Crime and White Owl.

For a complete list of Pen & Sword titles please contact
PEN & SWORD BOOKS LIMITED
George House, Units 12 & 13, Beevor Street, Off Pontefract Road,
Barnsley, South Yorkshire, S71 1HN, England
E-mail: enquiries@pen-and-sword.co.uk
Website: www.pen-and-sword.co.uk

or
PEN AND SWORD BOOKS
1950 Lawrence Rd, Havertown, PA 19083, USA
E-mail: uspen-and-sword@casematepublishers.com
Website: www.penandswordbooks.com

Contents

Acknowledgements ... vi
Introduction & Authors Note ... viii

Chapter 1 Cleopatra VII .. 1
Chapter 2 Empress Wu ... 16
Chapter 3 Joan of Arc .. 30
Chapter 4 Lucrezia Borgia ... 43
Chapter 5 Anne Boleyn .. 67
Chapter 6 Elizabeth Báthory ... 81
Chapter 7 Catherine the Great .. 95
Chapter 8 Marie Antoinette ... 107
Chapter 9 Lizzie Borden .. 127
Chapter 10 Empress Dowager Cixi 141
Chapter 11 Iva Toguri – 'Tokyo Rose' 161

Conclusion ... 176
Further Reading .. 178
Index ... 180

Acknowledgements

As always, the list of people who deserve a thank you here so long that I'm sure it would take several volumes if I were to list them all. So many people have been instrumental in me writing this book and, as I am sure I have mentioned before, it is always so incredibly difficult to pick and choose just who to include – I always end up panicking that I've missed out someone important! So I'm going to start with a blanket thank you – to anyone who has been part of this journey, thank you so much for all of your support. It means more to me than you could ever know.

My first thank you has to go to the team at Pen & Sword. They believed in me and my work when I was truly beginning to think I was no good at this writing lark. Every single member of the team that I have had the pleasure to talk to, even just in passing, have been friendly and beyond professional. Thank you for believing in me and for taking on my work, for encouraging me and helping me get back up when I have stumbled, and for your boundless enthusiasm when it comes to history.

To my wonderful editor, and friend, Carol Trow. If anyone can be called a magician, it's Carol. She is honestly one of the hardest working people that I know, and it is always an honour to work with her on a project – we have worked together already for a couple of my previous books and she has truly helped me to become a better writer. Not only that – she doesn't take any rubbish!!!! More importantly, Carol has become a wonderful and trusted friend.

To the entirety of Team RPD – I could say a lot about you all but most of it probably isn't appropriate. Just know I love you all. To Cat, Dawn, Craig, Joyce, Anita & Jeff, my postman (no, seriously,

Acknowledgements

they must be fed up of delivering so many books!), Melanie, Andrea, Pablo, Joe, the whole office crew – special shoutout to Andy for telling everyone about my writing on work nights out. You're all amazing. Mum and Dad of course deserve a special shoutout for helping foster my love of history and for all their love and support. And then there's the guy who is my constant and always in my corner cheering me on – Matt. My best friend, cheerleader and number 1 fan. I love you. Oh, and we can't forget Snowball aka 'Bozman' the Chinchilla. Thanks for constantly distracting me, you fluffy little demon.

Introduction & Authors Note

According to the Cambridge Dictionary, the term maligned is 'to say false and unpleasant things about someone, or to criticise someone unfairly.' There are many individuals throughout history who have had false and unpleasant things said about them and many such things are repeated until these things become ingrained as 'fact'.

This book concentrates on the word 'maligned' and a number of individuals who can be considered as such; in this specific case, women. That is not to say that men throughout history have not been maligned, but there are far more women throughout history who have been a victim of such talk. It is something that is seen from very early history – Mary Magdalen, for instance, is often objectified as a prostitute. And as you go through the centuries there are always women – more often than not women with some sort of power be it nobility or money – who are accused of being power hungry, whores, murderers and just plain evil. But how much of this is true? It can't be denied that there truly were some evil women who deserve that title, but what about the ones who actually weren't that bad? How many of the rumours are simply just that?

I have spent a long time researching a number of different women for this work and, if I am honest, it has become something of a passion of mine. Throughout the project I have written about women who for the longest time I have thought of as guilty but upon delving deeper into their stories, I have found that much of their bad reputation has come from those with an axe to grind. Some of them certainly did do wrong, but not to the extent that has been shouted about over the years. Take for instance, Elizabeth Báthory – was she guilty of murder? Yes. Was it as many as the legend says? It is highly unlikely.

Did she bathe in the blood of her victims? It is even less likely than her body count being in the six hundreds. And the vampire myth is just laughable. Anne Boleyn – was she a witch? That is an accusation that has been debunked time and time again by historians and yet still the story persists

In the writing of this book, I have tried to include women from as many spectrums of society as I can, and from many different eras. The truth is, though, that there are so many women who have been whispered and lied about that it would be impossible to include them all. Many here are those from noble backgrounds and who have held power, some have risen to great heights from being little more than concubines whilst others have been from upper class, yet still working, families. Truthfully, I could have included chapters on women right up until the modern day as you still see such things happening, especially to women in politics or royal families, or even just celebrities. They are power hungry liars who hide things and commit crimes in order to gain power or considered to be 'homewreckers' – and yet such things can also be said of many men. So why are women targeted for such things? That is the question that I have tried to ask myself as I have been working on this project. What we have to remember is that for women in the past, what we 'know' about them is often via narratives that were not crafted by their immediate contemporaries. Or if they were crafted by contemporaries (Lucrezia Borgia springs to mind), why have such things been said? There is always a narrative and in this case it often seems to be to make the woman in question look weak, or because the person crafting the narrative wants something that the woman has, be it land or power.

In today's society we tend to prefer a sexed up and dangerous story. You can see such things in the soap operas of today – people want scandal, they want affairs and blood and death. So is it any wonder that we still want to hang on to the idea of a dangerous woman from back in the day? To many, the story that Anne Boleyn was an incestuous witch is much more exciting than the real story. To many, the story that Lucrezia Borgia slept with her brother and committed

murder by poison is much more exciting than the truth. We remember Mary Tudor as Bloody Mary because people prefer the danger – it doesn't matter that her father and brother sent more to their deaths than she did. As an audience we are presented with a fantasy story interwoven with the smallest threads of the truth. My aim here has been to take a handful of women from history and to try to tell their stories as they really happened.

There have certainly been bumps in the road with a lot of these women and at times it has felt like I have been slogging through syrup to get to where I wanted to be. But it has also been a journey of revelation. Some of the women I have written about I had no idea existed until I began my research. Others I knew of, but only knew the fantasy that has been presented. Indeed, there are many who I have researched who have not made the cut to this book – there are certainly plenty more women out there who deserve to have their stories told and it is my hope that one day soon I'll be able to start a 'Most Maligned Women in History: Volume II'.

Each woman that I have chosen has their own chapter and I have aimed to make this book as accessible as I possibly can. It is not an academic work but rather I hope that this book can serve as an introduction to each of these fascinating women and encourage the reader to seek out more information should they so wish. At the end of the book I have included an extensive list of further reading to help the reader discover and explore more about the women I have chosen to write about.

And now, without any further ado, let us begin our journey into the lives of some of the most maligned women in history. Many were powerful, some were not. But all of them have their own legends. Do they deserve the vitriol they get? Read on, and find out.

<div align="right">

Samantha Morris
Southampton, 2023

</div>

Chapter 1

Cleopatra VII
69–30 BC

Cleopatra, Queen of Ancient Egypt, is today seen as something of an icon. Yet throughout history – dating even back to her own times – she has been totally maligned. Whether this is due to her sex or her choice in sexual partners, during her own time she was seen as a whore who used people to hold on to her power. The Romans called her a coward, painting her end as the only noble thing she ever did – in life they spat that she spent thousands on clothing and jewels when she should have been spending money to protect her people. But what was the reality of the Egyptian (or, as we shall see shortly, Greek) pharaoh? Was she truly as monstrous as the Romans made out, was she truly a woman who used her sexuality in order to hold on to power? This chapter will tell the tale of the life of a queen who has since become iconic in the history of Ancient Egypt – many know of the legends that surround her, the myths that have been whispered throughout the centuries. Here we will attempt to unravel fantasy from reality and to show that Cleopatra, the last Ptolemaic pharaoh, was not the monster that history has made out.

Cleopatra was born in either 70 or 69 BC to Pharaoh Ptolemy XII, known as the 'Auletes' or 'flute player' because of his love of music, and an unknown mother. A royal child then, born into the powerful Ptolemaic dynasty that had been established by Alexander the Great in around 330 BC. The history of the dynasty is certainly a bloody one, full of assassination and betrayal as well as violence from their subjects. The dynasty also practiced inbreeding, which was usual at the time, with siblings often being married to one another – Ptolemy II and

Arsinoe II were brother and sister for instance, as well as Ptolemy IV and Arsinoe III. This was a method of, it was believed, keeping the bloodline pure and had been practiced throughout earlier Egyptian history – the Greeks, to whom the Ptolemy line actually belonged, believed that such a practice was something of a taboo yet it soon became seen as a great way of keeping the bloodline pure and also allowed them to assimilate more into the country that they ruled, Egypt. Violence was endemic among the family also. Kings murdered their own parents and other family members; they frequently poisoned one another or sent armies after their sons or parents. Ptolemy VIII for instance, raped Cleopatra III whilst she was a child. He would then go on to murder their 14-year-old son and sent a box full of his body parts to her…as a birthday present.

Alexandria, the city in which Cleopatra was born, was established in 331 BC by the man whose name it would take – Alexander the Great. The city grew quickly and it eventually overtook Memphis as the capital of Egypt. The buildings of the city and its layout were impressive and it became a centre of learning, holding the famous library of Alexandria. Alexander, however, left his new city just a few months after founding it and he never returned. At least until his body was brought back to the city and interred in a grand tomb. As rulers came and went the city only grew – it was essentially 'Greek' but both Greeks and Egyptians lived amongst each other here. Their religions also intermingled, the Greeks adopting the pantheon of Gods that the Egyptians worshipped. The Gods, it was believed, were essentially the same just with different names. Things were adopted and changed yet at its essence everything remained the same. The buildings that emerged throughout the years were exceptionally grand, particularly the royal palace that Cleopatra would live in both as a child and during her reign. Yet of course, as with any city both then and now, there were areas that were less than desirable – living there were men and women who often became fed up of the laws and taxes put in place by their rulers. Rebellion was, therefore, often rife.

Little is known of Cleopatra's childhood but we do know she was afforded an excellent education. Languages came naturally to her and she was fluent in Egyptian as well as able to read hieroglyphics. She was also taught mathematics, philosophy and the Greek art of oratory. Much of her education likely took place in the famous library of Alexandria, a huge library full of books – or rather scrolls, that held knowledge from all across the world. It is said that every new book to arrive in Alexandria was confiscated and held in the library, whilst copies of these confiscated books were made in order to compensate the original, and probably somewhat upset, owner.

Cleopatra's father was appointed as pharoah following the death of Ptolemy of Cyprus, who committed suicide rather than take the Egyptian throne and surrender his beloved Cyprus to Rome. He was an illegitimate son but given the circumstances it did not matter – he was the only candidate that could reasonably take the throne and be able to keep the armies and politicians of Rome at bay. Rome was becoming an ever more prominent threat and something needed to be done. What he did to control the threat was essentially to buy support from Rome so they would leave him alone. It was a clever move but one that left him in massive amounts of debt by the time he died – the debt, however, was worth it as the plan worked. The powerful Caesar and Pompey had been circling Egypt like vultures, eyeing up the country in order to annex it. Thankfully they accepted the price that Auletes offered. On the flip side, however, taxes were raised in order to pay the debt and the people of Alexandria were not happy in the slightest. They rose up against him and Auletes fled, hiding out in a villa that belonged to Pompey. A young Cleopatra is likely to have gone with her father. With Auletes gone from Rome, his daughter Berenice took the crown for herself – and then murdered a new husband just a few days later. Thankfully for Auletes he had the support of Rome and with their help managed to take back his country.

To die of natural causes was a rarity within the Ptolemaic dynasty – many members of the family had reached their ends in horrible ways but Auletes managed to die peacefully in 51 BC. Power transferred

to Cleopatra, just eighteen years old, and to her younger brother – Cleopatra and Ptolemy XIII were married and expected to rule together but the issue was that the new pharaoh was just ten years old. Ten years old and surrounded by advisors who clearly had issue with his sister-wife. Such intrigue was, of course, usual at this time and Cleopatra was not about to take any of this lying down. But in the years following their accession to the throne, Egypt was plunged into famine which led to plague and starvation. Even in these early days, Cleopatra worked hard to make things easier for her people, and to show them that she was there – she worked on easing taxation for the people and doing her best to keep Rome well and truly out of the way. She also curbed the violence of the Galbiani, a group of soldiers who had been brought in to help her father out in the civil war against her sister. When they murdered the sons of the Roman proconsul in Syria, she had the murderers sent to face their crimes in chains. Her work and intercessions, despite the problems that plagued her country at this time, certainly made her popular among many of her people.

Relations with her brother-husband soon turned sour and in about 49 BC she left Alexandria, while her brother remained there, proving to be a nasty piece of work. When the Roman general Pompey came to Alexandria to seek help and refuge from who he thought were allies, he was brutally murdered while the young pharaoh simply watched. Pompey did not even manage to leave his boat, being stabbed in the back as he reached his hand out to be helped across to Ptolemy's own boat. As a final insult he was beheaded and his body tossed unceremoniously into the water. The headless corpse was eventually retrieved and given a funeral. Julius Caesar took the murder of Pompey badly, bursting into tears when he saw his friend's severed head. But Caesar did not exact revenge, he pardoned the men who had killed Pompey and then set about trying to broker peace between Ptolemy and Cleopatra. It did not exactly go to plan.

The story of how Cleopatra and Caesar met is certainly a famous one, though how true it is is up for debate. According to Plutarch, she was taken to meet Caesar in secret, 'tied and bound up together

like a bundle...this was the first occasion that made Caesar love her.' This tale has shifted throughout the centuries to Cleopatra emerging from a rolled up rug! It seems far more likely that she would have been secreted in to meet Caesar, hooded and cloaked. Other Roman authors have twisted this into a tale of seduction from a whore who had no business sharing Caesar's bed. This attitude towards the Egyptian queen was one that was so often repeated by those in Rome – she must have been a harlot and tempted Caesar (and later Mark Anthony) into her bed. But however the two first met, it is clear that the two had sexual relations. Unfortunately, it did not stop the civil war between Cleopatra and her brother.

The two sides fought bitterly until the young Ptolemy drowned. He had agreed to stop the fighting after Caesar had tried to keep the peace but quickly changed his mind. In his rush to get back to the fighting, caring little for either his people or himself, he ended up dead. It of course brought an end to the fighting and the Egyptian army which had fought under Ptolemy surrendered to Caesar, who had for so long tried to broker a peace. The crown was passed to the younger brother, who became Ptolemy XIV, and Cleopatra. Following the end of the war, Caesar and Cleopatra are said to have taken a cruise along the Nile in a massive pleasure barge. In the spring of that same year Cleopatra gave birth to a son who she named Caesarion, though Caesar was not there to see it. Many disputed that the child was even Caesar's and Caesar never acknowledged the boy as his own.

The war had all but destroyed Alexandria and Cleopatra took it upon herself to rebuild her city. The biggest loss, especially to history, was the Library, much of which had burned in the chaos.

Cleopatra was back in Rome just a year after her son was born. Whether or not the baby went with her has been disputed and it seems to have been more of a political visit than anything else. Perhaps she did take the child with her in an effort to have Caesar recognise him as his son and heir. Around the time of this visit, an event occurred which only made the Roman people dislike her even more than they already did – a golden statue of Isis was erected in the grounds of one

of the temples. It did not escape notice that Cleopatra called herself the embodiment of Isis, so could this statue actually have been her under the cover of something religious? This and the fact that she was now openly in Rome and living in one of Caesar's villas, made the affair more than obvious to everyone. The Roman people turned their nose up at this, particularly as her young husband had come with her – they were disgusted at the fact that her husband was her brother – and now it was well known she was sleeping with a man who wasn't her spouse. And then there was Cicero, a famous orator and statesman, who was one of Cleopatra's most outspoken critics. The icing on the cake for him seemed to be her promising to lend him a book that never materialised!

Caesar's death is a tale that everyone knows – it has gone down in history and is so famous that it has been written about and shown in visual media time and time again. His popularity in Rome had been waning for some time, particularly among the senate – his dalliance with Cleopatra certainly hadn't helped matters but Caesar's rise to power had been far too swift and it was feared he wanted to be crowned King of Rome. Those who conspired to murder him wanted to preserve the Roman Republic. It happened on the Ides of March in 44 BC – that morning Caesar made his way to meet the Senate who were meeting at Pompey's theatre. When he arrived and waltzed inside, dressed in his white toga and with a laurel wreath on his head, the entire senate rose to greet him. He was quickly surrounded by his colleagues and then suddenly one of the men who had come to 'petition' him grabbed at his toga and gave it a yank. This was the agreed signal and at that moment he was swarmed over by men wielding daggers; he tried to move away from the initial attack but there were too many and he was overcome, stabbed over and over again all across his body. Cleopatra was still in Rome at the time but it is unclear how she would have reacted personally to the murder of her lover but she was certainly in danger politically. The foreign lover of a murdered 'tyrant' certainly would not have been welcome in Rome. Her exit was swift following Caesar's funeral and she made her way back to Alexandria.

Upon her return, Alexandria was relatively peaceful. Her sister was still proving to be a thorn in her side however and had drummed up enough support from her exile in Ephesus to have herself crowned Queen of Egypt. Cleopatra had her son named Pharaoh of Egypt in response and she became his co ruler. It secured her position and was basically a middle finger to her despised sister – her son, a Roman, was just three years old and pharaoh. The power well and truly lay with her. She cemented herself even further with her people by playing more into the idea that she was the embodiment of Isis. The murdered Caesar played the role of Osiris who was murdered by his own brother but left behind a young male heir, who was obviously the little Caesarion. It cemented all of them as gods, which only raised their status in the eyes of the Egyptians.

In the run up to her fatal relationship with Mark Anthony, Cleopatra oversaw much change in Alexandria. Scholars were brought back to the city and the study of philosophy, history and medicine prospered. The city flourished under her leadership at this time, that is for certain. And yet things still went wrong, with disasters once again hitting the country and affecting the Egyptian people – the Nile failed to flood in 43 and subsequent years which meant that the crops also failed and the citizens starved. All the while, civil war raged in Rome following the murder of Caesar and it soon found its way to Egyptian shores. One of Caesar's supporters, Dolabella, begged her for support and of course she gave it, giving him a fleet that had been left to her by her murdered lover. The fleet defected, however, to Dolabella's enemy on the opposite side of the civil war, Cassius. He too asked for help, but she sent him excuses – why would she help someone who had been involved in Caesar's assassination when she had enough problems of her own at home? As she demurred, she was approached by two of Cassius' enemies, one of whom would become her lover.

Octavian, Caesar's named heir, and Mark Antony desperately wanted to destroy the murderers and Cleopatra was more than willing to help them. And it would bring Cleopatra into Mark Antony's orbit it would prove fatal for both of them, but it would also tar Cleopatra's

name long after her death thanks to the propaganda written about her and her new relationship. Plutarch was particularly outspoken about the Egyptian queen in his work on the life of Mark Antony, stating that she bewitched him and caused all of the issues that had honestly been there since before they had even met – he was already a womaniser with a love of excess but before Cleopatra he had always known right from wrong. His love of the Egyptian Queen would turn him.

Antony took over the management of Egypt once the second Triumvirate was created with him, Octavian and Lepidus and once he had received this job he made sure to organise a meeting with Cleopatra. It should be noted that the two had already met once before, when she was much younger, just 13 years old – was it possible that she had fallen for the handsome Roman back then and developed a crush on him? She made a huge effort when it came to this meeting, even going so far as to play hard to get and ignoring his summons. Instead, she arranged her own arrival on a sumptuous barge complete with musicians and full pageantry. Upon her arrival, Antony sent her a dinner invitation, but she insisted he come to her for dinner that evening – she was royalty, after all, so he could not really refuse. She had her slaves prepare a massive banquet that was laid out across twelve different rooms, golden cups and plates set out to eat from while she dressed to impress, covering herself in an incredible amount of jewellery. Incredibly, when the dinner was over, she sent each of the guests away with a 'doggy bag', but it wasn't full of food. Oh no – the guests walked away with the golden plates they had eaten their dinner from!

Antony's wife died suddenly, following an issue in Rome in which she went face to face with Octavian as a ploy to bring her husband home. He blamed her entirely for it and Octavian believed it, allowing Antony to marry Octavian's sister Octavia. They also divided the Roman Empire between them; Antony got the half with Egypt, which must have pleased him greatly. Around the time of his marriage to Octavia, Cleopatra gave birth to twins whom Antony would publicly acknowledge.

Despite the marriage between Antony and Octavia, the rift between him and her brother only widened. Apparently, the family marriage and splitting of the empire in two hadn't worked all that well. Octavia did her best to smooth things over and somehow managed to have them meet, exchange military gear and then they both went their own way. Antony went to Syria and immediately sent for Cleopatra – his obsession hadn't waned, it seemed. Nor had his wish to use the might of the Egyptian forces in his current military endeavours in Asia. When she arrived, Antony showered her with gifts, land being the main thing. Territory that had previously belonged to Egypt but taken by the Romans was returned to her. Of course the Romans were furious at this. How dare he give his Egyptian whore that land?

Their love continued to blossom and, according to Plutarch, it began to affect Antony's judgment. He was too smitten to even think about paying attention to his military endeavours, he was 'bewitched' by her. The idea of bewitchment is an issue that many women have come to be accused of throughout history – Cleopatra certainly was not the first woman to be accused of bewitching a man, and nor would she be the last.

Antony's expedition in Syria was a disaster, ending in famine. His soldiers were forced to forage for food and ended up eating herbs that made them go mad, and they drank water so polluted that it often killed them. Thousands of men were lost thanks to this and the enemy Antony was there to fight ended up taking full advantage. All the while his issues with Octavian grew worse. Even as his soldiers died of hunger and disease around him, he was dragged into further conflict. He marched himself and his soldiers through Armenia until he reached the shores of the Mediterranean where again he called for Cleopatra to join him. Antony's troops had suffered terribly on their march and when she arrived Cleopatra handed out food and clothing to them – not exactly the actions of an evil woman!

As things heated up militarily, Antony seemed desperate to make out that he had won his battles. He hadn't. Rather he had been defeated over and over again – an omen, perhaps, that there was no way he

could defeat Octavian should it come to a fight. Still he had to make out that he was better than he was and Cleopatra fed into that. They also handed out more gifts of land, this time to their children. The problem here though was that the land did not yet belong to them and perhaps never would. Rome took this as an insult and it became more and more obvious to them that Antony's loyalty no longer belonged to Rome, but to his Egyptian queen. This loyalty was also spitting in the face of his dutiful wife, Octavia, who had tried so hard to have her husband love her. During this time, despite having had three children with Antony, Cleopatra continued to try to have Caesarion acknowledged as Caesar's true and legitimate heir – another insult to Octavian, who had been named by Caesar himself as his heir. The whole thing was a failure before it even began.

It was obvious that battle was coming, and the couple headed for Ephesus, near the modern day village of Selcuk in Turkey. There they outfitted a number of ships and gathered their troops. Cleopatra remained with Antony and the two distracted themselves from the brewing war with daytrips, feasts and copious amounts of drinking. Antony demanded at this time that Octavia leave his house in Rome – she did so, but the Roman people took her side. She was being horribly mistreated by her husband who cared more for a harlot.

Both sides amassed troops but Octavian's numbers were significantly less on the sea side of things than Antony's. He did, however, have more troops on the ground. Antony made a decision here that would bring about not only his downfall but Cleopatra's, and the Republic's also. Cleopatra had come with him as his advisor rather than going back to the safety of Alexandria – her advice here convinced him that the battle would be better off being fought at sea. After all, they had the numbers. How could they lose? This battle has gone down in history as the major turning point in the lives of Antony and Cleopatra, and the true beginning of their downfall – Actium.

The Battle of Actium was a crushing defeat for Antony and Cleopatra. Not only did Antony ignore advice from military veterans that he should fight on land rather than at sea, a great number of

Cleopatra's ships turned tail and fled. More importantly, Cleopatra fled also. Mark Antony followed, completely betraying Rome and ruining everything that he had worked for. Here Plutarch is damning in his conclusions over Antony. 'He was dragged along by a woman ... as soon as he saw her ship sailing away, forgot everything, betrayed and ran away ... to pursue the woman who had already begun his ruin.'

Following the defeat at Actium, Cleopatra headed back to Egypt. Antony only followed later. He fell into a deep depression and kept asking his men to kill him, or threatening to kill himself. He hid himself away in a little hut on a beach where he contemplated his failures. He knew he was ruined and that Rome now had their eyes fully on Egypt. They would want to get their revenge on Mark Antony and Cleopatra, to destroy them and any who could rule in their name later. They could not risk any further trouble.

Somehow Cleopatra managed to lure Antony away from his little hut and the two distracted themselves once again with banquets and parties even as it became clearer that their future was bleak As this went on, Cleopatra made sure to try to secure Caesarion as the sole ruler of Egypt, to make sure that he would inherit the country once she had gone. Messages and threats were sent backwards and forwards between each side and Cleopatra offered to abdicate the throne in exchange for clemency and sent Octavian beautiful gifts. Octavian replied to her offer – he was willing to accept but only if her lover was executed or exiled from Egypt. He would not be allowed to live as a private citizen in Egypt as he wished. Antony tried desperately to gain clemency from his old friend also, sending one of Caesar's assassins to Octavian and even offering to take his own life if it would mean Cleopatra was saved. He was met with a stony silence. Cleopatra had far more to offer to Octavian after all. Antony was, at this point, a nobody who deserved death for his disloyalty.

As the months ticked by, Octavian kept on at Cleopatra, asking her to have Antony executed. Of course she would not acquiesce to killing her lover. Instead she seemed to have her own plans – together

with friends she created a group known as the partners in death. The name tells us everything we need to know with its apparent signposts to group suicide. She also began, or continued to, experiment with poisons – she seemed to be more obsessed with death than ever, working on a poison that would lead to a peaceful death and building what could only be described as a mausoleum for her and her macabre group.

In the spring of 30 BC, Octavian marched on Alexandria. Antony, surprisingly, rode out to meet his old friend at the head of a small army. He was only victorious because Octavian's troops were exhausted from their march. Their defeat would not harm them for long, however, and on 1 August it would all come to a head. Antony was furious when his ships and cavalry defected over to Octavian even as they were on the field of battle, raving that Cleopatra had betrayed him. He stormed into the city, but she had already fled to her mausoleum and locked herself in. Then she sent a letter to him, telling him of her death – false news and one to encourage him to admit defeat and give up. He had already offered to kill himself but now he was convinced his lover, who he had spent a good ten years of his life with, was gone and he had nothing left to live for. In his rooms he ordered one of his servants to kill him but the servant killed himself instead. So Mark Antony drew his own blade and sank it into his chest – unfortunately he missed any vital organs so he was left writhing in pain. His remaining servants refused to heed his requests to finish the job and instead ran.

It was at this point that it became clear that Cleopatra wasn't dead at all. Antony was then carried to Cleopatra, bleeding severely and clearly dying. The story goes that she lost all sense of herself and tore at her clothes, smearing his blood across her face. As his life ebbed away, he begged her to give herself up to Octavian, before dying in her arms.

News was taken to Octavian that Antony was dead and he wept, as he had for Caesar before him, at the news that his old friend was gone. But the tears soon stopped – Antony had been a thorn in his

side for far too long. Now he had to deal with Cleopatra. An envoy was sent to the mausoleum to try and get her to leave. She refused and instead stated that the envoy would have to talk to her through the locked door. So the envoy had a ladder raised and climbed into the mausoleum and took her into custody. Octavian had her placed under the care of Ephroditus and all instruments with which she could harm herself were taken away. She was however, granted the permission to bury Mark Antony herself and she did so in a grand fashion, honouring him in death. She became unwell after the funeral when wounds she had inflicted on herself during the ritual grieving became infected. When Octavian found out that she was refusing treatment he threatened her children – she soon gave way.

As she recovered from her illness she had a meeting with Octavian, insisting that she was a friend to Rome and begging him to recall the esteem in which his father had held her. Dio spins the tale that when Octavian refused to even make eye contact with her she burst into tears and threw herself at his feet, wailing that she had no wish to live and begging that she be buried with Caesar. She then insisted that she only did what she did because she was afraid of Antony but Octavian would have none of it. Finally, she surrendered, handing over a list of her treasures. Octavian was desperate to show off the captured wealth and have Cleopatra herself paraded in a triumph – when he realised that she had kept some of the treasures off the list he lost his temper but she implored him that she had kept them away as gifts to his wife and sister. That pleased him and he left her, pleased as punch that he had subdued the great Cleopatra. Except that he hadn't. She had absolutely no intention of being paraded and humiliated in a triumph. As Octavian made plans to leave Alexandria with the queen and her children in tow, she was making her own.

When Octavian sent word that he was planning to leave Alexandria on 9 August , she asked that she be allowed one last visit to Antony's tomb. The request was granted and she travelled there the following morning, Plutarch telling his readers how she draped herself over the tomb in tears. Following the display, she returned to the mausoleum

where that evening she dismissed all of her retinue bar two of her women and had herself dressed in her ceremonial gear. A letter was sent to Octavian in which she begged him to have her buried next to Antony – he knew immediately what she was planning and in a panic sent messengers to the mausoleum. But they were too late. When they arrived, she was lying dead on her couch, draped in her ceremonial robes and clutching the ceremonial crook and flail of her role as pharaoh. Beside her, also dead, were the two maidservants.

The story goes that Cleopatra committed suicide by having an asp bite her naked breast but this does not seem likely. As we have noted, she had been working previously with poisons and would have known of much better, faster and less painful ways to get what she wanted. But her death at the fangs of the emblem of the royal house of Egypt makes for a much more dramatic story. One of the maidservants had still been on her feet when the messengers burst in to the room and had collapsed shortly after – her death had been painless and it was likely that all three women had taken the same poison. The reality is, however, that we will never know what exactly it was that killed Cleopatra much like how we will never truly know much about her life.

Following his mother's death, Caesarion was convinced to return to Alexandria where he was murdered by Octavian's men. He could not be allowed to live and pose as a threat to Octavian. Cleopatra's other children were raised in the household of Octavian's sister. Antony's children from his previous marriage to Fulvia were sent to live with her family. They posed no threat, after all, and so could be allowed to live. All traces of Mark Antony were obliterated by Octavian, and it was ruled by the Senate that the names Mark and Antony could never again be given together. His birthday was even decreed to be unlucky. Egypt itself, known as the breadbasket of the world, was now a Roman province. Octavian had what he wanted – he had Egypt and its wealth, and he had removed a traitor and his queen,

From the moment of her death, and even before, Cleopatra's name had been sullied by her Roman detractors. She was a seductress, a

whore who had brought two Roman generals to her bed and who had married her own siblings. She was also painted by Roman writers as a coward who convinced her lover to flee from battle. An insatiable and bewitching woman, she was viewed as toxic and wicked, even being seen as disgusting in later times. Florence Nightingale even viewed her with derision. As time has gone on, her life has been looked at in terms of her successes as queen and the documents written by those at the time looked at in much greater detail, the bias understood. Yet still the image remains of a beautiful seductress who lured men to her bed and their doom, a siren surrounded by riches.

Cleopatra's story is certainly not unique and throughout this work we will see it time and time again – sex and scandal make for a better story than the truth, especially when it involves a woman in any sort of power.

Chapter 2

Empress Wu
604–705 BCE

The name of Empress Wu is one that has long garnered disdain in China, a name that has caused people to make out that she was one of the most evil rulers in their history – to many she was a wanton harlot, a power hungry deviant who schemed and murdered and slept her way to the top of the social hierarchy. These are views that began while she was in power and, like many of the women mentioned in this book, these are views that are still held on to today. But just how warranted are these views or has she been, like so many women that came before and after her, unfairly maligned? Unfortunately, it is incredibly difficult to separate fact from fiction in many of the sources available. The sources from her own town had their own political agenda and those written after her death were by those who deliberately wished to besmirch her name. Her story was rewritten many times in the years after her death, often by those who had good reason to make her out to be a true villain. What we do know about her, though, is that she was smart, ruthless and beautiful. She was a woman far ahead of her time – strong and incredibly sexually liberated in a world where no one would bat an eyelid at a man having a number of sexual partners, yet when it came to her, she found herself at the centre of a number of allegations on her sexual behaviour. But she rose above all of it and her strengths allowed her to reach the very top of the hierarchy in ancient China. It was completely against all tradition; women at the time were supposed to be secluded and isolated, kept far far away from politics. She faced down the norms in Chinese identity and challenged everything as

the first and only female ruler in China's history up to that point. Only Empress Dowager Cixi (covered in a later chapter) could hold a candle to Wu, yet even she does not seem to have garnered quite as much hatred. This chapter covers the extraordinary life of Empress Wu Zetian and her rise from concubine to ruler, by whatever means necessary.

Very little is known about Wu's early years but what we do know is that she was the daughter of Wu Shihou, a retired lumber merchant, and the Lady Yang. Both were middle aged at the time of Wu's birth in AD 625. As a baby, Wu was the subject of strange portents of her future – in 627 the family were visited, it is said, by a fortune teller named Yuanng. The fortune teller made a beeline for Lady Yang and stated that she would bear a noble child – he all but ignored Shihou's sons from his previous marriage and said the most they would do was become governors, but when he laid eyes on the baby everything seemed to change. It wasn't until the baby opened her eyes that the fortune teller was able to say anything. He commented with surprise that the child had 'the aspect of a man. The countenance of a dragon and the neck of a phoenix, resembling that of Fuxi – indicators of a most celebrated individual ... if this were only a girl, she could be the ruler of the Empire'

Little did the fortune teller know!

Following the death of Empress Wende in 636, when she was just 11 years old, Wu found herself summoned to the palace to join the Emperor Taizong's harem. But both she and her family knew that there was little chance of her rising through the ranks – Taizong already had sons, and he had plenty of other concubines to warm his bed. The Emperor's harem of women was topped by the Empress – she was no concubine, however. She was his true wife and the mother of his legitimate heirs. Any below her were nothing more than concubines, though there was a hierarchy to those below the Empress. There were four lesser wives, six women in the second grade, nine (elements) in the third and so on. Wu found herself as

one of the women of the fifth grade – she was by no means at the bottom of the pile as there were lower grades than her, but she was still low enough to have little chance of getting to spend any significant time with the Emperor. The concubines of Wu's grade were expected to be far more than just potential bed maids of the Emperor however with duties including that of chambermaid. Yet despite her mother's expectation that Wu would not rise, rise she did, not least thanks to a series of scandals with Taizong's children at their centre. Prince Chang-qian was Taizong's eldest and his heir but showed little interest in learning about matters of statecraft or, in fact, any lessons. He seemed to care more about horse riding in order to hide his limp, an injury from birth, and living like a nomad of the Turkish Steppes. His behaviour earned him a dressing down from his tutor but rather than do the right thing and apologise, the Prince ordered that two of his cronies to kill the tutor. When that didn't work, Taizong had a new tutor appointed which seemed to go some way to have the Prince up his game, outwardly at least. But in 643 everything was about to come crashing down for the prince. Chang-qian fell in love with a young dancing boy and, finding out about their tryst, Taizong had the boy executed. The Prince, stupidly, decided to seek revenge on his father and pulled together a group of disgraced and disenchanted nobles in order to commit the act of regicide. The plot never came to pass, however – one of Chang-qian's brothers got it into his head to try to murder his father, also. Prince Zhi made friends with a group who were less than friendly towards the Emperor. They whispered in his ear that it was time to overthrow Taizong, just as he had done to his own brother so many years before. Zhi's tutor took note of this, as well as the army that Zhi was pulling in around him and reported the news to Taizong. Zhi had the tutor killed and then, rather than wait on his father to rain hell down upon him, launched a revolt. It was over quickly, however, and Zhi was forced to surrender by government troops. He went back to court in Chang'an with his tail between his legs.

In the capital, a man stepped forward who agreed to spill everything in return for clemency. It turned out that the individual had been part of *both* plots – his confession dropped Cheng-qian well and truly in it. All of those involved in the plots were either banished or executed – Cheng-qian and Zhi were dispatched to the farthest corner of the Empire and left there, stripped of their titles and forgotten. They did not last long out there. Others were forced to commit suicide whilst others, including close friends of the Emperor himself, were executed. Nor were the womenfolk spared, though Taizong could not bring himself to have them executed. Instead, any woman in the palace associated with the plots was banished. This was incredibly important for Wu – it got rid of huge swathes of Taizong's concubines and gave her the opening she needed to make for even greater heights.

In 643, Prince Gaozong was raised as heir to his father. This young prince was shy and retiring for the most part but the important thing here is that he was part of his father's court at the same time as Wu. Whilst Gaozong had older brothers from his father's other women, he was the eldest son of the late Empress Wende, so he was, in essence, the only legitimate choice for Crown Prince following the fall of his siblings. Raised suddenly to now be his father's new favourite, the young man had the run of the court – did he come face to face with the beautiful young concubine? It seems incredibly likely. Taizong was not much longer for the world, however, and by 648 he was bedridden following a successful military campaign in Korea. As the emperor lay dying, the only ones by his side were his son, Gaozong, and the beautiful young concubine, Wu. With just each other for company is it any wonder that the two took notice of each other? Could the young prince, noticing this beautiful young woman and her sombre expression, have felt sorry for her? She was still so young and hadn't even risen up the ranks of the women – what was waiting for her once the Emperor died was a nunnery. Etiquette dictated that it was a disgrace for any man to touch a woman who had once been an Emperor's wife. If Gaozong and Wu had a physical relationship it

would have been considered an act of incest and would have caused a huge scandal. It has been suggested that the two were physically intimate before Taizong died, though there is no mention of it in the official histories of the Tang dynasties – rather it was popular gossip during Wu's reign as Empress and an 'instance' that would stick as another reason for her to be so hated.

Taizong died in 649 and Gaozong was crowned as Emperor. As tradition dictated, any woman who had borne Taizong a child was locked in the confines of the palace whilst any who had not were sent to a nunnery where they could not be touched by another man. Wu was sent to Ganye convent along with a number of Taizong's other women who had not given him children. She languished in the convent, seemingly forgotten, while Gaozong took his place as Emperor. But already the path was being set for Wu to rise – Gaozong's chief wife, Empress Wang, had failed to give him a son and heir which was her main job. Because of this, Gaozong's heir had to be chosen from one of his sons by other women.

Wu certainly had not been forgotten but the succession drama in the palace had taken precedence. An heir was adopted thanks to Wang's lack of a child – Li Zhong was chosen as crown prince, the son of one of the concubines. This choice upset many of the other concubines within the palace and, as ever, wheeling and dealing started to happen – Taizong's favourite, Xiao Liangi (known as the 'pure concubine') began to plot ways she could get the Emperor to make her own son his heir. But just a year after Taizong died, it is said Gaozong took himself off to the convent where Wu was living. He found her there with her beautiful long hair shaved off and utterly miserable. Yet by the time she was documented as back at court and giving birth to her child, her hair seems to have miraculously gone from completely shaven to seven feet long. Many questions can be asked about this period in Wu's life, but what we know for certain is that she was back at Gaozong's side by 652 and had given birth to a little boy. The Empress used Wu's return for her own ends – with his illicit lover returned, it meant that he spent less time in the pure

Empress Wu

concubine's bed, and more time in *hers*. But little did she know that Wu would turn everything on its head – over the next few years, Wu took complete precedence over the Emperor's other women, bearing him multiple children. But being the favourite wasn't enough for Wu, not when the pure concubine went to the Empress and begged for help in getting back into the Emperor's good graces. The events that followed would go down in history as one of the most disturbing in Wu's life.

In 654, Wu gave birth to another child, this time a baby girl who became somewhat of a favourite with the Emperor. The Empress, as head wife, visited the new baby as precedence demanded – she only stayed a short while before leaving the room, having briefly picked the child up when Wu wasn't in the room. Once the Empress had left and Wu was back in the room, Gaozong arrived. Wu took his hand and took him to the child's cradle – they found the baby dead. Overcome with grief, Wu screamed and demanded to know who had been in the room – the serving women then dropped a bombshell. Empress Wang. Today it is whispered that Wu strangled her own child in order to oust the Empress – how true this is we will never know but it may be that the child wasn't murdered at all, but rather was the victim of a cruel yet natural tragedy. Either way, Wang was the prime suspect, and this would be the beginning of her downfall. Gaozong had Wang demoted and the chosen Crown Prince removed also. With the prize now well and truly in her sights, Wu had to make sure that nothing stood in her way. A replacement had to be found to take Wang's place and Wu began to surround herself with support. Still Wang believed that she could return to the Emperor's good graces – but in 655 she made a fatal mistake and turned to sorcery to try and overthrow Wu. Gaozong's officials refused to formally agree to Wang's demotion so Gaozong took matters into his own hands, making Wu an auxiliary wife, or he would have if the four slots weren't already taken and he had been able to find an excuse to oust any of them. So a new role was created just for Wu – the Imperial Concubine. Wu's supporters tried to convince the Emperor that the best thing to do would be

get rid of Wang and invest Wu as Empress instead – unsurprisingly he jumped at the chance, he just had to find the right moment. And the pure concubine also had to be got rid of if his darling Wu was to be secure. So he issued a decree stating that Wang and the pure concubine had been caught plotting to poison him – the two were stripped of their ranks and kept under house arrest. Wu was quickly raised to the position of Empress, the position that she so coveted since returning to court in 652 – and it wasn't long before the new Empress took revenge on the two women that had for so long stood in her way.

Shortly after Wu gained the crown, Gaozong went to see them and they both begged that he set them free and said they would happily take on roles of palace servants. When Wu learned of this, she demanded that the two women be killed – she couldn't risk them gaining their freedom and overthrowing her. Some accounts say that the women were ordered to hang themselves while others have the two dying in a far more grisly way – their hands and feet were cut off, their arms and legs smashed and shattered and then their broken bodies thrown into vats of wine where it is said they took days to die. And Wu, Empress of China, is supposed to have said of their fates, 'Now those witches can get drunk to their bones.'

She was in a strong position, at least for now. As Empress she threw her weight behind various projects and sectors that she believed in. For instance, she set her eyes on the scholar class – they had always been very Confucian and traditional which was something she wanted to change. Why? Traditionalists and Confucians believed that women had no right to be seen, heard or have any power. So she became a patron of learning and sponsored a good number of projects, many of which challenged the role of women in society. She also headed a number of important reforms among the silk trade by reducing taxes, reforms within the farming community in an effort to stop any future food shortages; and then she demobilised many units of the Tang army that had been placed in other countries such as Korea – with that demobilisation she attached a proposal for peaceful conflict

resolution, a very Buddhist thing to do and perhaps inspired by her deceased mother, who had been an ardent Buddhist. She also decreed that following the death of a mother in the family, there should be a period of three years of mourning. What was so surprising about this? The period of mourning for the father was always three years. The decree brought women into line with the Confucian tradition always stuck to for men. It also brought equality between the sexes, something which Wu would work towards for much of her reign.

It cannot be denied that Wu did some good throughout her reign and many of her decrees can be seen as an early form of feminism. But we have already seen that she could be brutal. No one stood in her way and if they tried then they would either be exiled or killed. For example, Wu had her son Zhongzhong's wife locked up and starved to death after she had tried getting a little too close to the Emperor. Following the incident, her son, Li Hong, who had been conceived out of wedlock, stood up to his mother about what she had done, accusing her of murdering a virtuous woman, something that did not look good after she had so recently had biographies commissioned on virtuous women from history. Just eighteen days later, he was dead. The official story was that he had suddenly become ill whilst away on a summer getaway with his parents and died. But many chroniclers were immediately suspicious of Wu – after all, she hadn't shied away from having 'enemies' killed before. Had he been such a sickly young man, surely such information would have been known of before? Yet there had been no mention of such poor health by contemporary biographers. Or could this have just been an incident that Wu's detractors took hold of and twisted, accusing her of poisoning her own son?

In 683, following years of poor health, Emperor Gaozong died at the age of just 55. Wu had been the driving force behind his government as he had lain in his sick bed, issuing proclamations and leading in her husband's name, whilst making sure that any enemies were kept well out of the way. But with her husband dead and the accession of a new Emperor, her son Zhongzhong, she would be

expected to step back into obscurity and seclusion as the imperial widow but this wasn't something that she was prepared to do.

Wu, having already had Zhongzhong's wife starved to death, took advantage of the fact that her son had no experience as well as a clause in Gaozong's will – the people were to follow the Empress' rule should important matters of state come up in the immediate days after his death. Rather than disappear into the background, Wu deliberately had her son's coronation date pushed back until after Gaozong's funeral, and deliberately stuck around. She watched as her son and his current wife, Empress Wei, made huge mistakes and changed things within the court far too quickly. More crucially, Wei exercised an iron will over her husband – she insisted that her family members should be given powerful roles within government and got her way because Zhongzhong just could not say no to her. Even Wu had not been so blatant. Then, when a minister dared to question that Wei was being given too much power, Zhongzhong snapped at him that he could give his wife the entire Empire if he so wished. That was what Wu was waiting for. She stepped in and invoked the clause in her husband's will, She had the backing of prominent members of court, too. In February 684, Wu made her move. Just six weeks after he had taken the crown, Zhongzhong was overthrown in a coup that saw him accused of treason and exiled, along with his pregnant wife.

Wu's youngest son, Raizong, was proclaimed as the new Emperor. He was a compliant young man of 22 who spent much more of his time in his mother's presence than was deemed necessary for male children at the time. He was the little darling of the court and spoiled. Wu informed the court that Raizong had a speech impediment and that he had asked her to be his voice, just as she had been for his father in his last years. It was the perfect situation for Wu – she would not have to retire and be forgotten, rather she could hold on to the power that she had worked so hard to gain.

She made more changes following this. Under the guise of finding religion, she founded a number of Buddhist temples in memory of members of her own family. She made much of Buddhist relics being

found and where strange lights had been seen in the sky, and she also took part in a massive 'Act of Grace' – in essence having a number of criminals pardoned and rewards being offered to palace officials who had been overlooked or simply forgotten in the past. Other reforms happened too, including massive reforms of the military – rather than have commanders who had never seen battle and were simply noble, she made sure that those raised to such roles were *suitable* for the job. Many saw this as just another way of her having people around her who owed her – just as they did with the Act of Grace – but it certainly seems like a wise move especially looking back on the times from our modern perspective.

It cannot be argued that Wu did not make many changes for the good. Yet, as with every person of power, she had to deal with uprisings. In the south east of the country, the grandson of a Tang general, Li Jingye, raised a rebellion with the aim of supporting the one time heir Prince Xian. The problem here was that Xian was already dead and had committed suicide in 684. This rebellion, though over very quickly, really did show just how many people felt about her and an entire list of reasons why she needed to be got rid of were given in a public proclamation. She was described as having 'the heart of a serpent and the nature of a wolf' – she was both cunning and ruthless. She is then accused that she '[slayed] her sister, butchered her brother, killed her prince and poisoned her mother'. More so 'she is hated by men and gods alike'. In essence, these rebels believed that all she wanted was the power that came with being at the very top of the hierarchy and, like with so many women in power throughout the centuries that followed, they decided to insinuate that she was guilty of some of the worst crimes.

It was only a matter of time before Ruizong's supporters, believing that the young Emperor was in no need of a regent and could rule on his own, would start to rise up to try and have the regency removed from Wu. Small uprisings began to take place with the aim of setting Ruizong in his place, yet Wu was always one step ahead – her secret police worked hard at weeding out those who were

trying to stand up to her. Justice was meted out for those involved in the unrest, especially to those who apparently forged edicts from Ruizong authorising the uprisings. She also made sure to show her own power through huge events that would pave the way for her taking the throne. In a great sacrifice held in a building known as the Hall of Illumination, she made sure the Ruizong only had a small part to play, and she made sure to honour her own father. Although not a royal in life, this honour meant that her father could now be considered an emperor in heaven.

Wu made a number of further changes that only cemented her wish to be considered as the true sovereign – including creating a brand new character in the writing system so that her name, rather common, could be written in its own special way. She then banned its use, as it was illegal to use the ruler's given name. Then in 690 her ministers finally suggested that she became sovereign in her own right – she refused to start with, as protocol demanded. When her ministers came back with a petition signed by a number of her subjects, she refused again using the argument that China already had a ruler and it was not her place to overthrow her son. Amazingly Ruizong was still alive despite all of the uprisings in his favour, but he knew he was on very thin ice, so he approached her himself and said that he had decided to abdicate. More importantly, he wanted his mother to take his place as sovereign ruler of China. It was at this stage that she not too 'reluctantly' agreed. Finally, Wu had the ultimate power for which she had worked for so many years. She had started at the very bottom and had used her feminine wiles as well as her exceptional intelligence to work her way up. The Tang dynasty that she had married in to was no more – she founded her own dynasty, the Zhou, that she would have wanted to last for hundreds of years to come. Sadly for her, it wouldn't last long at all.

By the time she was Empress in her own right, Wu was already in her sixties and did not have much time left to her. She was too old to bear any more heirs and so Ruizong, who she had ousted, was still her heir. She would soon name Zhongzhong as her heir rather than

Ruizong. So what was the point in renaming the dynasty when it was inevitable that things would go back to the Tang?

The final years of her reign were uneventful when compared to the years leading up to her taking the throne. As she aged, she, as many have done after her, tried to find ways to extend her life – she founded the Office of the Crane whose job it was to find elixirs and methods that would help her live longer. But one of the methods that was 'found' to keep her young was particularly scandalous – young men, said to be eunuchs to try and keep the court happy, were brought to her bed chamber where it was said that they slept with the aged Empress. It was conveniently forgotten that these eunuch's were unable to perform sexually – all that mattered to Wu's detractors was besmirching her name. In return these men were given expensive gifts and stunning silks to wear. Had she been male such activities would not have been frowned upon, as she well knew given her humble beginnings as an imperial concubine. Indeed, such activities were seen as good for the health of the Emperor. Or could Wu's detractors have made up that she was using these boys for sexual gratification? Could it have been that they were simply there to keep her company in her old age?

In 705, the end came for Empress Wu. A conspiracy was afoot to get rid of two of Wu's favourite young men, the Zhang brothers – Wu had become unwell late in 704 and only the brothers were allowed to attend on her. Many believed that the brothers were planning a coup, so the conspirators played their hand, arriving at the house of Zhongzhong. He was just as useless as he had been previously and said that his mother was unwell so they should all go home. But it was too late and Zhongzhong was convinced that the only way forward was for him to ride personally to the palace and stop the Zhang brothers from enacting their coup. Unfortunately for Zhongzhong his appearance at the palace was the signal for the gathered army to strike. As soon as he appeared they sprang into action, rushing through the palace and taking Wu's eunuchs prisoner. The Zhang brothers were dragged from Wu's chambers and beheaded in the courtyard. Wu,

still unwell, emerged from her rooms and when she saw her son told him to go back to the heir's palace now that the killings had been done. She hadn't realised that this was the moment that she had been dethroned and even when she was told that Zhongzhong had taken over she answered with a barrage of insults and foul language, and then she went back to bed. Two days later she abdicated, passing the throne to Zhongzhong.

Finally, she went into the seclusion that she should have done so many years before. She travelled to the Palace of the Dawn just outside Luoyang. She remained there for ten months, visited every couple of weeks by Emperor Zhongzhong. The visits were unpleasant and she would bitterly tell him that everything would go wrong for him. As the months went on, she knew that death was finally coming her and she made an effort to make things right with those she had previously done wrong by, including the two women who she had brutally had murdered in her rise to being Empress. When she died, Wu was at that point the only woman who had ruled China in her own right. To this day she is *still* the only woman to have ruled China in her own right. She used her sex as a method of gaining power rather than allowing it to keep her under the thumb of the men who were supposed to have control. She was also ruthless in getting her way, having individuals killed just so she could have the ultimate power, and she was incredibly ambitious. Those around her hated the fact that a woman had such power in a male world which is a pattern that we see time and time again with women throughout history – so they twisted what mistakes she made to pin crimes on her that, quite frankly, are ridiculous. Yes, she was ruthless, but was she really ruthless enough to have her own children killed? These so-called crimes have stuck, though, and even now Empress Wu Zetian is considered by many to be one of the most evil women in history.

Was she evil? No. Ruthless and ambitious yes, but she certainly did a lot of good, driving reform and economic change that gave her at least some popularity with the general population. We cannot know

exactly what happened during her time as the documents that we do have are written after her death, and a lot of it comes from those who had known her. The official history of her reign presented her in a particularly bad light, but is it any wonder when it was written by the men who had watched and despised her for the power that she held? They looked down on her for her sex, refusing to admit the good that she had done. There is a bias there, as there is with all historical sources. Whilst we cannot know the full extent or truth of what exactly happened during her reign, our knowledge based as it is on court documents and histories written after her death, what we can say is that Empress Wu was a remarkable woman.

Chapter 3

Joan of Arc
1412–1431

Joan of Arc is a famous figure in history, a young woman who fought for her country and died in the most awful of ways. She has fascinated historians for centuries and her life has been documented time and time again – she is probably one of the most well documented women who lived in the Middle Ages. Her tale is one that ends in tragedy but ultimately one that has her being honoured as a heroine in her native France. Unfortunately, she has been maligned throughout her life and beyond, particularly by the English. She was viewed as a heretic and a witch who worshipped the devil, a harlot who slept with men simply to make sure her fame would grow. Shakespeare in particular helped to sow hatred not only of her, but the French, thanks to his take on her in *Henry VI Part 1*. In reality, she was a young woman who truly believed in what she was doing, and that she was being guided by divine intervention.

Joan of Arc was born in around 1412 in the village of Domremy to Jacques d'Arc and Isabelle Romee. Of peasant stock she was one of five children, but her childhood was unremarkable. She would have learned basic prayers and played the usual sort of childhood games – during her interrogation after she was captured, she admitted to dancing around a tree when she was a child which was taken by her captors to be a superstitious practice in order to summon fairies. As would have been normal at the time, she would have been raised to be pious – her mother in particular was very religious and had been on a number of pilgrimages. She was just 13 when she started

hearing voices which she believed was the voice of God – the first time she heard a voice she was standing in her garden. It came from the direction of the church and was accompanied by a strange light. Of course the first time she heard it she was afraid but she began to hear it more and by the third instance she truly believed it was a message sent from God. It told her to go to Paris and repeated the request at least twice a week until she finally sat up and started taking real notice of it. When the voice told her she would raise the siege of Orleans and that she should go and see Robert de Baudricourt at Vancouleurs where she would gain an escort, she packed up her things and left her father's house without so much as a word.

She was born during a time of great turmoil for France. The Hundred Years War had been raging for around 80 years or so at the time of her birth and involved a series of battles between England and France, as Edward III believed he had a claim to the French throne. By Joan's time, it was believed that the real heir to the throne of France was Charles the dauphin. Henry VI of England was not meant to be king, particularly as his claim came via his mother – France operated under Salic law, meaning that only male heirs could inherit the throne. Joan, and most of the French people, believed that this was God's will and nothing could countermand it – Henry and the English, however, believed the complete opposite. The Hundred Years War was part of an incredibly complicated political backdrop that would pull the young Joan in – not only were the French and English at each other's throats (with Burgundy siding with the English) but there was a schism in the Catholic church involving rival Popes who each supported a different side in the conflict.

When Joan made the decision to heed the voice's request, she knew that she would be unable to go alone. It was unseemly for women to do much of anything on their own at the time so she sought the help of her cousin's husband and together the two travelled to Vancouleurs where Joan asked if she could see the castellan, Robert de Baudricourt. When he asked her why she had come, she was straight to the point – she asked to be taken to the Dauphin of France, Charles,

for she had a message for him that had come directly from God. De Baudricourt scoffed at her and sent her away. But by this point word of her message had begun to spread and she was summoned to an audience with the Duke of Lorraine. He evidently believed the claims of the strange girl and she returned to Vancouleurs where Baudricourt had changed his mind. She was given a horse, a set of male clothing and a small escort who would take her all the way to Chinon.

The journey was a long one, stretching for 270 miles across France. News had already been sent ahead to expect her very likely by Rene of Anjou, son in law to the Duke of Anjou, whose mother was at the royal court. Upon arrival the peasant girl was taken to meet Charles and she told him of the messages she had been given. It was a private meeting witnessed only by Charles' chief advisor but as always happens, word soon got out about this spirited young peasant girl who seemed to be able to converse with the divine. In this meeting she was straight to the point, telling Charles that she had been sent by God and that if he gave her an army she would save France from the English menace and pave the way for his coronation.

In an era that was so religiously fervent, is it any wonder that Charles and his retinue were wary of what Joan was saying? For all they knew she could have been possessed by the Devil and was there to ruin everything for them. Plus, she was wearing men's clothes! How could a woman claim to be so virtuous that she was bearing a message from God when she was wearing the clothing of a man? It was, in the minds of the religious and according to the bible itself, an abomination. So they had to make sure she was as pious and god fearing as she claimed – as an unmarried woman she should be pure, that is to say a virgin. Two women of the court examined her in private and confirmed that she was indeed completely unsullied. Following this further guidance was sought from the Archbishop of Embrun – despite the fact that Joan was pure they still could not believe that a woman would be the chosen carrier of God's message. He stated that Charles should keep her at a distance while she was questioned further by the Church. It was decided that Joan should be

sent to Poitiers – there she could be questioned in greater detail by those with more theological expertise. Only then could they decide just what to do with her.

Once in Poitiers she was watched closely to try and establish just whether she was telling the truth. She kept up her routine of devout prayer but those watching could not decide just whether or not she was what she said she was. And until they could decide, how could they let this young peasant girl lead the royal army? Eventually it was decided that there was no fault in her at all – she was polite and she was pious, and more importantly she had this unshakable belief that she had been told by God to help Charles take his throne. When she was questioned just that little bit further about how she would go about doing this, she spoke with resolve and said that she would raise the siege of Poitiers herself. It was the perfect test for the girl. If she managed to do what she said, then it would be obvious that she truly was sent from God but if she failed, then she was a liar and would be damned for it. Further tests on her virginity took place which continued to confirm her purity. The title of Maid (*la Pucelle*) also became hers – she became publicly known as the Maid of Poitiers. It should be noted that during her lifetime her family name was never used by her. Following the questioning at Poitiers, Joan was back in Chinon where she dictated a letter that stated her mission, and that was to be sent to the English as a warning. She threatened them and demanded that the keys to five towns that they had taken and that if they did not leave Orleans, she herself would do them great harm,

'King of England, if you do not do this…I will have them all killed.'
It was only once this had been sent that Joan was finally presented to the king, and her mission to Orleans started to be organised. A suit of armour was ordered to be made for her by the king's master armourer – she would not be able to don a bog standard suit so it had to be specially made. Standards were also made and embroidered for her and the men she would lead. Troops were mustered and news was spread that the Maid was on her way to free the town of Orleans from the English.

The English soldiers at Poitiers had heard of the young woman leading the French army to try and free Poitiers, even before her threatening letter had arrived. But they were sceptical of her claims – she had to be a heretic, spouting all that about hearing voices from God. And what's more, how had she managed to convince her male betters that she should lead the army? She had to have seduced a man with power and convinced him using her womanly wiles. The English army, however, was battered and hungry. Their defences were not good enough to hold up against the fresh French army. The battle began on 5 May 1429 and the people of Orleans waited in hope for the English to be ejected. Joan rode with the soldiers but did not hold a weapon – instead she wielded her standard. The fighting was harsh and even Joan was injured – an arrow hit her between the shoulders but she shrugged it off as a flesh wound. Losses on the English side were massive and they ended up retreating from Orleans, leaving Joan and the French victorious. Joan had successfully done what she said she would. The siege was over.

Three days later, Joan was presented once more to the king. It was clear to everyone now that she truly was a messenger of God, so she started to be listened to. She insisted that Charles now had to get himself to Reims so he could be crowned, finally, as King, but first they had to get rid of the English so the route there was clear. She was once again given command and troops were mustered over the following month. By 11 June, Joan and her troops were laying siege to Jargeau and once again they were victorious. The town of Beaugancy was next and soon that town was also in French hands. The Maid of Orleans was doing what she said she would do, guided by the voice of God. More and more towns fell, and Joan's celebrity only grew. Following these victories, she returned to the king who praised her and the power that she wielded, and agreed that it was time to head to Reims as she requested. Reims was under enemy control, however. The king mustered an army of thousands and rode at the head of them towards Reims – the size of the army was obviously off putting as many enemy-held towns gave up without a

fight. The army reached Troyes but unlike previous towns, this one would take some work.

Within the walls of Troyes lived a holy man named Brother Richard. This man had been preaching for months about the coming of the Antichrist. But he ended up singing Joan's praises – the people of Troyes were less than impressed and decided that this apparently honourable holy man was actually a sorcerer who had been bewitched by the madwoman at their gates. She was a heretic and a madwoman, a messenger from the Devil rather than from God. The siege began and Joan led the army once again to victory. Still, as the gates opened and the king entered the city that Joan the Maid had promised him, those within were less than impressed with the whole thing – as Charles rode by, they politely cheered for him, even as they begged for help from the Duke of Burgandy and the English king. Charles was crowned on the morning of 17 July in a makeshift ceremony just as the Maid had promised he would be. She knelt as his feet, stating that God's will was done and crying with sheer emotion. She had kept her promise and now, finally, France had a real king again.

This miraculous event only served to turn Joan into a major celebrity, rather than the B list that she had been before. This was a peasant girl who said she was spoken to by saints and God, and who had said she would lead the king to reclaiming his crown. She had done so, and she was praised across the country and beyond,

This event, however, would be the high point of her career. Following the coronation of King Charles, she would only have about a year left to live. Things were about to take a darker turn for the young Maid of Orleans. Her victories certainly could not last forever.

The next objective was to take Paris. The capital was in the hands of the English and their allies, and they were, understandably, worried. So they set about setting up defence of the city to make it all but impregnable. Joan and the army prepared to lay siege to the city, but given the preparations Paris was making, there would be no way that they could take it. They were camped outside the city of Senlis, to the north of Paris, when the English came out and offered battle. This was,

of course, a trap and Joan was so naïve that she tried desperately to convince her generals to take up the offer. They wouldn't, having seen such traps before. So Joan rode out and taunted the English in an effort to get them to come out from behind their lines. They didn't. Both armies soon moved on and still Joan tried to convince Charles to press forward in a direct attack. Eventually Charles reluctantly agreed to attack Paris. The attack was authorised from Saint Denis on 7 September but it was a disaster from the word go. The attack failed miserably, and Joan was injured on 8th. Charles ordered the retreat the next day. The loss was a massive disappointment for Joan and the French army – the English and Burgundians had learned from Joan's successes and turned things around. More so, the people of Paris had no time or patience for a king they regarded as a pretender. They were loyal to King Henri II (King Henry VI of England), so they fought back and fought back hard.

More losses followed. After managing to take the fortress of St-Pierre-la-Moutier, she ended up facing the formidable garrison at La Chrite-sur-Loire – outnumbered and outgunned she begged the locals to help her attack but it fell on deaf ears. She ordered a bombardment but it failed, and the weather did not help matters at all. She had to lift the siege and retreat back to Jargeau.

What happened next would be the beginning of the end for the young Maid of Orleans. In 1430, after a number of failed sieges, she decided to use her own stratagem and went off on her own. A previous agreement between Charles and Philip, Duke of Burgundy, meant that Paris was supposed to be given up to Charles and in return Charles would give up the town of Compiegne. But the locals of Compiegne really didn't want to give their home up to Philip, so they prepared to disobey his orders. Off she went, arriving on 14 May. Just eight days later an Anglo-Burgundian force surrounded the town and she was defeated, pulled from her horse and given to Jean de Luxembourg as a prisoner of war.

This capture was not just a blow to the French, but a vicious blow to her own cause. If she was so smiled upon by God, then surely

He would not have allowed her to be captured? That had to mean that she was lying, a heretic being driven by the Devil himself.

There was, of course, no question about whether or not Joan would be put on trial. The problem was that she was a valuable commodity, and to ransom her off could end up being a good day for the coffers. But her captors were keen to have her tried as a heretic before an inquisitorial court. So that was what was arranged, and it was a show trial from start to finish, spearheaded by Bishop Cauchon, a man who was so outspoken against and absolutely despised Joan. But his bias did not matter as she had been captured in his diocese. He was also allied to Henry VI, against whom Joan and her soldiers were fighting. His bias against her was clear from the word go – he interrogated her and demanded she give him answers that she legally was not obligated to give. Not only that but the interrogation happened before she had even been charged! It was, even for those times, not exactly the best way of doing things – even if he believed that she truly was a sorceress, legal processes should still have been followed. Still, he had learned from the 'best', having been present at the Council of Constance in 1415 when the preacher Jan Hus had been put on trial. Cauchon was not stupid – he was aware that Joan was certainly not on the same academic level as Hus, who was an articulate and influential critic of the Catholic Church, in effect, an early Protestant. Where he could argue his points academically, hers was based on blind belief. There was, therefore, no way that Cauchon could lose here. It was a foregone conclusion.

The fate that awaited heretics was a bleak one. In previous inquisitions in countries like France, those accused of heresy were executed in the most horrendous of ways. Many were condemned to be burned at the stake. There were so many who believed Joan was a witch – she had to be, to have convinced the French army to let her lead them – the main man who stood up and accused her of witchcraft was John of Lancaster, Duke of Bedford and he was so loud about it that people sat up and took notice.

In 1430, Joan was sold, like a prize pig, to the English. While negotiations went on as to who would be the one to keep her locked

up, she tried to escape. When this failed, she was kept locked up tight in a tiny, damp and dark cell. From there she was transferred into the care of Jean de Luxembourg at his chateau in Beaurevoir – another escape attempt happened while she was there when she tried to jump from the tower but again it failed. From there she was placed under lock and key at Jean's home in the city of Arras and then on 3 January 1431 she was technically handed into Cauchon's hands and her trial was arranged. It would be made to look as if it was fair but there was no real way that it could be – the English wanted her out of the way, and the only way to do that properly was to have her put to death.

Here began the 'preparatory trial' where Joan was questioned and cross examined in order to find out on just what grounds she could be indicted for heresy. The evidence against her was read out on 13 January and on 19 January the Inquisitor was summoned – the officers had to remind the Inquisitor, who did not seem to want to bother with the whole thing, that heresy was a disease. Then, on 21 February, the first public session of the trial took place in the chapel at Rouen castle, which was in the hands of the English. Joan was required to take an oath in which she said she would tell the truth. Except she responded that 'concerning the revelations from God, those she had never told or revealed to anyone…nor would she reveal them to save her head.' The questioning began which to start with was the usual, routine questions about her childhood and life at home. She was also asked to recite the Paternoster which she said she would happily do in confession – that wrong footed Cauchon, who was leading the questioning against her, as he knew a witch would not be able to recite the prayer out loud. Nor would he hear her confession so she could recite for him. He was, in this instance, stuck between a rock and a hard place.

It was ordered during this part of the trial that she be put in chains in order to prevent her escape. She was also appointed English guards to make sure she remained locked up. None of this was correct legal practice at the time, but Cauchon did not seem to care. More followed on 22 February in which she spoke on what the voice told

her in the first instance, that she should raise the siege of Orleans. She volunteered this information but refused to answer why she was wearing men's clothing, saying only that it was necessary and that the voice told her to do so. When asked specific questions on what the voice asked and what happened when it spoke to her, she refused to answer. When she was pressed further on the voice and how she had reacted to it, she warned the one questioning her – Beaupere, at this stage – to be careful as she was sent by God. A veiled threat, perhaps? Still she refused to go into specifics, only that she was sure the voice came from God and that there was a light when it spoke to her. Joan was proving difficult and causing much irritation to those questioning her.

On 1 March, after a series of sessions in which she had refused to provide specifics on anything that had been asked of her, she placed her hand on the gospel and promised to tell the truth at the upcoming trial. More questions followed but she remained defiant, even when they moved on to a line of questions in order to prove that she was a witch. Asked about the fairy tree in her childhood home she replied that she had never seen any fairies there and only occasionally made flower garlands, as children do. When asked about St Michael, she gave them a sharp telling off for thinking the saint was naked. Superstition and sexual fantasies were going to be difficult to prove, then.

It was decided around 10 March that the sessions should continue in private and so the interrogations took place in her prison. Even in private she proved to be a bit of a headache to her interrogators, asking for a copy of the questions she was being asked and the replies she had given. Still she refused to answer many of the questions thrown at her, remaining defiant that everything she had done was done at the hand of God.

Sexuality was a recurring theme during the questioning – why did she insist on wearing men's clothing? Would the voices stop talking to her if she were to lose her virginity? Was she truly on intimate and personal terms with St Catherine, who she stated had appeared to her? Did she have magical powers?

All of this was just the preliminary questioning. It was decided that Joan would go to a full trial – she was already a traitor in English eyes, and in French eyes she was a heretic and a witch. It was now down to the trial to decide just how much the heresy and witchcraft had to do with the treason that she had committed. The outcome was already a foregone conclusion.

Her trial proper began on 26 March and the charges against her were read out. She was a witch and a schismatic, accused of inciting war and immodest. She was, most of all, accused of heresy. Witnesses and experts were called to speak against her – theologians stated that the revelations from her voices had not come from God, they were lies that came from the Devil. Still she replied that she believed and trusted in the King of Heaven as her judge. She insisted too, when they told her that as they represented the church they were infallible, that she had private conversations with God and the angels – her destiny was to do as 'God' had told her. On 9 May she was taken before the trial judges and threatened with torture. Still she remained firm and stated that 'if you were to tear me limb from limb…I would not tell you anything more'. Her trial was officially over by 23 May – it was decided that she should be publicly admonished and she signed a document stating that she would no longer bear arms or wear men's clothing. She submitted to the will of the church right as her sentence was being read. The document that she signed was an agreement that she would no longer commit heresy and that she would fully submit. She was officially repentant. Following this she was sentenced to life in prison with only bread and water. But her repentance did not last. On 28 May she was back in male dress, despite agreeing that she would no longer wear it. Her argument when asked about it was that she had actually signed under duress. She would only agree to wearing women's clothing from there on out if her voices told her to do so. That was all the courts needed. She was sentenced as a lapsed heretic on 29 May and would be burned to death at the stake the following day.

A pyre was built in the town square in Rouen and Joan prepared for her death. Still she insisted that her visions were real, 'whether they are good or evil spirits, they appeared to me' and that she was the angel who would bring her King his crown. This time there was no defiance in her voice. She knew that she was going to die and there was no way to save herself – yet still she insisted that everything she had said was true. Yet her voices had deceived her by saying that she would be freed and saved from such a fate. She gave her confession and was then led out to the town square where the stake was waiting for her. In her last moments she was humiliated. Her head was shaved and she wore a cap that stated she was a lapsed heretic and apostate before she had to endure a recitation of the sins she had committed, one of the biggest being that she had accepted the goodness and salvation of the church only to once again turn her back on them. English soldiers lifted her to the pyre and tied her to the stake. As the ropes were tied and the wood lit, she prayed, and as the fire burned, she cried out 'Jesus' over and over until she was silenced, her body burning to ashes before the eyes of the gathered crowd and those who had condemned her.

But this was not the end for Joan. Despite her vilification by her enemies when she lived, her memory would live on and she would soon be vindicated. In 1450 it was decided that she had not been treated or tried correctly and that there was no basis for her being put to death and in 1455 Pope Calixtus III gave his permission for a rehabilitation trial to begin. This trial found that the previous trial was unjust. She had been a devout Christian and so had a duty to obey the Holy Spirit in whatever way it was to show itself. Many witnesses were called who defended her – one such witness was her steward who had been with her during the siege of Orleans and who had been at her side through practically everything at that point in her life. He knew her to be good and true. Other witnesses included those who had known her as a child and who could attest to her piety. There was no evil in her and it was clear to all who met her that she truly believed she was following the word of God. In 1456, the

verdict was given – Joan had been a victim of injustice and unfairly condemned. Proper legal procedure had not been followed, and she should have been allowed to take her case before the Pope. It was over, and on 7 July 1456 the archbishop of Rouen publicly read out the rehabilitation for Joan. It was ordered that a cross be erected in her memory, at the place of her death.

In the years after her death Joan was consigned to history, almost forgotten as nothing more than a figure of myth. It was only in more modern times that she became something of a cult heroine. She was used in French propaganda during the First World War and it was stated that she symbolised the freedom for which the allies were fighting. She became a national symbol of France. Orleans in particular celebrated her, and festivals celebrating her memory were held for centuries. Her family even moved to the city that had been so dear to Joan. Since then, many theories have been put forward as to whether or not she actually was visited by the Divine or whether she suffered from a mental illness – some have argued that she may well have been epileptic or perhaps even schizophrenic. Whether or not any of this is the case we can never truly know, but what we can be sure of is that she truly believed in what she saw and what she was doing. She was both loved and hated during her life, a symbol of everything the English hated about France but also a heroine to those she fought for. She was declared a Saint in 1920, but not as a martyr. Rather she was canonised as a Virgin. In 1922 she was made Patron Saint of France. She has only grown in popularity since and still has yearly celebrations in her honour, particularly in Orleans.

Joan today is a symbol of feminism, a woman who stood up and refused to bow to the will of others. She exuded self-confidence at a time when women were not supposed to do anything other than submit to men. It was incredible for a woman at the time to dare to do such a thing – no wonder so many hated her during her life and believed she was acting on the advice of the Devil. Thankfully times have changed and now, Joan of Arc can take her place in history as a strong yet wronged woman.

Chapter 4

Lucrezia Borgia
1480–1580

The name Borgia has become synonymous with villainy, thanks to slander both whispered and screamed from the moment the family rose to power. This continued long after the Borgia family were gone, with those who had known them (and it should be said, hated them) continuing to slander them. As always with these things, the salacious stories outsold the truth and people just ran with it, twisting the false stories with small nuggets of truth. Sex sells, after all. It sells even more when it's salacious and taboo, when incest is at the core of the tale, and when it mixes in a nice bit of murder. These tales may seem exciting, but the truth is far more so. Was Lucrezia Borgia truly an incestuous, murderous harlot; or was she a woman who, despite starting out as a pawn on her father's political chessboard, grew into herself and became a self-assured and confident political figure in her own right? In truth she was far more complicated than many in the past, and indeed the present, give her credit for and one has to ask – is Lucrezia Borgia more sinned against than sinner?

On 14 April 1480, a baby girl was born within the walls of the fortress at Subiaco. Her mother was Vanozza Cattanei, a well known mistress of Cardinal Rodrigo Borgia, and her father … well, one can easily work that out given who her mother was. Named Lucrezia, she was not the only child born to the couple – she had two older brothers, Cesare and Juan, and would have a younger brother when Jofre was born in 1481/2. Growing up, although Vanozza remained friendly with Rodrigo, the children had little contact with their mother.

Before becoming Pope, Rodrigo Borgia maintained at least some discretion when it came to his illegitimate family. This is probably why Lucrezia was born in Subiaco, a strategic fortress outside Rome. We know very little of Lucrezia's early life, probably due to this discretion but it is likely that she spent a lot of time at the convent of San Sisto – as in her later life she would spend time there when she needed peace during particularly difficult times. What we do know though is that she was brought up by Adriana de Milla, her father's first cousin and a member, through marriage, of the powerful Orsini family. Adriana was the mother figure in the children's lives, while Rodrigo took a very keen interest in their upbringing and development. He loved his children deeply and was a constant figure in their lives.

Following Rodrigo's elevation to the papacy in August 1492, when he took the name Alexander VI, he moved Adriana and Lucrezia to a palace close to the Vatican – the Palazzo Santa Maria in Portico. This move served Alexander in more ways than one; not only was he able to keep his daughter close but he was also able to stay close to his new favourite mistress, the beautiful Giulia Farnese. This move brought a considerable change to Lucrezia's young life – it brought her into the centre of a bright and sparkling world that was dominated by her father, the head of Christendom. It also brought her to the attention of those who would do anything to bring her father down and leave her family name in tatters. Therefore it was incredibly important that this bright and beautiful young woman be nothing less than perfect. Anything less and the hostile vultures circling her father's court would swoop in and not let go – in fact, even perfect wouldn't be good enough for them and later, Lucrezia would find herself whispered about across the world. For now, the child, the only daughter of Pope Alexander VI, shone like a diamond within the Vatican and her beauty was admired widely. Niccolo Pagnolo of Parma wrote the following of the dazzling young Borgia. 'She is of middle height and graceful in form…Her face is rather long, the nose well cut, hair golden, eyes of no special colour. Her mouth is rather

large, the teeth brilliantly white, her neck is slender and fair, the bust admirably proportioned. She is always gay and smiling.'

She was educated well, though of course not to the same extent as her brothers. She was educated, though of course not to the same extent as her brothers, in the fashionable humanist literature of the time as well as learning a number of languages and fluently speaking Catalan (the language spoken exclusively within private family occasions), Italian and French. She was also an excellent dancer. Well educated and graceful, she also matched her father in wit and charm and would prove herself as she grew to be an excellent diplomat to the point where her father would even leave her in charge of the Vatican.

Lucrezia was close to her brother Cesare and the two were exceptionally loyal to one another, to the point that he would come to be accused of committing incest with her. Was it any wonder that detractors of the Borgia family took one look at the siblings and thought something was a little off? In reality, Catalan families such as the Borgias were always incredibly close and there was little to no evidence of any sort of incest happening within the family. There certainly was in other Italian noble families, and in royal families across the world. We may look upon such a practice with revulsion but back then, it was relatively normal and it was a way of keeping blood lines 'pure'. Relatively normal but still with some element of taboo, so that even when there was no evidence for such a thing happening it was brought out to besmirch a family name.

Cesare was the most ruthless of all his siblings and he certainly didn't share the religious piety that much of his family did – his father, despite his ambition, must have had some sort of religious affinity to be so entrenched in the church and Lucrezia would become more and more pious as the years went on, spending a good amount of time staying in convents in her later years. He was known for his domineering willpower and jealousy, something that would directly affect Lucrezia for her entire life, at times to the point of causing her to dislike her brother immensely. Despite this, it is abundantly clear that Lucrezia was one of a very small group of women that Cesare ever truly respected.

Rodrigo Borgia was elected as Pope after spending his career as Vice Chancellor for a number of previous pontiffs and working behind the scenes to gain the support that he would need. Upon his election to the papacy he made a number of promises including one which every Pontiff since time immemorial had made – that he would reform the church. He began his reign with all kinds of good intentions. In a letter to Florence just a few days after the election, Manfredo Manfredi wrote of Alexander's promises to dismiss any tyrannical officials from office and also that he would keep his children away from the Eternal City. It was this promise at least that he kept to, at the beginning of his reign if not later.

Cesare was kept at the castle of Spoleto, where he had remained since his return from Pisa and Lucrezia remained in the household of Adriana de Mila. Despite being kept away from Alexander, the Borgia children were not forgotten. Cesare was quickly granted the Archbishopric of Valencia along with 16,000 ducats a year and marriage prospects were quickly spoken about for Lucrezia. Within just a few months of Alexander's election to the Papacy, the Borgia family were once more together in Rome. Cesare took up residence in a palace within the Borgo, a neighbourhood around the Vatican while Lucrezia at this time lived in the palace of Santa Maria in Portico and was kept well away from her mother's household.

As has been previously mentioned, all of Alexander's children had their lives and careers planned out for them. Whilst Cesare was to be made a cardinal and Juan was to be Gonfalonier of the Papal army, Lucrezia was to be used in alliances for the family through marriage. Now that Alexander occupied the chair of St. Peter, this became all the more important and on 2 February 1493, Lucrezia was betrothed to Giovanni Sforza, the Lord of Pesaro and related to both Cardinal Ascanio Sforza and the powerful Ludovico 'Il Moro' Sforza of Milan. It was, of course, a political match.

The wedding took place on 12 June 1493, although the two had previously been married by proxy on 2 February. Lucrezia brought with her a dowry of 30,000 ducats. The wedding itself was a

magnificent affair, full of the pomp and circumstance that came to be associated with the Borgia family. Just two days previously, Sforza made a magnificent entry into Rome and stopped outside Santa Maria in Portico so his young bride to be could have her first glimpse of him. She was, at this stage, just 13 years old so her new husband – aged 26 – must have seemed ancient to her. Such a prospect must have been incredibly frightening.

The wedding was attended by some of the most prominent members of society, during which the couple were presented with magnificent gifts. Boccacio describes the wedding in a letter to his master, mentioning the grand gifts that were presented to the new couple – including a gift of gold brocade, two rings, a diamond and a ruby from the Duke of Milan. Traditionally, at the end of the night there would be a bedding ceremony in which the marriage would have been consummated. However on this occasion the ceremony did not happen. Pope Alexander ordered that the marriage was not to be consummated until the November, possibly out of concern for his daughter's youth but it was more than likely a way of keeping the door open for dissolution of the marriage on the grounds of non-consummation. The whole marriage was, of course, part of Alexander's complicated political chess game.

That summer, as in every summer before it, plague had raged throughout Rome. Lucrezia's new husband had taken himself away from Rome during the August of 1493 and gone to Civita Castellana. There is no record of her having left Rome to be with her husband. She was certainly in Rome during October of that year along with Sforza where it seems he was given permission to sleep with his wife who was still just thirteen years old. Sforza himself made use of the fact that his young wife was one of the best ways to become close with the Holy Father – he even boasted about such access to the Mantuan envoy and said that 'all these women that surround the pontiff' were worth speaking to, but 'principally his wife'. He was right, of course. The best way to curry favour with Alexander was through the women who were in residence at the palace of Santa Maria in Portico.

But the political situation in Italy was once more becoming dangerous and it was a situation that would have dire consequences for the Sforza Borgia alliance. The situation was a precarious one – in the January of 1494, King Ferrante of Naples had died and in the March of that year, Alexander VI had announced his intentions that he would support Ferrante's son Alfonso in his claim to the throne and have him crowned king. Such a decision not only meant that the French, whose own king had a claim to the throne of Naples, would more than likely invade Italy with the aim of taking Naples by force, but also that it put the Sforzas in a very awkward situation indeed. After all, Naples and Milan were enemies, so how could they sit idly by and support the Pope's decision to ally himself with Naples?

Giovanni knew his position was a precarious one – he had to be seen to support the family he had married into, but he also had to support his own family. He was called before the Pope in the April of 1494, who was somewhat irritated with Sforza's dithering – Giovanni wrote of the meeting in a letter to his patron, Ludovico:

> Yesterday his Holiness said to me in the presence of Monsignor (Cardinal Ascanio), 'Well, Giovanni Sforza! What have you to say to me?' I answered, 'Holy Father, every one in Rome believes that your Holiness has entered into an agreement with the King of Naples, who is an enemy of the state of Milan. If this is so, I am in an awkward position, as I am in the pay of your Holiness and also in that of the state I have named. If things continue as they are, I do not know how I can serve one party without falling out with the other …. I ask that your Holiness may be pleased to define my position so that I may not become an enemy of my own blood, and not act contrary to the obligations into which I have entered by virtue of my agreement with your Holiness and the illustrious State of Milan.'.

Pope Alexander replied that Giovanni Sforza should choose whose side he was on, whilst Sforza himself tried desperately to keep both sides happy. Alexander's allegiance to Naples was made concrete with the marriage between Jofre and Sancia, the alliance also bringing with it a number of titles for Juan.

Despite his dithering, Giovanni Sforza was just about hanging on to favour with his wife's family. In May 1494, Pope Alexander finally granted Sforza permission to leave Rome for Pesaro and he allowed Lucrezia to accompany him, along with Adriana de Mila and Giulia Farnese. They arrived in Pesaro in June in the midst of an incredibly heavy rain storm. Yet despite the rain, the people of Pesaro came out to enthusiastically greet their new Duchess. The visit to Pesaro came at a dangerous time for Rome and, from the safety of the little town, Lucrezia was told of the ills happening in Rome in a dispatch from Francesco Gacet, a confidant of Alexander. He reported that not only was the plague once more sweeping the Eternal City, but Alexander was also beset by pro-French factions within the City – mainly the troublesome Colonna family. Lucrezia wrote to her father, asking him to take the greatest care of himself during such a difficult time.

Alexander soon became desperate to have the women back in Rome, writing to them and asking when they would return. Although they were expected back in the city by June, Lucrezia was having too much of a good time to even think about returning, let alone write to her father regularly. Alexander, who adored his daughter and who was completely obsessed with his mistress, began to panic and by the end of June had convinced himself that the women in Pesaro had died, or were so ill that they would not live – it was only when he received a letter written by his daughter that he calmed down,

Lucrezia was safely tucked away in Pesaro whilst the drama of the French invasion unfolded in Rome and Giovanni Sforza dithered about having his wife return to the city. He certainly did not trust the Borgia family and when the Pope sent a letter telling Giovanni that in no circumstance was he to return to Rome but rather join the troops

of the Holy League, Giovanni ignored the order completely. Rather it seems he was planning to take himself off to Milan and beg the protection of Il Moro. Already rumours were rife throughout Rome that there was something wrong in the Borgia Sforza marriage. But what the rumour mongers did not suspect was that the Borgia family were already planning to have the marriage annulled.

Lucrezia returned to the Vatican, to her old palace of Santa Maria in Portico, in the April of 1496 and in May the Borgia family reunion was complete when Jofre and Sancia returned to Rome. Sancia's reputation had come before her – gorgeously attired for her ostentatious entry to Rome, Lucrezia was anxious not to be outdone.

Things were definitely not going well within the Borgia Sforza marriage. Giovanni Sforza suddenly disappeared on Easter morning, declaring that he would be going on a pilgrimage about the Churches of Rome. Instead, he took hold of a horse and left Rome in a hurry, reaching Pesaro in just twenty-four hours. But what made Giovanni flee from Rome, apparently afraid for his life? Gregorovius mentions that chroniclers at the time stated that Cesare had threatened to kill Giovanni on the basis that he was no longer needed in the Borgia scheme. Whether or not this was the case, it is clear that Giovanni Sforza knew that something was wrong. By 4 May 1497, Giovanni's cousin Ludovico, who had been concerned with a possible falling out with the Pope, learned that it was indeed Borgia threats that had caused Giovanni's flight from Rome – whilst Ludovico promised Giovanni that he would not force his return to the Eternal City, Giovanni did request that Ludovico step in to have his wife sent to Pesaro. A messenger was instructed to send the message, a message that stated if the Pope then demanded both Giovanni and Lucrezia return to Rome then Giovanni would of course obey. But by the beginning of June, Ludovico had received letters from the Cardinal Ascanio Sforza stating that the Pope had made up his mind – he wanted an annulment of his daughter's marriage. Lucrezia left the Vatican on 4 June and headed for the convent of San Sisto – it is likely that she took herself off to the convent, a pattern that she would repeat time

and again throughout her life, in order to escape the tensions that were seething within the walls of the Apostolic palace.

Already rumours were rife as to the reasoning behind the divorce proceedings. The Venetian diarist Sanuto states that one reason was that he had not 'consummated the marriage because he was impotent'. Indeed, it was Giovanni's apparent impotence that was used to annul the marriage between him and Lucrezia. He was, understandably, outraged at the suggestion he had been unable to consummate his marriage – he argued that he had known his wife an infinite number of times and that the only reason the Pope wanted the marriage annulled was so that he could have his daughter all to himself. A suggestion was made that Giovanni could prove himself to not be impotent by sleeping with a woman in the presence of a papal legate. The matter that his previous wife, Maddalena Gonzaga, had died in childbirth seemed to be conveniently forgotten. Giovanni refused to perform in front of witnesses and the arguments went on.

Tragedy struck while Lucrezia was still staying in San Sisto when her brother, Juan Duke of Gandia, went missing in the June of 1497. His body would later be found floating in the River Tiber covered in stab wounds.

In the aftermath of Juan's death, Lucrezia's reputation was once more dragged through the mud. There were whispers that she had been involved, sexually, with one of Alexander's Spanish chamberlains, Pedro Calderon – known more familiarly as Perotto. The young chamberlain suddenly disappeared. Johannes Burchard, the Papal Master of Ceremonies notes in his diary that the young man 'fell not of his own will into the Tiber'. Rumours circulated the city that he had been murdered for getting Lucrezia pregnant and that he was the reason she had been closeted away in San Sisto – so she could give birth to the child she was apparently carrying. His rotting corpse was allegedly found alongside the body of one of Lucrezia's serving women, Pantisilea – could it be that she knew of the supposed affair and was murdered to make sure there was no evidence left anywhere?

The murder of Perotto was later attributed to Cesare in an overly sensational manner and the tale has since become an unshakeable part of the Borgia myth. The story goes that Cesare, fuelled with rage that a lowly chamberlain should have taken his sister in such a way, pursued Perotto through the halls of the Vatican. Perotto threw himself at what he thought was the safety of the Pontiff's robes. As he clung to Alexander's papal vestments, Cesare plunged the dagger over and over into the back of the chamberlain with such force that his blood spattered all across the fabric of Alexander's clothing. Ferrara mentions that this event is only mentioned in an anonymous letter sent to the exiled Silvio Savelli, a letter that was written to not only blacken the Borgia name but destroy the Borgia reputation entirely. This letter is a source that truly cannot be trusted – it is a compendium of stories from those who despised the Borgia family and wanted their reputation completely blackened.

The whole Perotto affair was only made worse, and Lucrezia's reputation soiled even further, with the appearance of a new baby within the walls of the Vatican. This child, Giovanni Borgia, became known as the *Infans Romanus* and rumours circulated that the child was Lucrezia's and had been born during her seclusion in San Sisto. Officially, the child's paternity was attributed to Cesare; however, in a secret bull dated September 1502, Alexander admitted that the child was actually his.

But despite this scandal, a new marriage for Lucrezia was of the utmost importance. Alexander once more began to negotiate with Naples – he had, after all, already had Jofre married into the Neapolitan royal family – and wished for Lucrezia to marry King Federigo's illegitimate son, Alfonso. But Federigo began to prove difficult, not particularly wanting to have more of his children marry into the Pope's family. Alexander was understandably furious at the whole situation and in retaliation, told the king that Lucrezia would actually marry Francesco Orsini. He kept up the pretence whilst negotiations continued and until Alfonso arrived secretly in Rome and finally an agreement was made – Alfonso and Lucrezia were to

marry. Alfonso was given the Duchy of Bisceglie whilst Lucrezia brought with her a dowry of 40,000 ducats.

Just a few days later, on 21 July, the two were married and Lucrezia became the Duchess of Bisceglie. It soon became very clear that the newly married couple were head over heels in love with each other. Part way through the feast, Cesare appeared dressed as a unicorn and danced during a performance. Other members of the family also joined in with this magnificent celebration – Jofre was dressed as a sea goose and Cardinal Juan Borgia as an elephant. Sancia's account describes the celebrations in all their glory, describing how those dressed as animals even wore costumes that matched the colour of their chosen animals. She describes how they danced one by one in front of the Pope, before drinking from a special fountain and then, once they had all had a drink they danced as a group. Cesare presided over the majority of the celebrations – not only were there days and days of dancing and feasting, but he also organised a huge bullfight. Ten thousand spectators attended the event and Cesare himself appeared on the field.

The two were happy together and very much in love. Lucrezia soon fell pregnant and gave birth to a son, Rodrigo, in 1499. He would be their only child and would sadly die when he was just 12 years old. Following the violent events of 1500 and his mother's subsequent remarriage he would never see her again.

The Borgia/Aragon marriage was to end in heartbreak, however, and would mar the siblings' relationship for the rest of their days. In 1500, Lucrezia's world was to be rocked to its core. Cesare, having left his place in the college of cardinals following the death of his brother, had spent time campaigning in the Romagna and had managed to take Forli from the indomitable Caterina Sforza before bringing her back to Rome as his captive. With the campaigning over for now he had little to do but wait out the summer and hope that his requests to King Louis XII of France to allow his wife to join him in Italy would be heeded. They weren't and Cesare's new wife, Charlotte d'Albret, remained in France.

On 15 July, Lucrezia's husband was crossing the Piazza San Pietro when he was viciously attacked and desperately wounded. Johanne Burchard, the Papal Master of Ceremonies, reported the event in his diary:

> On Wednesday, July 15, at about six o clock in the evening, Don Alfonso of Aragon, the Duke of Bisceglie and Donna Lucrezia's husband, was attacked at the top of the steps before the first entrance to St. Peter's Basilica. He was gravely wounded in his head, right arm and leg, whilst his assailants escaped down the steps to join about forty waiting horsemen, with whom they rode out of the city by the Porta Portusa.

Alfonso was taken to a room in the Torre Borgia where he was watched over day and night by Lucrezia and his sister Sancia. Rumour once more stalked the streets, whispers of who could have been behind the attack on the Duke. Dispatches went backwards and forwards and although names were not actually given, it soon became obvious that there was only one name on everyone's lips: Cesare Borgia. The diarist Sanuto recorded in his diary on 19 July: 'It is not known who wounded the said Duke, but it is said that it was whoever killed and threw into the Tiber the Duke of Gandia'

The attack, although it was bungled, could well have been ordered by Cesare. It was well known just how much Cesare had come to distrust his brother-in-law. It can also be said that Cesare was jealous of the close and loving relationship that Alfonso shared with Lucrezia – whilst this jealousy is, of course, no proof of the incest accusations against the siblings it can go some way to explain just one of the many reasons why Cesare would have wanted his brother-in-law out of the way. What seems likely is that the attempt on Alfonso's life was made by a number of members of the Orsini faction – Alfonso had been in league with the Colonna faction, the Orsini's bitterest enemies, after all. Either way, Cesare certainly showed himself as

having been willing to be the one behind the attack and reportedly stated the words, 'I did not wound the Duke, but if I had it would have been no less than he deserved!'

Lucrezia and Sancia nursed Alfonso in his chambers within the Torre Borgia, only allowing doctors summoned from Naples to treat him, preparing his food with their own hands out of fear of a poisoning attempt and taking it in shifts to sit with him. Their hard work paid off and around a month later he was almost completely recovered, able to sit up in bed and laugh and joke with his wife and sister. But of all a sudden, the door burst open and the room was taken over by Michelotto – Cesare's manservant. Whilst the accounts differ slightly but it seems clear that Michelotto did indeed enter the room and seized Alfonso. When both Lucrezia and Sancia demanded to know what was going on, he excused himself and stated that he was simply obeying the will of others but if they wished, they could go to the Pope who would be happy to grant Alfonso's release. The two women immediately ran to Pope Alexander, leaving Alfonso behind with Michelotto – they were gone for just a few moments but when they returned, they found Alfonso's door guarded, the armed men outside telling them that Alfonso was dead. Both young women were immediately maddened with grief, neither of whom believed Michelotto's overly hasty story that Alfonso had been struck down by a sudden haemorrhage. Why should he have been, after all, when he had been well on the road to recovery? Alfonso had in fact been strangled and in this case there can be no doubt who was behind the attack on him – Cesare Borgia.

Alfonso's body was taken to the Church of Santa Maria della Febbre. But the question remains as to why Cesare would have ordered the murder of his brother-in-law – his jealousy over his sister cannot have been the only chess piece in play. Rather, politics would have been more important in this than anything else. It must be remembered that Cesare, since throwing off his Cardinal's robes, had allied himself entirely with France whereas Alfonso, and his entire family, were allied with Spain. It was also no secret just how much

Lucrezia loved her second husband. Could Cesare have noted this and believed that Alfonso was taking his beloved sister away from him? Alfonso of Aragon, Duke of Bisceglie, was a threat not only to Cesare Borgia's political life, but his personal life as well. And he had to be got rid of.

It should be noted that the day after Alfonso's murder, Cesare visited Lucrezia in her rooms. He was surrounded by a number of armed body guards. But what transpired between the two siblings is not known – did she hate her beloved brother for murdering her husband? Did she forgive him? These are questions that, unfortunately, we will never know the answers to, although it is telling that Cesare felt able to visit his sister so soon after the tragic event.

Whilst Lucrezia was hidden away at Nepi, her father was already contemplating a third marriage for his daughter. She initially opposed another match – her first two marriages had ended in scandal and the people whispered awful things about her. However she could not stave off marriage forever and in the September of 1500, she received a proposal from Louis de Ligny, her father's cousin. Lucrezia refused his offer, stating that she did not wish to leave Italy. Further suits followed from Francesco Orsini and Ottaviano Colonna. Still she refused and when the Pope demanded to know her reasons for it, she replied, 'Because my husbands have been very unlucky!'

Thankfully, for Cesare and Alexander, Lucrezia soon came around to the idea of another marriage and was particularly taken with the idea of a marriage to Alfonso d'Este. They had set their sights high for the third marriage – the Estes of Ferrara were one of the oldest and grandest families in Italy. In February 1501, Alexander had the Cardinal of Modena write to Ercole, the head of the Este family, proposing an alliance between the two families. Ercole was initially horrified at the idea and tried his best to worm his way out of things – after all Alfonso had previously been married to a princess and it would be unseemly for him to now marry a bastard with a sullied reputation.

Ercole had tried desperately to worm his way out of the marriage by getting King Louis of France on side and to start with it seemingly

worked. Until the pope managed to talk the king around. Ercole was understandably furious at this news and sent letters to his envoy, practically begging the envoy to ask Louis to change his mind. In Ferrara, Ercole was bombarded with messages from Louis, the Pope and Cesare yet still the patriarch of the Este family refused to budge. More letters were sent to Louis begging him for help but by now he was growing tired of it all. He responded to Ercole, saying that if he really didn't want the marriage to go ahead then he should make overly difficult demands on the Pope – Louis' envoy to the Borgias even advised the Ferrarese envoy to have Ercole demand the huge sum of 200,000 ducats, absolution from the Papal census, an estate for his son Ferrante, extra benefices for Cardinal Ippolito and support for regaining lost Ferrarese lands. Ercole, realising that the demands were exceptionally high, finally acquiesced to the Pope's wishes and agreed to offer his son, Alfonso, as a husband to the Pope's daughter.

Negotiations over the dowry began and Alexander wrote to Ercole offering half of what was originally asked for. Eventually all was concluded and the marriage contract was drawn up on 26 August and a proxy wedding was arranged. Celebrations were arranged as soon as news of the marriage went public, with cannon fire from the Castel Sant' Angelo and constant rounds of dancing and parties. Lucrezia impressed the Ferrarese envoys, particularly when she was so tired out from constant dancing that she became unwell, yet still managed to carry on with all that she needed to do.

But Lucrezia was worried about what would happen with her young son, Rodrigo, her child from her second marriage Unfortunately, it had been made very clear by Ercole that the child would not be welcome in Ferrara. She announced that her child would remain in Rome with a yearly revenue of 15,000 ducats.

The escort from Ferrara who would be taking Lucrezia to her new home arrived on December 23. Lucrezia met her escort the next day, wearing a mulberry gown and a necklace of rubies and pearls. Now, with the escort in Rome, proper celebrations could happen as well as the anticipated proxy marriage.

The proxy marriage took place just after Christmas on 30 December. Her escort from Ferrara had brought with them a casket of beautiful jewels including the Este family jewels but, unfortunately for Lucrezia, she was only permitted at that point to have access to the wedding ring. She would receive the remaining jewels following the official marriage, once she reached Ferrara, in case she were to unexpectedly die on the journey. The Este family, who had already refused to allow Rodrigo to join her in her new home, did not wish him to inherit any of the gifts that they had given her. Following the ceremony, in which Lucrezia was dressed in a gown of beautiful gold brocade, she stood at a balcony above the Piazza San Pietro and watched as the celebrations for her marriage continued. After watching the celebrations which included a mock siege, the wedding party moved to the Borgia family's private apartments where they partied until the early hours of the following morning. The piazza outside was cordoned off for bullfights which took place over the next two days whilst in the evenings, the party continued within the Papal apartments.

The celebrations could not last forever, however, and the hour of Lucrezia's departure began to loom. Alexander was understandably distraught at the thought of his beloved daughter leaving Rome and, on the day of her departure, she spent time alone with her father before he summoned Cesare to join them. When the time came, she was escorted from Rome by Ippolito d'Este and Cesare in the midst of a thick snowstorm and, as they left, Alexander moved from window to window of the Vatican in order to catch one last glimpse of his beloved daughter.

The journey took Lucrezia and her entourage through the states that had recently been taken over by her brother. After a stop at Bentivolglio, she was met by her new husband on 3 January 1501. They then made the joint decision to finish the route to Ferrara by land, as opposed to by water which is how Lucrezia had originally wanted to finish her journey. Alfonso's sudden arrival must have seemed incredibly romantic to Lucrezia, especially from a young

man who was not exactly known for his romantic tendencies, and it must be noted that up until that point, Alfonso had been less than enthusiastic about marrying her.

Following the surprise meeting, despite agreeing with Alfonso to complete the journey by road, Lucrezia and her entourage finalised their trip by travelling the remaining miles to Ferrara by water. She was met by her new sister-in-law, the formidable Isabella d'Este, at Malalbergo. The relationship between the two women would certainly not be an easy one. Isabella certainly made no secret of her distaste for Lucrezia, making sure that she went out of her way to compete with the young Borgia at every moment she possibly could. More than anything, Isabella was seemingly jealous of Lucrezia and terrified that when Lucrezia became Duchess of Ferrara she would be outranked.

Upon arriving in Ferrara, Lucrezia came face to face with her new father-in-law for the first time. Ercole d'Este seemed utterly entranced with her to start with and according to one of Isabella's spies held great 'affection and honour for her'. He had even arranged for her rooms within the palace to be completely redecorated.

Lucrezia's formal entry into Ferrara, which would be completed with her official marriage ceremony to Alfonso d'Este, happened on 2 February 1502. Their marriage was consummated at least three times, according to one of Isabella's spies yet, at this early point in their marriage, there seemed to be little more between the couple than sexual attraction..

Ercole, however, was still charmed by his daughter in law. Once the wedding festivities were over, he took Lucrezia and Isabella with him to a local convent where they met Sister Lucia, a nun who made up part of Ercole's collection of nuns. The following day he collected Lucrezia again and took her back to see Sister Lucia, as well as a nun who had previously been an Anchoress in Rome.

But the happiness was not to last. Lucrezia was already highly aware that Isabella was constantly spying on her, and things were made worse when Ercole dismissed the majority of her serving

women and replaced with local women so that she was left with just her cousins, Angela Borgia and Adriana de Mila. The rest were now made up of men and women hand-picked by Ercole – the women that he employed for her were all under eighteen and the daughters of local aristocrats and nobles. Ercole, well known as a tight-fisted penny pincher, also held back a large amount of Lucrezia's allowance money. It caused a huge amount of arguing between Alexander and Ercole whilst Lucrezia, as she had done in the past during difficult moments and would continue to do later in her life, took herself off to the Convent of Corpus Domini in Ferrara. During her time in Corpus Domini, whilst the arguments between the two men carried on, Lucrezia began to show the first signs of being pregnant – except this time she was incredibly unwell and had very little appetite – something that was not reported to her father until 21 April 1502. In the May of that same year, whilst her husband and father-in-law had gone to visit the French king, she took herself off to the Este retreat at Belriguardo. There, away from constantly being watched and having her every move reported, she found herself somewhere where she could relax and began to enjoy herself amongst her Spanish intimates who had remained with her. Yet she still struggled with her pregnancy, possibly suffering from hyperemesis gravidarum, borne out by the fact that this would certainly not be the last difficult pregnancy that she would go through – it would be a pattern that she would, unfortunately, repeat right up until the end of her life.

In this state, and evidently tired from all of the arguing over her allowance, Lucrezia began to rebel against her father-in-law. When she returned from Belriguardo she deliberately kept the Este patriarch waiting. According to reports from the Este court, she also became difficult towards her Ferrarese household, to the point where four of them begged Ercole to let them leave her service as only Spaniards found favour with their mistress. At this point, Angela Borgia was dangerously ill and Lucrezia decided to stay in Ferrara to look after her beloved cousin. She took up residence in the Belfiore and she was still there when Cesare once more began to take Italy by storm. He

soon took his leave from his military endeavours when he received the concerning news that Lucrezia's health was in crisis – since falling pregnant Lucrezia's health had taken a turn for the worse and now, in her seventh month, things were not improving. On 3 September she began to suffer from spasms and her doctors feared for her life – she gave birth at this point, but the child was stillborn. When Cesare arrived, she was too ill to receive him until the next morning. She was so unwell she was assumed to be at death's door, so her physicians decided that she should be bled.

The next morning her health worsened again and the priest was called to give her the Last Rites. But Cesare decided that, despite the situation, it was time for him to leave his sister. She would never see him again. Eventually her health improved and life got better for her – Ercole agreed to give her the full 12,000 ducats a year from her dowry and she became the centre of attention at the court in Ferrara. It was during this time that she would meet both Ercole Strozzi and Pietro Bembo – Bembo in particular would become one of her closest friends and confidants and would later come to be thought of as one of Lucrezia's lovers. Is it any wonder when one looks at the letters the two exchanged that such things were thought?

> Gazing these past days into my crystal, of which we spoke during the last evening I paid my respects to Your Ladyship, I have read therein, glowing at its centre, these lines I now send to you upon this paper. It would be the sweetest consolation to me and more prized than any treasure if in exchange your Ladyship might permit me to see something that she may have read in hers.

As summer dawned in 1503, Lucrezia's life was about to change for the worse and she would find herself in an incredibly dangerous political situation.

August, one of the hottest months of the year in Rome, was deadly – malaria raged during the summer months and the majority

of the College of Cardinals left the city to get to the cleaner air in the country. Normally Rodrigo would have followed the example of his Cardinals and left the city for the summer months, however in 1503 he opted to stay given the tense political situation involving France, Spain and even his own son. It would prove to be his undoing.

One August evening Alexander and Cesare attended a dinner with the new Cardinal Castellesi – a week later on 12 August, Alexander was struck down with a fit of vomiting and fever. Cesare felt unwell also, but he would later recover. It didn't take long for rumours of poison to spread around the city of Rome and beyond. On 18 August, Pope Alexander VI died having suffered from fever for almost a week. Still the rumour of poison persisted, even though he died a completely natural death caused by fever. At four o'clock that very same afternoon, Michelotto and his men threw open the doors to the Papal apartments and announced that Rodrigo Borgia, Pope Alexander VI, was dead.

When Lucrezia heard the news that her beloved father had died, she was inconsolable. It was Pietro Bembo who advised her that the best thing she could do was show composure in public – she was Duchess after all. And so she did, grieving privately whilst remaining the calm and composed woman that she had become. In the months and years following her father's death, she remained in close contact with her beloved Pietro Bembo who had been forced to move to Venice. The letters were affectionate and sometimes romantic, written in code in case of being discovered.

1505 saw the death of her father-in-law – Alfonso and Lucrezia became Duke and Duchess of Ferrara. As Duchess, she stepped up to the plate and worked hard for the people of Ferrara. For instance, when plague broke out that summer she made sure that food and supplies were brought in. In August 1505 she gave birth to another son who she named Alexander in honour of her father. The child died less than a month later. 1506 was spent in organising marriages for her women, including her cousin Angela. She also spent time celebrating when she heard that Cesare had managed to escape incarceration in Spain. Her happiness at his freedom was not to last, however.

Cesare died on 12 March 1507 after a drama filled few years. He had escaped imprisonment in Rome only to be taken prisoner by the Spanish and incarcerated in La Mota and Chinchilla castle. Upon a daring escape he ended up in Navarre where he fought for his brother-in-law, only to die alone outside the walls of Viana. Lucrezia didn't find out the news for over a month but when she did, she was heartbroken. But despite her grief, outwardly she remained calm. It was only when she was alone at night that her ladies could hear her sobbing and crying out for her brother.

The remaining years of her life were spent seeking solace in the arms of others, Francesco Gonzaga, her brother-in-law being the main one. Another was Ercole Strozzi who would later be murdered on the very street that had seen the birth of the Dominican friar Savonarola. Much of her time was spent pregnant, each pregnancy proving to be more difficult than the last. Mixed in with almost constant war between her husband and the Pope, life was becoming increasingly difficult. In fact it would be pregnancy and childbirth that would end her life.

Illness stalked her during these times as well as almost constant worry over her husband's safety as well as yet more personal loss. Despite this though, she still worked incredibly hard and looked after Ferrara when her husband was away. He had left Ferrara in the November of 1518 in order to try and regain his territories of Modena and Reggio, leaving Lucrezia in charge of the city. And it was only shortly after Alfonso left that Lucrezia received news of her mother's death.

She was kept informed of her husband's progress in France and was pleased when he arrived safely in Paris, writing to him of her delight over how well he had been received at the French Court and sending him news of their children. His visit lasted until the early months of 1519 and he returned home on 20 February, heading straight to see his wife where he received joyous news.

Lucrezia Borgia, Duchess of Ferrara, was pregnant again. It was a pregnancy that would be the most difficult of Lucrezia's life, and a pregnancy that would ultimately cause her end.

Francesco Gonzaga, Lucrezia's beloved, died on 29 March 1519, from the syphilis that had wracked his body. Lucrezia had kept up her correspondence with him until the end of his life and, with his passing, wrote a letter of condolence to his wife and her sister-in-law, Isabella d'Este.

On 14 June 1519, Lucrezia Borgia gave birth to a baby girl. The birth was a difficult one and the child was born so weak that it was feared she would not survive long – Alfonso made sure to have the child baptised straight away and christened Isabella. Following the birth Lucrezia suffered with a mild fever but, given that she had come through difficult pregnancies and fevers previously, it was hoped that she would come through this one. Unfortunately, the fever got worse and by 20 June it was feared that she would die. Following the birth, Lucrezia had not been purged of the bad material that had accumulated in her womb – a Renaissance belief that during pregnancy, menstrual blood would accumulate and needed to be purged following a birth. Doctors bled her and, as her head ached, her beautiful blonde hair was shorn off – her nose then bled and she soon became completely incapable of speech and could not see. The doctors gave her just hours to live but still Lucrezia fought – she was a Borgia after all – she woke and regained her senses with Alfonso at her side. Continuing to improve, the doctors said that if she did not relapse then there was hope of her survival.

But Lucrezia knew she was dying and, using the last of her remaining strength, dictated a letter to be given to Pope Leo X. It is the last letter written by Lucrezia:

> Most Holy Father and Honoured Master,
> With all respect I kiss your Holiness' feet and commend myself in all humility to your holy mercy. Having suffered for more than two months, early on the morning of the 14th of the present, as it pleased God, I gave birth to a daughter, and hoped then to find relief from my sufferings, but I did not, and shall be compelled to pay my

debt to nature. So great is the favour which our merciful Creator has shown me, that I approach the end of my life with pleasure, knowing that in a few hours… I shall be released. Having arrived at this moment, I desire as a Christian, although I am a sinner, to ask your Holiness, in your mercy, to give me … blessing for my soul …

The letter to the Pope shows just how heavily the past weighed on Lucrezia and she wanted desperately to receive forgiveness from the highest religious authority in the world and to ensure that her husband and children would be looked after.

Still she clung to life and her doctors tried desperately to purge her of the bad material that they believed had accumulated in her womb. Nothing worked however and Ferrara prepared for the death of their Duchess – Alfonso stayed constantly by her side, only moving to eat and sleep a little.

She died in the fifth hour of the morning of 24 June 1519, unable to fight the fever and sickness that had plagued her not only following the birth of her daughter, but during the pregnancy. She was just 39. Alfonso was utterly grief stricken by her death – he wrote personal letters to two of his friends describing his anguish and that, 'I cannot write without tears.' The two had grown closer during Lucrezia's last years and had a deep respect for each other, even if they did not love one another. She had borne him multiple children, having been almost constantly pregnant since their marriage in 1502, providing him heirs that would rule Ferrara for centuries to come. Not only that, but she was a respected Duchess and the people of Ferrara loved and respected her, deeply mourning her loss.

The eagle eyed will note that at the beginning of this chapter, it was mentioned that one of Lucrezia's supposed crimes is that of poisoning and yet there has been no mention since. That is because during her lifetime, her name was not mentioned in relation to any poisonings. Rather they were attributed to her father and brother. Lucrezia's name is only linked to poisonings in the Victorian age when she is written

about as such by Victor Hugo in his play *Lucrèce Borgi* in 1833. It mattered little to the Victorians that this woman had been pious, that she had been used as a pawn by her father and brothers – they saw her sexual misdemeanours and decided that she must have committed murder by poison. This myth has become cemented in the history of Lucrezia – plays, novels and films have taken the idea from Hugo and made it their own with very little regard to the lack of evidence to support this.

Lucrezia Borgia, Duchess of Ferrara, was buried in her beloved convent of Corpus Domini where she still lies to this day. Her life had been one of incredible wealth and incredible loss, as well as surviving the terrible rumours that stalked her throughout her life. She was vilified as an incestuous harlot who poisoned her enemies yet the truth was, she was a simple, pious woman who loved her family deeply. Her only crime was to be born a Borgia, their name and actions both real and imagined, tainting her even after death.

Chapter 5

Anne Boleyn
1501/7–1533

On 19 May 1536, the woman who had been Queen of England stepped out onto the scaffold within the walls of the Tower of London. Accused of treason; of plotting the King's death and of sleeping with other men, Anne Boleyn had been sentenced to death by beheading. She addressed the gathered crowd, as etiquette demanded:

> Good Christian people, I have not come here to preach a sermon. I have come here to die…For according to the law and by the law I am judged to die and therefore I will speak nothing against it. I am come hither to accuse no man or to speak what whereof I am accused and condemned to die, but I pray God save the King and send him long to reign over you…and if any person will meddle of my cause, I require them to judge the best. And thus I take my leave of the world and of you, and I heartily desire you all to pray for me.

She knelt, blindfolded, and prayed. The swordsman from Calais, hired especially for the execution at the orders of Henry VIII, removed Anne's head in one swing. She was then buried in a simple narrow chest beneath the floor of St. Peter ad Vincula, the chapel within the walls of the Tower, and her enemies rejoiced. Thus ended the woman for whom Henry VIII had divorced his first wife of well over 20 years, and for whom he had broken from the Catholic church. Her enemies rejoiced that the harlot who had bewitched King Henry was

gone, and things would be better. She would go down in history as an incestuous harlot and a witch with six fingers. But who was Anne Boleyn and what was it about her means that she still has falsehoods spoken about her?

Anne was born in Norfolk in either 1501 or 1507 – no concrete date for her birth has been found but the choice offered to historians comes from the late sixteenth and early seventeenth centuries – rather than at the manor house that has come to be associated with Anne and her life, Hever Castle. Her parents were nobility – her father, Thomas, was the son of the Earl of Blickling and her mother, Elizabeth, was a member of the eminent Howard family so her breeding was absolutely impeccable. Both parents also had links to the royal courts. In 1513 Anne was sent abroad to complete her education at the fashionable court of Margaret of Austria. It was an experience that would shape the young Boleyn for the remainder of her life. Margaret was a woman who ruled as regent of the Low Countries for her nephew, Charles of Burgundy, and she built a court that was for a long time a centre of learning and attitudes that had people flocking to it from miles around. Anne was joined here by her sister, Mary, and the two were sent not only to be educated by Margaret but also to be companions to her nephew, Charles, and various nieces. What was even better, especially for Anne's parents, was that Margaret had close links to the English court – she was sister-in-law to the Queen of England herself, Catherine of Aragon. It was the perfect way for Thomas and Elizabeth to ingratiate themselves at the English court. In Margaret's household, Anne underwent rigorous education and training, learning how to serve as a lady in waiting and how to conduct herself. It was, in essence, a finishing school.

Anne's time in France certainly left her in good stead for a career at the English court. She returned in the winter of 1521/2 and by the new year she had managed to secure a post within the Queen's household. Her official debut came at the celebration of Shrovetide. In this, Anne had a leading role in the Shrovetide revel in which Henry

and his group of knights 'attacked' the Chateau Vert. This castle was defended by eight noble ladies, all named after a virtue – these ladies were the most desired at the Court, the best of the best, and they were headed by Henry's sister Mary who was Dowager Queen of France and Duchess of Suffolk. Among these ladies was Anne Boleyn, who played the role of Perseverance. Was it here that she first caught the eye of the King?

Either way, part of her role at Court was to make a suitable match with a young man and to marry him. A marriage was sought and watched over by her family who wanted to make a strong, noble march for their daughter – their eyes fell upon James Butler, son of a man who argued that he should inherit the earldom of Ormond in Ireland, but the marriage never took place. Anne, for her part, found her own prospective match in Henry Percy who was the son and heir of the Earl of Northumberland and a resident in Cardinal Wolsey's household. According to David Starkey in *Six Wives: The Queens of Henry VIII* (Vintage 2004), Anne and Henry became 'secret but unacknowledged lovers…[entering] into a form of betrothal. Some have even thought – though it seems unlikely – that they anticipated the ceremony and slept together.' Percy had competition, however, with the poet and diplomat Thomas Wyatt. Wyatt, whose first marriage would fail, wrote a number of poems detailing his infatuation with Anne. Anne, however, would not settle. Just as would happen with Henry VIII, she would not simply become Wyatt's mistress, even though being associated with him would enhance her reputation. She knew, having already been sought to be the wife of a future earl, that she was worth much more. So she encouraged his flirtations … to a degree. And she would always make sure that she stopped things with him before they went too far.

Henry's aim, to start with, was to install Anne as his maitress-en-titre or his principal mistress. Had she accepted this she would have taken the place of Bessie Blount, who had given birth to a son for Henry, and her own sister Mary. Henry wanted Anne at all costs and began making sure he could have her by having Wolsey get rid of

Anne's love, Henry Percy. A fresh marriage was arranged for Percy to Mary Talbot and Anne was temporarily sent away from court. When she returned, she knew that Henry had his eye on her.

The next part of Anne's story is one of the best known in English history – in a nutshell Anne refused to give in to Henry and become his mistress, he took on the Roman Catholic Church to annul his marriage and when that failed, he had himself declared as head of the Church. His marriage to Catherine of Aragon was declared null and void and he married Anne Boleyn. It was a choice that certainly did not sit well with supporters of Catherine. Of course, there is much more to the annulment of Henry's marriage and his split from the Church and many excellent books – both popular and academic histories – have been written on the subject. The break with Rome caused him to dissolve a number of monasteries, for instance, by seizing their land and taking all of their wealth. The excuse? These Catholic monasteries were full of monks and nuns who did not follow the vows they had taken, were keeping all the wealth for themselves and were committing fraud by having pilgrims view false relics. So it was all seized and those living in the monasteries were forced out of their homes. The money that came from these religious houses went into the royal treasury to fund Henry's wars. And, importantly, it got rid of a lot of opposition against Henry and his break with Rome. A few violently protested the closure of their monasteries and those who did were treated as traitors – most either moved into other monasteries that had approval or took retirement and went into a secular life.

Henry and Anne were married in a small private ceremony on St Erkenwald's Day, 14 November 1532, following their return from a trip to Calais where Anne had received King Francis I's blessing on her marriage. She and Henry had been living together for a while before this, with her already acting as his consort. By the end of 1532 Anne was pregnant with the longed-for heir to the throne. Henry hoped desperately for a boy.

Anne was to be crowned as Queen of England on 1 June, 1533 and by this point she was heavily pregnant. It was to be a massive affair,

spread over four days and full of incredible pomp and ceremony. Pageants were to be performed on the coronation route and the whole route lined with beautiful decorations. On 29 May Anne was taken by water from the palace at Greenwich to the Tower of London, waited on by the Mayor of London and a number of barges. Her progress was followed by ceremonial gunfire. The procession was described as '…a right sumptuous and a triumphant sight to see and to hear as they past upon the water.' Anne spent the next forty eight hours sequestered in the Tower with her husband, their time spent in reconstructed apartments in the south east corner. On 31 May, Anne was taken by procession to Westminster – she was accompanied by hundreds of court members, from servants to courtiers, with her litter at the end of the procession, covered in cloth of gold. Anne, whose dark hair was worn loose, had a canopy that covered her held up by Barons of the Cinque Ports.

As the procession wound by the crowds, a report sent to Brussels stated that the crowds did not cheer their new Queen or remove their hats. Could this have been true dislike for Anne, who had helped unseat the popular Catherine of Aragon, or were they silent out of curiosity for the woman who was to be their new Queen?

The coronation itself took place on Whit Sunday, 1 June. Anne was dressed in purple coronation robes and a gold coronet. As she processed from Westminster Hall she was once more covered with a cloth of gold canopy carried by the barons of the Cinque Ports. Westminster Abbey was, of course, the place where the coronation took place. The coronation itself was done in the form of a High Mass and Anne was anointed before the altar. Rather than being crowned with St Edward's Crown, which was incredibly heavy, it was swapped out for a lighter crown. She then took the sacrament and made an offering at the shrine of the Saint. She would have also sat on St Edward's Chair, the chair that has provided seating for almost every monarch that has been crowned in the Abbey since the fourteenth century, whilst she was given the regalia of Queen of England – the crown itself, the sceptre and rod of ivory. Following the

ceremony, the Queen returned to Westminster Hall where a huge banquet took place.

Of course, more hostile accounts of the event followed. Eustace Chapuys, Imperial Ambassador, described the whole thing as 'a cold, thin and very unpleasant thing.' It certainly was not the first dispatch he had written that made it clear how much he disliked Anne, nor would it be the last. Chapuys was, of course, an advocate for the overthrown Catherine of Aragon who was the aunt of his master, Charles V.

The birth of Henry and Anne's child was awaited with bated breath and Henry hoped for his long sought male heir. In the run up to the birth he began to plan extravagant celebrations and even planned to name the boy either Henry or Charles – after all, he had managed to have a son with Bessie Blount so why could he not with Anne? He was to be disappointed when, on 7 September 1533, his daughter was born. Both parents were disappointed – they had both been expecting the longed-for heir, but positives had to be taken from it all. Anne's labour had gone off without a hitch when so many women suffered and lost their lives during childbirth. Of course the parties and jousts were cancelled – a princess wasn't worth the trouble of such things. But the christening of the King's legitimate child (his daughter by Catherine had been declared a bastard after all) was to be a splendid affair and was arranged for 10 September. It would be followed by bonfires across the country and free wine in the city of London. The little girl was christened at the Church of the Observant Friars in Greenwich, just a short way away from the palace. Once the ceremony was finished, little Elizabeth was escorted back to the palace and her waiting mother by over 500 attendants and blazing torches, a blatant snub to those who had criticised Anne and Henry's marriage. Yet more humiliation for the critics came in the choice of the child's name – Elizabeth, after Henry's grandmother, Elizabeth of York. More tellingly, one of Catherine's best friends and closest confidants was made a godmother. This was a show of strength from Anne and Henry. They had won – their haters were left humiliated by the fact that Anne had been crowned Queen of England and Catherine

was left languishing, by the fact that Anne had safely delivered a child and would obviously be able to have many more, by the fact that the Boleyn's were no longer just on the rise but they were at the very top.

But what comes up must come down. For now, Anne was triumphant but her critics waited in the wings for the perfect moment to strike and overthrow the upstart concubine and her family. It wouldn't take long. Many already hated her but by the time May of 1536 came around even more would do so – and their vilification would last for centuries.

It didn't take Anne long to become pregnant again, offering the couple hope that a son would soon join their daughter in the nursery. Yet Anne still continued to fail to give Henry the son that he so desperately desired, and it soon began to prove problematic in their marriage. This wasn't helped by other problems. One of the biggest thorns in the couple's side was Henry's daughter Mary, who refused to recognise Anne as Queen or Anne's child as her superior. Her behaviour was abominable in Henry' eyes – if he could not control his own daughter, then what hope did he have with the rest of his subjects? He pressured the young woman, aged 17 at the time of her father's second marriage, to conform, yet she was stubborn, doing everything that she could to not have her will broken by her father. Anne was certainly also instrumental in the pressure that was put on her stepdaughter – when friendship did not work, Anne resorted to threats. She even threatened to have Mary put to death, not caring that it would anger her husband. Mary remained strong, insisting that she would recognise no queen but her mother. To Anne, that was dangerous. More dangerous in Anne's eyes was that Mary refused to recognise Elizabeth's precedence. She was a princess and her new half-sister nothing but a bastard and this stance only solidified her view that she was legitimate. She could be a rallying point for those who wanted to overthrow the Boleyns and have the first marriage reinstated. And this could see the end of Anne's life – she even stated, 'She is my death, and I am hers', knowing that the stakes here were as high as they could possibly be.

Anne certainly had many problems even in the early stages of her marriage. Her biggest was, of course, the lack of providing a male heir. But she was already beset from every side. The people blamed her for everything that was being shaken up in their lives from taxes to religion while those at court whispered behind her back and blamed her for not gaining them the power that they believed they were owed, or blamed her for their worsening situations.

It should have been no surprise that Henry's eyes would roam to another woman. After all his eyes had roamed when he was married to Catherine of Aragon – famously he had fathered bastards (and male ones) with his mistresses when Catherine only gave him girls, and had even slept with Anne's own sister. Kings were notorious for having mistresses alongside their wives – after all, where else could they turn when their wives were pregnant? So Anne was bound to have a rival. But first, the original rival would finally be dealt with. Catherine of Aragon died on 7 January 1536 at Kimbolton Castle in Cambridgeshire. When Anne was given the news, she was elated, giving the messenger a lavish gift. The day after the news was brought, Henry and Anne appeared in bright yellow garb, parading their little daughter all the way to church and then they spent the rest of the day dancing and celebrating. The cause of so much woe was gone. With the previous queen now dead and gone, Anne felt more secure than ever. It was a feeling that was not to last. In one last snub to Catherine, she was not even accorded the honour of being buried as queen. Rather Henry had her buried in Peterborough Cathedral following a funeral that was to be used to cement her position as Dowager Princess of Wales. Mary was not permitted to attend her mother's funeral.

As the beginning of 1536 ticked by, things were about to get desperate for Queen Anne. On 24 January, Henry suffered so devastating a jousting accident that Chapuys reported that the king 'fell so heavily that everyone thought it a miracle he was not killed'. Others reported that the King had been knocked out and couldn't talk for two hours, but other than that he was not hurt. What we do know, however, is that the accident caused a change in Henry that was hard to deny – his

moods, his whole personality changed, and it is more than likely that the accident caused an old ulcer on his leg to burst. It also shattered his honour and ended his jousting career. Anne was not present at the time of the accident, but the shock of his accident soon saw the heartbreaking loss of her unborn child. Chapuys reported in a letter to his master that Anne miscarried a male child on 29 January, the day of Catherine of Aragon's funeral. Another report, this one by Charles Wriothesley, states that the miscarriage happened on 30 January.

It was at this point that the first concrete mention of Henry being 'bewitched' came into existence. Chapuys reports that in his grief:

> the King had said to one of them in great secrecy, and as if in confession, that he had been seduced and forced into this second marriage by means of sortiledges and charms, and that, owing to that he held it as null. God had well shown his displeasure at it by denying him male children. He considered that he would take a third wife, which he said he wished much to do.

Of course Henry was grieving for the loss of his child but he placed all of the blame at Anne's door. Nor did he seem to care that she was grieving also, that she had given birth to a dead child. This was truly the beginning of the end for Anne – had this child survived, this male child, she would have been saved and her position cemented for the rest of her days. Instead, it left her standing on the edge of a precipice with a marriage that she could see crumbling before her eyes. But this was Anne, a strong woman who took the bull by the horns and insisted on saving things between her and her husband. So she picked herself up, brushed herself off ... and decided to confront her husband over a certain woman who seemed to have caught Henry's attention.

This woman, Anne's rival, was one of her own ladies in waiting. Her name was Jane Seymour and she would be to Anne Boleyn what Anne had been to Catherine. But Jane was everything that Anne was not – she was unassuming and didn't make any sort of scene ever,

and more importantly she didn't make any demands, unlike Anne. And it was that that attracted Henry to her. Yet Jane played a clever game – just as Anne had done, Jane refused to take Henry to her bed and even refused his gifts. When she told Henry that the greatest gift he could give her was an advantageous marriage, her wishes were clear. She wanted to be his queen and take the place of Anne. Her refusal inflamed Henry's passion and he fell head over heels in love with her, even giving her family members gifts and a rise in status. Her brother, Edward Seymour, was given Cromwell's rooms. But while Jane's star was on the rise, Henry was clearly tiring of his wife and the intrigues of her family even going as far as to refuse to give George Boleyn, Anne's brother, a place in the Order of the Garter.

There is a very famous story in the run up to Anne's downfall. Anne surrounded herself with her favourites and, as queen, was required to take part in the games of courtly love. Unfortunately for Anne, by this time it seems as though she began taking things to extremes – perhaps due to rising panic at the situation she had found herself in. Her husband had a new amour, and her family were slipping down in Henry's estimation. On top of that, many of her supporters were jumping ship. In April 1536 Anne was spending time with some of her closest companions who she was able to feel comfortable around and let her hair down. One of these friends was Sir Henry Norris who was also a member of the King's household and a massive Boleyn supporter who was close to her brother. Anne turned around to Norris, a widower, and asked him why he had not yet remarried. When he said he was waiting, Anne scoffed and said, 'You look for dead men's shoes … for if aught came to the King but good, you would look to have me' Norris, evidently flustered, replied, 'If he should have any such though, he would his head were cut off.' Anne spat back, 'She could unto him, if she would.' It was treason to mention any possibility of the king's death so both Henry and Anne were in a lot of trouble here. If word were to get out of this recklessness, then their lives were on the line.

The fall of Anne was to happen swiftly following this. For weeks her enemies had been plotting behind her back. Not only had she committed

treason by just mentioning that Norris looked for dead men's shoes, but she had been accused of adultery with many of her favourites including the musician Mark Smeaton and even her own brother. The king attended the May Day jousts at Greenwich the day after this treasonous exchange. Henry Norris and George Boleyn headed the lists in front of crowds of people yet all of a sudden the king suddenly stood up and left with a group of six people. Among the six that rode by horseback rather than travelling by barge to Whitehall, was Henry Norris. On the journey, the king questioned his companion and promised him a pardon if he spoke the truth. Norris did just that, maintaining his innocence, yet Henry still remained convinced of his guilt. Perhaps he wanted so badly to believe that his wife had committed offences against him that he convinced himself that Norris was lying. Or perhaps he just wanted Anne out of the way. The very next day, Norris was arrested along with George Boleyn, William Brereton, Sir Francis Weston and Richard Page. Mark Smeaton had already been arrested and placed in the Tower. Anne was also arrested and taken to the Tower. All arrested were close to the queen; all arrested had been heard to speak carelessly – Norris' comment about dead men's shoes was not the only careless comment. Weston had been heard telling the queen that he could not marry her cousin, Madge Shelton, as he loved someone else far more. When Anne asked who it was, Weston is said to have replied, 'It is yourself.' Smeaton had confessed after torture that he had known the queen carnally and George was guilty simply because he was too close with his sister. In simple terms, lines of propriety had been crossed when playing the game of courtly love and this was not acceptable. Whilst courtly love demanded that men served and loved the queen faithfully, the banter had been too much and thus, they must have all been guilty.

On 12 May 1536, Brereton, Weston, Page and Smeaton were tried and all four were found guilty. Smeaton had specifically pleaded guilty to carnal knowledge of the queen whilst the others maintained their innocence. The punishment was to be death by hanging, drawing and quartering – a traitor's death in which the victim was hanged until nearly dead, their innards pulled out before them and then their

bodies cut into pieces. Anne and her brother were tried on 15 May in the King's Hall at the Tower of London in front of a massive crowd. Anne was tried under Statue 26 of the Treason Act 1534. This act, which had originally been brought into force in order to protect Anne and Princess Elizabeth from malicious slander stated:

> For as much as it is most necessary, both for both common policy and duty of subjects, above all things to prohibit, provide, restrain and extinct all manner of shameful slanders, perils, or imminent danger or dangers which might grow, happen or rise to their sovereign lord the king, the queen or their heirs…if any person or persons…do maliciously wish, will, or desire, by words or writing, or by craft, or by craft imagine, invent, practice or attempt any bodily hard to be done to the king's most royal person…every such person…so offending in any the premises…shall be adjudged traitors…[and] shall have and suffer such pains of death and other penalties, as is limited and accustomed in cases of high treason.

The two were tried before twenty-six peers of the realm and their uncle, Thomas Howard, presided over it. The trial itself covered the aspects of treason that the siblings had apparently committed, including having so-called carnal relations as well as joking about the king's manner of dress and Anne's apparent saying that the king was rubbish in bed. George was questioned on this and carefully sidestepped the issue, but when he was questioned about whether he had said Princess Elizabeth was not the king's child, he did not say a word. Was this indicative that he had said something along those lines, even in jest? George was handed these accusations on paper and asked to read them out, which he refused to do. At this point his fate was sealed and Chapuys reckoning that he would be acquitted did not come to pass. In truth this was little more than a kangaroo court and the outcome was nigh on guaranteed. Both were found guilty – George

would face a traitor's death by hanging, drawing and quartering and Anne would be burned or beheaded at the king's pleasure.

As Anne languished in the Tower awaiting her fate, the king began making preparations for her execution. He agreed – perhaps at her own request – to hire a swordsman from Calais to commit the deed. In the warrant for her execution, it clearly states that the king was moved by pity and not willing to let her burn. Instead, he hired the swordsman, who charged £236s 8d. Legend, thanks in part to Chapuys, states that Anne watched the execution of her brother from her rooms, 'The concubine saw them executed from the Tower, to aggravate her grief.' This is unlikely, as the execution site cannot be seen from where Anne was imprisoned.

As she waited for news of her own demise, she suffered with mood swings. At one moment she was sure that she would be sent to a nunnery or that the king was simply doing this to test her love for him. She would also share macabre jokes with Anthony Kingston, the constable of the Tower who had been charged with her care, naming herself as Anne the Headless. In between the hopes and jokes she spent increasing amounts of time preparing to take her leave of the world, spending hours upon hours with her almoner. On 17 May, just to add insult to injury, Princess Elizabeth was bastardised and Anne's marriage to Henry was declared null and void, Even though she had entered the Tower as Queen of England, she no longer held that title.

The date of her execution was originally set as 18 May and she prepared herself for it. She even spoke with Kingston that morning and swore that she had never been unfaithful to the king, on the damnation of her immortal soul. She was a highly religious woman, so would she have risked her soul to keep a lie going? Yet the execution was delayed, and Anne spoke to the constable stating, 'Master Kingston, I hear I shall not die afore noon, and I am very sorry for it, for I thought to be dead by this time and past my pain.' Kingston attempted to put her at ease and saying that it would be over quickly, the blow subtle and without pain. Anne replied, perhaps in a moment of mania with another macabre joke that has gone down

in the legend of Anne Boleyn, 'I heard say the executioner was very good, and I have a little neck.' She is then said to have put her own hands about her neck and laughed,

In the end the date was set for 19 May. She was escorted to the scaffold by Sir William Kingston and was dressed in a blue damask gown. On the scaffold she made no admittance of any sort of guilt on her part, only that she had been judged to die and so would die. And then it was over. One swing of the axe and the Queen of England, Anne Boleyn, was dead.

Was she guilty of the crimes of which she was accused? The evidence strongly suggests that she was innocent – she constantly spoke of her innocence, even swearing it upon her immortal soul. Only one man, Mark Smeaton, admitted to carnal relations with her and that was after torture. Even the dates put forward for her alleged indiscretions have been discredited and her apparent 'bewitching' of the King was a comment made with entirely different meaning. Yet the idea of Anne as a seductress, as a temptress and a witch has struck the imagination of many – novels have been written that show Anne as sleeping with her brother in order to beget an heir that she can pass off as Henry's and her portrait can even be seen adorning the walls of J.K. Rowling's mythical Hogwarts. The idea of her guilt has stuck with many historians and yet it cannot be denied that the evidence points to the fact that she was innocent. What we can say for certain though is that she was a woman before her time, a woman in her own right who certainly strikes an ideal with many modern-day women. She was strong and stood up for what she believed in, fighting for her daughter when the chips were down. In the end, though many turned their back on her in the years immediately following her death, she has come to be remembered as a woman of incredible courage, spirit and intelligence. Perhaps it is only that which she was guilty of, rather than anything else, and it is that which keeps our interest in Queen Anne Boleyn alive and well.

Chapter 6

Elizabeth Báthory
1560–1614
The Blood Countess

'Look how cold my hands are.'

It was Sunday, 21 August 1614, and Countess Elizabeth (Erzsébet) Báthory had been imprisoned within the walls of Čachtice castle for two years. Her guard told her it was nothing and that she should lie down. Lay down she did, singing herself to sleep. She was found dead the next morning. Legend states that she was bricked up inside her own apartments within its walls, destined to end her days in captivity. Myth and legend are things that surround the life of Countess Báthory, known as one of the most prevalent serial killers of all time (before serial killers were even *known* as serial killers) to the point where just the mere mention of her name has even people not hugely well versed in history looking up in interest. Her infamy started whilst she was alive, and it has stuck to her name throughout the centuries. A murderer, there is no doubt, but the numbers she has been accused of killing are staggeringly high. But the accusations don't just stop at murder – the sobriquets of 'Countess Dracula' and the 'Blood Countess' are both huge clues as to just one of the biggest accusations that she has faced throughout history. To many, she murdered countless young women and girls to bathe in their blood in order to stay looking young. To many, she is one of the most vicious vampires of all time. But how much of it is true – did she really kill over 600 young women and girls? Did she really bathe in blood? Or was she just a victim of a conspiracy by those who wanted to take her land?

Elizabeth Báthory was born on 7 August 1560 at the Ecsed family estate in Hungary. Her parents were Gyorgy and Anna Báthory, both of whom came from separate branches of the noble Báthory family. Her father was a son of the Ecsed branch whilst her mother was from the older and more distinguished branch, the Somlyo. Not only was the little girl the outcome of an incredibly powerful political union but was born into one of the most powerful noble families in Central Europe at the time. Uncles on both sides of the family were Voivods (rulers or governors) of Transylvania whilst another uncle was King of Poland.

Somewhat surprisingly for the time, Elizabeth had an excellent education thanks to her parents being progressive and believing that girls deserved such an upbringing. Just like boys of the time, she was tutored in the classics as well as a number of languages – she was able to speak Latin, Hungarian, Greek, German and Slovak. Throughout her life she continued to read around her interests, buying a number of books from both merchants and other noble families – occultism and the sciences were particular favourites of hers. She was certainly far more educated than many at the time – reading and writing tended to be left to administrative staff, while the nobility considered such things a waste of time. As well as a keen interest in learning, as a child she also took part in a number of activities that were also seen as more appropriate for boys such as fencing and horsemanship, dressing in boys' clothes and demanding to be treated the same as her male contemporaries. However, there was one thing usual to a young noblewoman's life – engagement and an early marriage.

In 1571, at the age of just 11, she was engaged to Count Ferenc Nadasdy who was 16 at the time and a member of one of the most influential noble families in Hungary. She left her family home in 1572 and moved to Sárvár where she was placed under the care of her future mother-in-law, Countess Orsolya who sadly died before the wedding day.

The wedding did not take place until 8 May 1575 at Varanno Castle in Vranov, modern day Slovakia. It was usual for weddings to be

celebrated lavishly and over a number of days – the Nadasdy wedding was no different and even had invited distinguished individuals including the Holy Roman Emperor himself, Maximillian II. Unfortunately, he could not make it, so sent his apologies and a gift for the newlyweds. The celebrations included jousting and tournaments, as well as a ritual in which Ferenc had to prove his loyalty to his new wife. Elizabeth and a number of her bridal party covered their faces with veils – they all pretended to be the bride and it was Ferenc's job to pick out the real Elizabeth.

Following these celebrations the actual wedding ceremony took place, probably in the town's huge gothic cathedral. Feasting and dancing followed before the couple were escorted to the bridal chamber where they consummated their marriage. The newlyweds, with Elizabeth retaining her maiden name, inherited a vast amount of wealth and property from their parents – so vast in fact that they very quickly became one of the country's richest families, possessing even more wealth and property than the king himself. This would prove to be a problem for Elizabeth down the line.

Accusations against Elizabeth did not start right away. In fact, the first years of her marriage passed without much in the way of incident. Ottoman Turks started raiding in 1578 and Ferenc began to fortify his properties and building an army in preparation for any sort of attack. What began was years of war and Elizabeth was left to take care of the Nadasdy estates – she was just 18 years old at this point and must have been incredibly lonely when her husband was away, despite being surrounded by servants. During these years of war Elizabeth certainly came into her own, running all of the properties, she travelled between each estate to make sure they were running correctly and that the staff were doing their jobs. She would also entertain visitors and dealing with local diplomatic issues that arose. It put her in good stead for when her husband died in 1604.

Ferenc had suffered greatly with poor health but still fought on against the invading Turks. In 1603 however, he became so ill that the family began to prepare for his death. As he lay dying, he sent

letters out asking for his children and wife to be protected – ironically one such was sent to Gyorgy Thurzo, a man who would be deeply embroiled in Elizabeth's downfall. 'God has visited upon me this disease ... should the unthinkable happen, I formally entrust my heirs and widow under your generous protection.'

Ferenc's funeral was, of course, ostentatious despite the country being embroiled in war. His body was displayed in state in the castle hung with black cloth and lit up by huge candelabras. Readings from the New Testament were done throughout the night. The next morning, the funeral itself began with hymns and a eulogy delivered by the local Lutheran priest, Stephen Magyari – Magyari had previously been a vocal critic of the countess and accused her of cruelty. That was 'forgotten' for the moment however, and Magyari praised the deceased Lord and reminded the congregation of just how generous Ferenc had been – never mind that the priest had previously spoken out about how Ferenc had oppressed the serfs under his control, for now the tale was spun that Lord Nadasdy had clothed and fed the needy, paid for the studies of poor but brilliant scholars and never taken food or drink in excess. Following the eulogy, Ferenc's body was taken in a covered carriage out to the graveyard where it was buried although the location of his final resting place has been lost to history.

Rumour had begun to circulate about Elizabeth Báthory's cruelty from around 1601 when people began to whisper that girls within the castle were disappearing and locals were convinced that the girls were being tortured to death. The accusations became far more intense following Ferenc's death. Shortly before he died, Elizbeth began to build herself a close circle of servants. These included Anna Darvolya; Janos Ficzko Ujary, a young man known simply as Ficzko; Ilona Jo Nagy, the woman who had been the wet nurse to Elizabeth's children; Dorottya Szentes, a friend of Ilona's and Katalin Beneczky, a washerwoman. Ficzko was the only male within Elizabeth's inner circle and the name 'Ficzko' meant 'lad' or 'kid', pointing to him being young and, in fact, his later sentence would be commuted due to

his youth. It is likely that he was kidnapped and sold into Elizabeth's service, but either way he was incredibly loyal to his mistress and did everything that she desired. This made him useful to her, and also made him one of her favourites, to the point that she let him get away with absolute chaos. He would run riot, beating servants of other noble families and spouting off about the number of girls he had killed. Regarding the rest of her inner circle, Anna Darvolya had already proven herself to the countess and been part of her staff for a number of years and would later be described as running the Lady's torture chamber. Ilona Jo had also worked for Elizabeth for a number of years, decades most likely and had been wet nurse to all of the children. Once Elizabeth's youngest son no longer required a wet nurse, Ilona was relocated to the manor at Csejthe, sometimes called Čachtice, where she took charge of the servant girls there. Dorottya, also known as Dorka, had been part of Báthory's household from 1605 and later told investigators that she was originally taken to the castle against her will and put to work. The last member of the inner circle was a woman named Katalin Beneczy who was a washerwoman. Together these individuals were Báthory's inner circle, a circle who she trusted to commit the atrocities that happened within the walls of her estates. Between them they murdered dozens of young women and, like the countess, would suffer the consequences.

What was it that pushed Elizabeth Báthory into having these girls beaten, tortured and murdered? What was it that started the rumour that she bathed in the blood of these girls in order to keep herself looking young? The legend goes that during a beating of one her servants, she struck the girl so hard that blood splattered across her skin. Where the blood touched made her skin shine and look youthful, and so the bloodletting began. It was whispered that she would drain her victims entirely of their blood and fill a bath tub, then she would bathe in this apparent magic elixir. This rumour did *not* start whilst Elizabeth was living, however, and no one mentioned it during the trials of her servants. The idea of the vampiric countess was first reported by a Jesuit priest called Lászlao Turoczi who discovered

the sealed trial documents of the countess in the 1720s. He placed parts of these documents in some of his work along with verbal tales from the local population. They spoke of the local vampire countess who murdered servant girls and bathed in their blood. When an academic, Matej Bel, picked up on this story and wrote about it in an encyclopaedia of Hungarian history, no one said anything against it because he was credible. But things *really* took off when Michael Wagner, a German writer, told the tale of Báthory beating a servant so hard that blood splattered across her skin. When the story was introduced to the English-speaking world it went, for want of a better word, viral. Sabine Baring-Gould told the over-the-top tale in his 1854 *The Book of Were-Wolves: being an Account of a Terrible Superstition* and during a time when Gothic horror and vampire fever was well and truly on the rise, was it any wonder that the morbid tale took a hold of the public imagination? It was, after all, already a macabre story that involved murder – add superstition on to that and it was a recipe for success.

> Elizabeth formed the resolution to bathe her face and whole body in human blood so as to enhance her beauty. Two old women and a certain Ficzko assisted her... this monster used to kill the luckless victim and the old woman caught the blood, in which Elizabeth was wont to bathe in ...After the bath she appeared more beautiful than ever.

This was all an embellishment. There is nothing in the trial transcripts that indicates the countess made any use of the blood from her victims, only that she would beat the girls so hard that she would have to change her shirt as it would be so saturated with their blood. Witnesses also testified that in her rage she would often bite the girls and tear out chunks of flesh, that she would stick needles beneath their nails and then chop off their fingers if they tried to remove the needles and that she would attack them with knives. This is hardly the

Empress Wu Zetian by an unknown artist. (Wikimedia Commons)

The Qianling Mausoleum, site of Empress Wu's tomb by Jonathan Wilsonn. (Adobe Images)

Left: Lucrezia Borgia by Bartolomeo Veneto. (Wikimedia Commons)

Below: Castello Estensi, Ferrara. Home of Lucrezia Borgia at the time of her death by Leonid Andronov. (Adobe Images)

The Grave of Lucrezia Borgia at the Monastery of Corpus Domini, Ferrara by Samantha Morris.

View of the Castello Estensi, Ferrara by Samantha Morris.

The Portrait of Anne Boleyn at Hever Castle by an unknown artist. (Wikimedia Commons)

Hever Castle, Anne Boleyn's Childhood Home by Rolf. (Adobe Images)

View of the Tower of London, site of Anne Boleyn's Execution by andreyspb21. (Adobe Images)

Portrait of Elizabeth Bathory by an unknown artist. (Wikimedia Commons)

Castle of Čachtice, Home of Elizabeth Bathory by Jareso. (Abobe Images)

Portrait of Catherine the Great by J.B. Lampi. (Wikimedia Commons)

Profile Portrait of Catherine the the Great by Fedor Rokotov, 1763. (Wikimedia Commons)

Above: The Winter Palace, Russia by Mistervlad. (Adobe Images)

Left: Catherine the Great by Juulijs. (Adobe Images)

Portrait of Marie Antoinette by Koningen der Fransen. (Wikimedia commons)

Portrait of Marie Antoinette at the Petit Trianon, Versailles, by Samantha Morris.

Marie Antoinette's Estate near Versailles Palace by Packshot.

The Marlborough Tower and pond at the Queen's Hamlet – Marie Antoinette's Estate near Versailles by WishMeLuck. (Adobe Images)

Above: Panoramic View of the Conciergerie, Paris by Kelly Ermis. (Adobe Images)

Right: Interior view of the Concierge, where Marie Antoinette was held prisoner by Samantha Morris.

The Execution of Marie Antoinette on 16 October 1793 by an unknown artist. (Wikimedia Commons)

Above: Photograph of Lizzie Borden from 1890. (Wikimedia Commons)

Left: Lizzie Borden's House in Fall River, Massachusetts by kirkikis. (Adobe Images)

Above: Crime Scene Photograph Showing Andrew Borden's Body. (Wikimedia Commons)

Right: Drawing of Lizzie Borden's Trial by B.W. Clinedinst. (Wikimedia Commons)

Left: Photograph of Empress Dowager Cixi from circa 1890. (Wikimedia Commons)

Below: Photograph of Empress Dowager Cixi on the walls of the Summer Palace in Beijing by zhang yongxin. (Adobe Images)

View of the Summer Palace Beijing by Darrenp. (Adobe Images)

Tomb of Empress Dowager Cixi by zhang yongxin. (Adobe Images)

Mugshot of Iva Toguri from Sugamo Prison, Japan, 7 March 1946. (Wikimedia Commons)

Profile Mugshot of Iva Toguri from Sugamo Prison, Japan, 7 March 1946. (Wikimedia Commons)

story of a bloodsucking vampire a la Dracula, but rather the actions of a woman who could only be described as a psychopath.

Whilst the idea of Elizabeth Báthory being a blood sucking vampire is an embellishment that has embedded itself into the minds of those that have heard her name in the years since her death, what was true was that under her care a large number of young women lost their lives. As their employer, even back in those days, she had a duty of care towards the girls in her service. They should have been safe and yet they found themselves at the mercy of a woman who seemingly had no limits. And it all came to a head at the estate of Csejthe (Čachtice), which was her main residence. Of course atrocities happened elsewhere, but Csejthe was the eye of the storm where it all took place under the watchful eye of Benedek Deseo, the castellan of the estate. He was the eyes and ears of the estate and would have witnessed many of the horrific events that took place behind the walls of the estate, though he never spoke a word of it to anyone. Instead, the young Ficzko testified that Deseo saw more of what happened than even some of the Countess' inner circle. He eventually testified, telling the court tales of a young servant who was stripped naked and tortured before his very eyes with beatings and being burned with a candle, how another had her mouth sewn shut after taking too long with her sewing, how she forced the girls to drink their own urine. The worst involved the use of a heated iron bar. 'The smaller, round fire iron was also heated ... until very hot and – on my honour – shoved into their vaginas.'

Other stories emerged of how the Countess took part in black magic, praying over a grey cake to curse her enemies and how she would conjure, and create poisons. The use of herbs was often used in healing at the time, but it must be noted that with certain herbs if enough was used then they could certainly be used for nefarious purposes. As the investigation into the countess gathered pace, more and more stories emerged – the local church began to refuse burials for the girls who died in the castle because there were so many of them and it was suspected that something was up, so her team of

accomplices started looking for other places to dispose of the bodies. The dead girls were buried in secrecy in ever increasing numbers – not only were they disposed of in the local graveyard but also in fruit pits and grain bins.

As the bodies piled up, so did the stories of heavy disciplining and torture, of stolen coins heated up and pressed into thieving maids' hands, girls being locked away in isolation for days at a time, candles being held to the genitals of a misbehaving girl … the list goes on and on with some of the worst involving tales of servant girls being submerged in freezing cold water and left out in the biting winter weather until they died of exposure. And the stories of missing girls meant that the locals began refusing to send their daughters to work for the countess. People were getting suspicious, and time was running out for the countess. Once the supply of girls dried up, Báthory and her cronies decided that the best way to restock on the ever-dwindling supply of girls was to open a finishing school. But then these girls, the daughters and family members of the aristocracy, started going missing too – when Janos Belanczky didn't hear from his sister, who had a place at Báthory's school, he personally travelled to her court and demanded the return of his sister. When the Countess refused, he asked that he at least be allowed to see her – she kept Janos waiting for well over an hour before the girl was brought out, severely weakened from being tortured. In testimony from Martin Chenady, he explained that once Janos left – though why did he just leave his sister there despite seeing how much she had suffered? – the girl was tortured to death. Other testimonies came out that included beatings that left girls so injured their flesh peeled from their bodies as well as stories that the sound of beatings could be heard coming from behind Báthory's walls. Then there were the stories of how the bodies were disposed of – a number were buried in a small garden outside, only for their bodies to be dug up and dragged around by dogs.

As with every serial killer, of course, Countess Báthory started to get sloppy when it came to hiding her crimes. Local people began openly seeing girls with wounds, while bodies began to openly be

removed from the castles. Stupidly, the finishing school had no students left within a matter of weeks – had these girls not been daughters of the aristocracy then perhaps Elizabeth could have got away with it, but when news filtered up the chain of command that these girls had been tortured, it truly was the end of the line for Countess Elizabeth Báthory. The king and other nobles were already looking for an excuse to move against her – this was the perfect opportunity.

It was not the king who made the first move against Báthory though; it was someone much closer to home, and someone she believed she could trust thanks to his long standing friendship with the Nadasdy family – György Thurzó. Letters had been secretly sent to Thurzo from the pastor of Csejthe, Reverend Janos Ponikenusz, that included a report from the previous pastor of the town detailing the secret burials of girls from the castle. So why was Thurzó the one to make the move? He had long been a Nadasdy family friend and had made a promise to Ferenc on his deathbed that he would keep an eye on the countess and her children. Could it have been that Thurzo was aware of the money owed to the countess by the king and aware that the king was losing patience with her? Did he hope that if he agreed to help the king get rid of his debt problem, the whole thing would quietly go away? Or was he aware that if charges were brought against Elizabeth and the debt was wiped off, he'd likely end up being rewarded by the king? In such a cut throat time, it seems as if the thought of extra land and wealth would have won out over any sort of friendship or loyalty. Having been made Palatine of Hungary in 1609, it should also be noted that putting a halt on the power of the Báthory family would directly benefit him.

Official legal proceedings began against Elizabeth in the February of 1610 – the king ordered an official investigation to be begun into the reports of Elizabeth's murderous activities. A huge number of witnesses were questioned, many of them being commoners from the towns surrounding Csejthe as well as a number of servants who worked for a local pastor. Whilst many of the witnesses called would

never have seen anything firsthand, they still told the investigators what they had heard. Yet only one actually witnessed anything. The rest were relying on hearsay. Investigations at Báthory's property in Sárvár weren't going any better. Though there was no solid evidence coming to the fore against Countess Elizabeth Báthory, the proceedings kept going – in June of the same year, Elizabeth's sons-in-law met with Thurzó to discuss how they could keep such a scandal from getting out of hand. Of course these legal proceedings couldn't remain secret forever and Elizabeth made the effort to try and prove that she was, in fact, innocent. On 24 August 1610, she personally appeared in court accompanied by the mother of one of the girls that she had supposedly murdered – the mother stated categorically that her daughter had died from natural causes, though it must be noted that the court did not take the woman's statement into account and, in fact, it did little to nothing in helping Elizabeth's situation.

The wolves were closing in around the countess and she knew it. She drew up her last will and testament on 3 September 1610 in which she ordered that her wealth be split equally between her children – though she asked that her grown up daughters wait until her son came of age to divide up the property that she had left to them:

> I have asked both my daughters and sons-in-law to wait for their brother to come of age before distributing the goods acquired from Sárvár, Kapuvár and Léka and not to cause any harm to come to them....The remaining goods...are to be divided in three portions...I have also included all of my property owned since childhood....I also pass into their hands all of the deeds, titles and letters, as the decree so provides and for which the law provides. The gold works I have bequeathed to Pál Nádasdy, because my two daughters have already received their shares.

Things began moving fast and on 12 December 1610, it was confirmed that Thurzó had life imprisonment in mind for the countess.

Her son-in-law, Miklos Zrinyi, who was already in cahoots with Thurzó, was evidently concerned that he wouldn't get his hands on any of the Báthory property (and thus probably unaware that she had passed her property into the hands of her children) and he sent a contingent of his men to 'protect' the castle of Csejthe. It must have seemed incredibly suspicious to Elizabeth. Now, Thurzó was to make one of his final moves on the chess board – just before Christmas of that year, he went to Csejthe and personally told her of each and every thing of which she stood accused and tried to force her to admit to her misdeeds. Of course she protested her innocence and tried to convince her old friend, and possibly lover according to some, that it was all just hearsay and that the girls who had died whilst in her care had done so from natural causes. Thurzó left and Elizabeth was safe for a little while longer.

But on 29 December 1610 it was all over for Countess Elizabeth Báthory. Thurzó's men entered the manor at Csejthe and arrested her before escorting her up to the castle. Then they began a search for bodies that were reportedly hidden in the castle – according to witnesses, a large number of which had gathered to watch the spectacle, bodies were quickly found, all of which had been badly injured. And then a survivor was found who named the servant Katalin when questioned over her injuries – she later named the countess herself. And then the questioning began, much of which has already been detailed. On the morning of 30 December, the countess was taken back up to the castle where she was imprisoned in the dungeons beneath. Her four accomplices were taken to Bytča where they were imprisoned and tortured – following this they were then called to testify as both defendants and witnesses against the countess. Two trials took place, both held at Bytča, in which the accomplices were questioned and numbers of murdered girls were given – the numbers were certainly high but nowhere in the hundreds that legend has come to be associated with her. The biggest estimate came from a young woman by the name of Szuzanna, who testified at the trial. The number she gave was eye wateringly high – she stated that 650 girls had lost their

lives at the hands of the countess and her accomplices, figures which had been dutifully recorded in Elizabeth's own hand. She said that the list had been seen by Steward Jakob Szulvassy who had found it in a box. But the document was never submitted as evidence, nor did the Steward ever make any mention of it when he was questioned. Did the document actually exist or was it a fabrication used to cement a guilty verdict against the countess?

This trial ended with Dorrotya, Illonya and Ficzo being found guilty of multiple murders. They were, as expected, sentenced to death. Dorrotya and Illonya were sentenced to die by being burned alive whereas Ficzo had his sentence commuted to beheading due to his youth. Only then would his corpse be burned. The three were led out to the place of execution that same day. Katalin, another accomplice, seems to have escaped execution – there is no mention of her fate, however.

Now it was time to decide what was going to happen to Countess Elizabeth Báthory. King Matyas had his official representative demand that she be physically brought in to be interrogated but Thurzó refused. He stated that such a thing would not happen as long as he was Palatine, and he would not put the rest of the family through such dishonour. The king and his court were not happy with this and continued to apply pressure on Thurzó to have her brought in and tried – she could not be convicted or even sentenced without input from the king *and* parliament, after all. Could it have been a guilty conscience on Thurzó's part? In a letter to his wife written after the event, Thurzó only mentions that Báthory's four accomplices were caught in the act. It must be noted that in this era, the nobility could certainly be held accountable for their servant's guilt. This meant that even if she wasn't caught in the act herself, she could be held guilty for their wrongdoings.

Whilst locked away in the castle, the Countess maintained her innocence and sent letters far and wide in an effort to clear her name – her main aim was to be able to testify in front of court, yet Thurzó repeatedly denied her requests. She also threatened to have family

members, in particular her cousin and the voivod of Transylvania, march on the castle to rescue her. Such threats came to nothing. Plots were also hatched to break her out, with the help of a small number of servants. Again, this came to nothing. But by this point Thurzó was on his last nerve – following the trial of her accomplices, he showed up at the castle where he confronted her and sentenced her using his own authority as Palatine of Hungary. His sentence? Lifelong imprisonment. He made it very clear that she would disappear from the world entirely, that she would be forgotten entirely. The king, unsurprisingly, was unhappy – he wanted Countess Báthory dead so he could get his hands on her property. So vexed was he that he ignored Thurzó's sentencing, demanding that Báthory be questioned by a special council. He only wanted one outcome – the death sentence. Things did not go his way however – questioning the countess would mean her torture. And torturing such a high-born noble would bring shame upon the ancient family. So her family members stepped in – her son, Pál, wrote directly to Thurzo and asked him to do all he could to stop the king from getting his way. He argued too that Thurzó had already done enough and so no further questioning was required. More importantly, the king would not get what he wanted as Elizabeth had already signed her property over to her children.

Pál's letter did the trick and Thurzó went back to the king, stating that he had come to the right sentencing and even had it confirmed by a separate judge. It was all above board and by the book and so the legal council called by the king wrote to the monarch and told him that nothing more could be gained from another trial and the best thing to do would be to sign off on Thurzó's sentence. In his ire he refused to do so, instead having a number of other witnesses called up with the aim of dirtying the countess's name even more. The only problem was that the witnesses started bringing up news about surrounding noble families as well as about Ferenc. Ferenc was a national war hero so the reality was that the king could not allow his name to be tarnished. So he called more witnesses to be on the safe side and these witnesses only corroborated the previous stories. Finally, the

king stepped back and agreed to Thurzó's demands, except there would be one extra caveat. Legally, Countess Elizabeth Báthory was to be wiped from history and it would be as if she had never existed – all documents mentioning her, including all trial documents, were to be sealed away. The king would also get a small portion of Báthory land, just as a little sweetener. And that was that, it was agreed. The King officially signed off the sentence of life imprisonment.

There she was kept, locked away in her room, for a further two and a half years before she finally breathed her last. On the night of 21 August 1614, she called out to her guards to point out how cold her hands were. She was told it was nothing and that she should simply lie down and go to sleep. Lay down she did and she quietly sang herself to sleep.

Countess Elizabeth Báthory did not wake up.

The current location of her remains is unknown. The story goes that despite being interred in the churchyard at Csejthe, the locals did not agree to her being laid to rest in holy ground and so her body was moved. It is said that she was moved to the Báthory family crypt at Nyírbátor, yet excavations showed no trace of her. The body of this most infamous lady has been speculated on for years and yet no solid proof of her whereabouts has ever been found. For all intents and purposes, she had disappeared from history, just as Thurzó and the king had wanted. What they didn't bank on, however, was that the legend of Countess Báthory would take hold of the public imagination for centuries to come – tales of mass murder, vampirism and witchcraft. True or not, she certainly became far more famous, or infamous, than her enemies ever wished for.

Chapter 7

Catherine the Great
1729–1796

The name Catherine the Great conjures up images of sexual scandal and salacious love affairs which often overshadow the good that she did for Russia. Her life has often been turned into television dramas that concentrate solely on her love life. What is the truth behind these rumours? How many lovers did she actually have? Did she really have sex with a horse? Or was it all just baseless rumour aimed at tarnishing the name of one of the greatest rulers Russia has ever known?

On 2 May 1729, the future Catherine the Great was born in the town of Stettin, in the kingdom of Prussia. She was born as Sophie August von Anhalt-Zerbst to parents Joanna Elizabeth of Holstein-Gottorp and Christian August, prince of Anhalt-Zerbst. Though a noble family and linked to the rulers of Germany, they were relatively poor. As was common at the time for noble families, the best way for a family to improve their financial position was to marry their daughters off to a man with both power and money. The higher he was on the social scale the better and Sophie's parents had their sights set high. Nothing less than a prince would do. The man chosen for Sophie was the future Peter III of Russia, her second cousin and Prince of Russia's ruling Romanov family. The young Sophie was a pretty little child with blonde hair and bright blue eyes, but her mother seemed to not exactly enjoy her company, at least not when she was very young. Instead, she was handed straight over to a wet nurse and placed under the supervision of Frau von Hodendorf. Hodendorf did not retain her position for long as she was prone to raising her voice.

Such treatment only made Sophie ignore any orders that were given unless it was repeated many times over. Her relationship with her mother seemed to get better as she grew older – her mother began taking Sophie on trips where she was introduced to the delight of visiting other royal courts where she was spoiled rotten. When Sophie was seven years old, she was taken to the court of Brunswick. It was somewhere that her mother would often spend a good many months as it was the home of the woman who brought her up. Sophie joined her mother on any trips from that moment on and it helped her learn all about the way such courts worked.

In 1744, Johanna received a letter inviting her and Sophie to the court of Russia to spend time at the court of the Empress Elizabeth in Moscow. This letter was a huge deal for both Johanna and Sophie – being invited to the court of Russia was a massive honour and it meant that the young Sophie would have attention on her. It was the perfect place to seek a marriage. Sophie was not told about the letter, but she managed to sneak a peek at it as her mother read it – Johanna seemed to struggle to come to terms with the idea that her daughter would be the centre of attention and so kept the news from Sophie. Sophie was far too clever and precocious, however, and confronted Johanna with the news that she knew all about the exciting letter and the wonderful opportunity that it offered to both of them and declared that the entire household knew about it. She also made the point that it was too good an opportunity to pass up. Johanna was taken aback by her daughter's insistence and told Sophie to ask her father if it was okay to make the trip – the easy way out, perhaps? He was not entirely convinced – Russia was dangerous, after all, and the religion of the country went against the Lutheranism that he and his family followed. But he could not deny that this was an excellent opportunity for his daughter to make a marriage that would raise her to the heights of the Imperial court.

The visit was a great success, despite being difficult at times. Sophie could not speak a word of Russian when she arrived so found adapting to life at court to be a tough adjustment to make. Those

first few weeks and months were also a trial period for the young woman – despite the fact that she had made a good first impression on the Empress and the Grand Duke, she had to make sure she was on top form to secure her marriage to the future Peter III. She made a great effort to learn the Russian language quickly and in her memoirs stated that she would even get up during the night to practice her vocabulary. She was sure to maintain her image even when laid up in bed with pleurisy and a high fever – when Johanna asked that a Lutheran priest be brought to her daughter's bedside, Sophie asked instead for a Russian Orthodox priest. Image was everything and she only had sight of the end goal. She passed the trial period with flying colours and she was given permission to write to her father to request his formal acceptance for her betrothal to the Grand Duke. Of course the issue of religion was a niggle with her father, but Sophie responded that she couldn't see any real difference between Lutheranism and Russian Orthodoxy so there would be no issue with her converting. The betrothal was agreed, and a grand ceremony was organised to make it all official, starting with her conversion to Russian Orthodoxy. It was organised for the Feast Day of St Peter and St Paul which also fell on the name day of the Grand Duke, and took place in the chapel of the Annenhof Summer Palace on the edge of Moscow. During the service Sophie officially converted and was given the name of Ekaterina (Catherine) Alekseyevna. The betrothal officially took place the following day at the Cathedral of the Assumption in the midst of Moscow, not far from the Kremlin. This Cathedral was very important to the ruling Romanov family, having been built by Ivan the Great in the 1470s, and it would go on to be very important in Catherine's life, and reign, in Russia. The procession began at the Empress's apartments at the Kremlin and they were met at the door of the Cathedral by the Archbishop who then led them to a raised dais in the centre of the Cathedral. Peter and Catherine bowed before the Empress and the Empress's decree was read out, proclaiming that the two would shortly be married. It also proclaimed that from that moment on Catherine would be known as

Grand Duchess of All Russia as well as Her Imperial Highness. Rings were then placed on the fingers of Peter and Catherine before a mass and service took place – four hours later the party moved back to the Empress's apartments where the young couple were congratulated and gifts exchanged. A ball was then thrown that evening in the throne room which lasted long into the night. The celebrations then finished up with a private supper.

The marriage took place on 21 August 1745 and was a grand occasion. Catherine was attired splendidly, her hair dressed and covered in jewels. The Empress placed the ducal crown upon her head and then told her that she could wear as many jewels as she liked, which must have been incredibly exciting for a young girl on her wedding day. Her gown was made of cloth of silver with a cloak of silver lace worn over it. The ceremony took place at the church of Our Lady of Kazan and was conducted by the Archbishop of Novgorod – it began with a mass and a prayer before the marriage ceremony itself began. Two crowns were held above the Grand Duke and Duchess's heads throughout the whole thing and the wedding rings were blessed first by the Archbishop and then the Empress, The couple then placed the wedding rings on the same finger as their engagement rings. Once the ceremony was over a sermon was preached and a Te Deum sang to celebrate the marriage of Peter and Catherine, the couple who would one day rule over all of Russia. It was another long ceremony and another long day, finished up with a sumptuous meal that involved lots of toasts to the happy couple and a lot of very drunk courtiers before the end of the second course! A short ball then followed which lasted for only about an hour and a half before the couple were escorted to their bedchamber. Catherine was prepared and then placed in the royal bed before being left all on her own for two hours before her new husband finally reappeared, The marriage however, was not consummated – Peter did not seem at all bothered about doing the deed.

Nor did he seem interested in spending much time with his new wife once the celebrations were over and it left a sour taste in Catherine's

mouth. He showed her barely any affection. In her memoirs, she mentions that in those early days she came to a stark realisation. 'I told myself that life with this man would certainly be very unhappy if I allowed myself tender feelings that were so ill repaid, and that to die of jealousy was of no benefit to anyone.'

Instead, in the days following her wedding, while her husband spent his time playing soldiers with his valets, she spent time with her mother who was preparing to leave Russia. Johanna took her leave on 28 September. But she left under a cloud having spent her time meddling in court goings on and taking part in a scandalous affair. She also left Catherine in charge of a significant debt, which Catherine would be paying back for many years to come. Johanna did not even say goodbye to her daughter. Perhaps this was due to the fact that she had always been emotionally distant from her or perhaps, which is what Catherine evidently believed and stated in her memoirs, she did so to make sure her daughter's grief was lessened.

Catherine's relationship with her husband only continued to deteriorate and in the run up to her and Peter taking the throne, Peter spent more time with his mistress rather than his ailing mother. Nor did he care for his young children. The fact that the two had children in the first place shows that they did eventually consummate their marriage – it took them five years to do so. While Peter had his mistress, Catherine began to seek out her own happiness in the arms of others and began an affair with Sergei Saltykov, her chamberlain. She was delighted by the attention that he showed her and his assurances of love. It was something she just didn't get from her husband. In 1754 Catherine gave birth to a son whom she named Paul. It has been argued by many both at the time and in the years since that the child may well have been the son of Saltykov rather than her husband. Was there any truth to this? We cannot know for sure but Catherine herself insisted, much later, that Paul was Saltykov's child. But she also showed considerable dislike towards the child as he grew. Could that insistence and her hatred towards the child stem from her wish that Paul was in fact the child of her lover? Could it be that she hated the boy for being Peter's son?

In fact, it was believed by many, Catherine included, that he would not be any good as a ruler once the Empress breathed her last. Even the Empress believed that Peter would be a poor ruler. Catherine began to study and work out just how things would go once the crown came her way. Even in these early days she began to note that it was time to get rid of serfdom. She already had good ideas, many of which she would try to bring in once she was empress in her own right.

Just as Catherine had come to loathe the sight of her husband, Peter hated Catherine just as much. For all his faults he wasn't exactly stupid. As Catherine took lovers and fell pregnant at one point he even stood up and screamed that he did not even know if the child was his.

On 23 December 1761, the Empress suffered a stroke. The outlook did not look good and she was taken to a bedroom in the Winter Palace. Catherine who was heavily pregnant at this time by another of her lovers, Grigory Orlov, was at her mother-in-law's bedside along with the Empress's own lover, Ivan Shuvalov. Peter was too busy drinking outside his mother's bedchamber to seem to care much about spending her last hours with her. She died at around 4pm on Christmas Day and it was announced that Peter was now known as Tsar Peter III. Of course Peter reacted with glee at his ascension rather than sadness at his mother's passing, gloating to all and sundry that he was the one at the top now.

It only took a matter of days for Peter to prove that he wasn't up to the task of ruling. First, he brokered a peace with Prussia, a country which had long been an enemy of Russia. But Peter hero-worshipped Frederick the Great, King of Prussia, so the anti-Russian standpoint mattered little to him. All the while he remained barely civil to his wife, somewhat childishly refusing to say her name. So much was his hatred of her that all he would call her was 'she'. His childishness only continued at his mother's funeral when he was openly drunk and allowed himself to fall behind the magnificent procession bearing her body, only to race his horse forward to catch up. Some of his early measures proved to be popular with the Russian people – for instance his reduction on the salt tax was looked upon very well. He also decided

to get rid of members of the nobility being forced into compulsory military service during times of peace. This was mostly seen as a positive move, though some started to worry that Peter was aiming to deprive the nobility of their place in society. But then his childishness once more reared its ugly head and he tried to order more and more measures that were distinctly anti-Russian. Not only that but he made it clear that he wanted to divorce Catherine and marry the Countess Vorontsova – is it any wonder that Catherine was so miserable?

Things started to heat up very quickly. After a banquet that ended in chaos and Peter demanding the arrest of his wife for daring to call herself a member of the Imperial family, a plot began to take shape. Peter mistakenly asked his adjutant to arrest his wife, but the adjutant was loyal to Catherine. He managed to convince Peter to cancel the order but sent a warning to Catherine. She and Orlov, along with a group of conspirators, decided that the best thing to do was arrest the Tsar as he left to go on holiday, and instal Catherine as Empress of all Russia. When a minor conspirator was arrested and forced to reveal the whole thing, the revolution was officially begun. Catherine was woken up when Orlov's brother burst into her bedroom on 28 June and told her it was time. She dressed quickly and was bundled into a carriage where they swiftly rode toward St. Petersburg. At the Winter Palace she was greeted by a group of senators who had gathered to issue and sign a manifesto that announced her as Catherine II. The support she had was insane – soldiers who had been forced to wear Prussian uniforms now gleefully changed back into Russian colours and cheered her. Catherine then ordered a march to Peterhof where they would arrest Peter III. Peter tried to escape on a galley that left during the dead of night but when the ship tried to dock three hours later at Kronstadt, it was realised that the whole thing was in vain. The arrival of the Emperor was announced but it was shot back that there was no longer an Emperor in Russia, only an Empress. When Peter heard them cry 'Long live Catherine II' he fell into a dead faint and realised it was useless, he would have to try to negotiate with his wife. In the end, though, he penned a letter of abdication.

Catherine received this letter, quickly scribbled in pencil, on 29 June when she and her troops arrived at Peterhof. Peter arrived there, escorted from his ship after having been refused entry into Kronstadt, around an hour later, He was then accompanied into a room at the Winter Palace by Alexei Orlov where he was made to give up his ribbon of St. Andrew as well as his uniform of the Tsar's Lifeguard's (Preobhazensky). Peter, no longer Emperor of Russia, was then taken to his estate at Ropsha and Catherine, now Empress Catherine II, made her return to Saint Petersburg. Husband and wife never saw one another again.

In fact, Peter would not live for much longer. Whilst at Ropsha he was under the care of Alexei Orlov, who was known by the terrifying nickname of 'Scarface', who terrified him – Orlov was an exceptionally heavy drinker who made no secret of his hatred for the ex-ruler and called him 'our ugly freak'. Yet Orlov ate meals with Peter and played cards with him and the other men stationed to keep their prisoner in check. Heavy drinking was not just a pastime for Orlov, however – Peter often enjoyed a drink (or three!) so it was only a matter of time until something went wrong. Orlov sent a note to Catherine on 2 July which by rights should have aroused some suspicion,

> We and the whole detachment are all well, only our Monster is gravely ill with an unexpected colic. I fear that he might die tonight, but more so I fear that he might live. The first fear is caused by the fact that he talks nonsense … and the second that he really is a danger to us all.

On 6 July Catherine received another note from Orlov that comes across as desperate, perhaps even fearful of the reaction he would get:

> Matushka, how can I tell you, how can I describe what has happened … We are finished if you do not pardon us, he is no more … at table he got into an argument

> [and a brawl with Baryatinsky, another of his jailers] and before we could separate them, he was no more. I don't remember what we did but all of us are guilty. Have mercy on me for my brother's sake.

Peter III was dead and Catherine was now free. But how could suspicion not lie on her after the deed was done? The two disliked each other immensely and she had overthrown him in a coup. Getting rid of him would only make her more secure. To make matters worse, she hid the letter from Orlov away in a cabinet for the rest of her life. The official cause of death given was haemorrhoidal colic which was, of course, absurd – especially given that his body was made up to lie in his coffin not looking as if he had been beaten black and blue.

Catherine was crowned as Empress of all Russia in the September of 1762 and shortly after her son, Paul, fell ill with a fever. He was the only strand that gave her any sort of legitimacy. She had no blood link to the throne of Russia – Paul was her heir so if he died, all could be lost. She was standing on a knife edge. Thankfully the child recovered and her position remained, for the most part, stable.

Catherine certainly did a lot of good for Russia during her reign but as with any woman who came into power, she found herself the victim of whispers and threats that turned into rumour. One of the first things that people think of when they hear her name is that she was a sexual deviant who had sex with a horse. But how true is this? We know that she had lovers and that she had children with them. Her greatest love was Grigory Potemkin, one of the brothers who helped her to overthrow her husband. The two exchanged a number of letters that all but shouted their love from the rooftops and though the flame of their relationship soon burned out they remained good friends and when he died in 1791, Catherine fell into a deep and desperate grief.

Over the course of her life, she had twelve lovers but why did she seek out such intimacy? She admitted once that 'my heart is loath to remain even one hour without love.' We know that her childhood was devoid of love and that her marriage was completely loveless, so is it

any wonder that she sought out the love she had so long been denied in the arms of others? As for the rumour of her death being caused by her having sex with a horse, there is no truth to this at all. Her death was caused by a stroke in 1796. So well-known were her sexual endeavours that it was remarked upon during her reign – her lovers had great political influence and were rewarded with high office. Frederick the Great of Prussia stated rather bluntly, 'In feminine government, the cunt has more influence than a firm policy guided by reason.'

The changes that she made during her reign were generally well received, although not all of what she proposed saw the light of day. Russia expanded its borders with her at the helm – she annexed the Crimea after Potemkin told her simply to imagine having it in her possession. It would, he said, bring her 'immortal glory' and make sure that Russia had dominance over the Black Sea. Not only did she ensure that Russia expanded its territory, but she also headed what can only be seen as a Renaissance. She was a huge collector of art, describing herself as a 'glutton' for it. Her collection is now housed in the Winter Palace where she spent much of her time, now available for public view. Not only was she a patron of the arts but she also spearheaded educational reform for women and girls. One of her biggest crowning achievements was the Smolny Institute for Noble Maidens, the first establishment of higher education for women in Russia. It opened on 16 May 1764 and accepted girls from the age of 6 – they had to be from noble, but not rich families, and would be students at the institute for twelve years. Getting into the institute was no mean feat and potential students had to pass tests in Russian and French. Once their long education had finished, the girls were guaranteed employment. Education was important to Catherine and many schools were founded during her reign. She certainly did a lot of good for Russia not only with her extensive art collection, educational reform and expansion of Russian borders. Early in her reign she extensively rewrote the legal system, calling it her Nakaz or 'Instruction' – it made clear that every man was equal before the

law, whether they be serf or noble, though it did not bring about any serious change. Still, her extensive work had the people discussing calling her 'Catherine the Great' for the first time – something that started to annoy her greatly. In her mind she did not deserve such a sobriquet.

Following Potemkin's death in October 1791, Catherine fell into a deep grief that affected her greatly. Not only had she lost a lover and a friend, but someone politically important. She knew she had to rebuild the group of men that she had around her and yet her head was not truly in the game. Her selective skills had started to decline, whether through her grief or her age is another question. Either way, those who she selected to help her started to take advantage in order to grow their power. Yet despite her advancing age, Catherine reported to many that she was in good health.

On 5 November 1796, Catherine got out of bed as she normally did and made her own coffee just as she did every morning. Her servant asked her how she slept and she replied that she had not slept as well as she usually did. When she did not emerge from the washroom for half an hour her servants wondered what had happened – perhaps she had slipped out to go for a walk? Yet they found none of her clothing missing that would suggest she had gone out. It was her valet, Zakhar Zotov, that found her collapsed on the bathroom floor and noted her struggling for breath and her face turning purple. She was taken to her bed and doctors were called – they immediately said that she had suffered from a stroke and that there was absolutely no hope of recovery. Her son, the Grand Duke Paul, was summoned to the Winter Palace – it was only a matter of time until he would be proclaimed Emperor, so he needed to be there. Meanwhile, Catherine had fallen into a deep coma and at dawn on 6 November, Paul summoned priests to the bedroom in order to administer the Last Rites to his mother. She died that same day, at quarter to ten in the evening. The funeral took place on 5 December – the coffin of Peter III had been brought from its resting place to lie alongside the coffin of his wife and together they were taken to the Cathedral of St Peter and Paul. There the two

bodies were left on public display for two weeks before being laid to rest. Despite the fact that they had despised one another and that Catherine had deposed Peter, they were laid to rest together – it was done entirely on purpose by the new emperor, to make out that they had ruled side by side in harmony.

With the death of Catherine the Great, the age of Russian Empresses came to an end. Paul, having found the note confirming that his father had been murdered, made sure that there could never be another ruler like his mother. Female rulers were banned – never mind that his mother had done so much good for the country. No woman, in his mind and indeed the minds of many, should ever hold such power. Since then the legend that Catherine was a depraved nymphomaniac has grown – the story that her death happened when a specially constructed machine was made so that she could have sex with a horse is particularly malicious. The legend goes that, rather than dying of a stroke, the machine broke and the horse fell on Catherine and crushed her. Much like other women throughout history, both with and without power, it is the bad that has attached itself to Catherine and the things that have made her 'Great' have been conveniently forgotten. People would rather read stories full of sex and scandal. Thankfully historians have begun to tell the real story of Catherine the Great, the story of both her faults and her favours. She may have had a number of lovers and been desperate to find the love that she had been so lacking since she was a child, but one thing is for sure; she helped to usher Russia into the modern age.

Chapter 8

Marie Antoinette
1755–1793
'Let Them Eat Cake'

On 16 October 1793, a woman ascended a scaffold that had been built in the Place de la Revolution – known today as the Place de la Concorde – in the middle of Paris. The scaffold was surrounded by people who were there for one reason only – to watch the former Queen of France lose her head. Nine months after the execution of her husband, King Louis XVI, Marie Antoinette was to fall victim to the French Revolution. She remained composed as she was taken, by cart, to the place of execution. That composure only wavered when she climbed the scaffold and accidentally stood on the executioner's foot. Her last words were reportedly an apology, 'Pardon me, Monsieur. I did not mean to do it.' By the time of her death, Marie Antoinette was truly hated by the people of France. Why was this, and did she deserve the hatred? This chapter will explore the life of Marie Antoinette, her mistakes and her spectacular downfall.

Marie Antoinette was born on 2 November 1755, to Empress Maria Theresa of Austria. The baby was Maria Theresa's fifteenth child. Until the time of the birth, Maria kept herself busy working on papers and signing decrees as well as getting a tooth that had been giving her grief removed. That done she settled herself in to give birth to a little girl at about 7.30pm. The child was baptised the next day as Maria Antonia Josephina Johannaa, but her mother called her Antoine both for simplicity's sake and to avoid confusion – all Grand Duchesses were named Maria so were oftentimes called by their second names.

The court chamberlain, Count Khevenhüller, described the happy occasion. 'Her Majesty has been happily delivered of a small but completely healthy Archduchess.' Once the birth was done with, Maria Theresa was sat back up in bed as soon as she could and was back at work.

Marie always held her childhood to be idyllic – she grew up surrounded by beauty, music and dancing and was encouraged to play with ordinary children. Duty and formality were still important but really only in public life. Personal time was to be enjoyed and the imperial children grew up surrounded by fun. Yet the young archduchess was still brought up to obey – as a young noblewoman she was little more than a pawn in a game of political chess. This little pawn would end up being moved into the path of one of the most important royal families in Europe – France. Her education concentrated more on how to conduct herself in public than any sort of traditional education. She particularly excelled in dance and was able to sight read music to an exceptionally high standard. Maria Teresa was a central figure in Marie Antoinette's young life, and the lives of her siblings. The future Queen of France would later go on to state, 'I love the Empress but I'm frightened of her, even at a distance; when I'm writing to her, I never feel completely at ease.'

The young 'Antoine', as Marie Antoinette was called as a child was a pretty little thing and her mother was generally pleased with her appearance. She did have slightly wonky teeth, however, and was treated with an early form of braces.

The young man chosen as a husband for Antoine was the Dauphin of France, Louis Auguste. He did not have the best start in life and had never been his parents' favourite – when his eldest brother died having suffered an incredibly long and drawn out death, life certainly did not get any better for the boy. He was moved into his brother's apartments at Versailles on the same day as his death, and his mother's grief left him was a massive inferiority complex. Louis Auguste was, from the moment he took his elder brother's place, told that he would never be as good. He was then thrust as close to the French

throne as was possible without actually being king, when his father died in 1761. The new Dauphin was far from princely, however, and certainly did not look the part. Like his father, Louis Auguste was overweight and he was also incredibly clumsy and very shy. Yet this did not matter – he was heir to the throne of France, and a dynastic marriage with Austria was needed. And so negotiations began to have the young Dauphin and Archduchess joined in matrimony.

Negotiations were complete by June 1769 and in the run up, Antoine had to go through a transformation. She would be moving to France and so would have to look as if she belonged. A hairdresser was called in from Paris to work on her hair and she was dressed in the latest French fashions. She also had to learn to speak the language which proved to be a bit more of a stumbling block – thankfully she had a good tutor who managed to win her over and help her at least get a good start in the language. At the time of negotiations, her spoken French was terrible and her written French even worse. Just a year later she had made great strides and her language would come on leaps and bounds once she actually arrived at the French court. She even had to be taught French history, some of which she took to with gusto. Still the young Austrian's apparent lack of education would be looked down on by her future courtiers. The preparations for the wedding were immense and the dowry was, customarily, particularly large at 200,000 florins. There was then the organisation of sorting out the journey. A massive amount of money was spent on this – over 400,000 livres was paid to make sure that the journey was particularly magnificent. But that would come later. In April 1770, the wedding between Antoine – who was to be known as Marie Antoinette from this point forward – and Louis Auguste was completed by proxy. Her stand in bridegroom was her older brother, the Archduke Ferdinand. In the ceremony he simply spoke a Latin vow and took part in the supper that followed. After this, the young Archduchess was now Dauphine of France and one of her first actions was to write a letter to her new grandfather, King Louis XV.

On the morning of 21 April, at 9am, Marie Antoinette left her childhood home forever. It was hoped that the early start would mean avoiding any unnecessary distress for the bride. Yet there were still tearful embraces and heartfelt goodbyes. Empress Maria Theresa hugged her daughter close and wished her safe travels, and then she broke down in tears. Antoine, dauphine of France, leaned out of the window as the carriage drove away and could not hold in her own heartbroken sobs. In that moment she left behind her life as Antoine forever. She was now a princess of France, who would one day be its queen. Her life was about to change forever.

Two and a half weeks later, Marie Antoinette was officially handed over into the custody of France. The handover took place on a little island in the middle of the Rhine river, right on the border between France and Austria. A structure was built on the island so that she would leave her homeland on one side and enter her new home on the other. Within the structure she was symbolically stripped of her clothing and given new clothes that were entirely French made. She was not allowed to retain anything of her old life. She was not even allowed to take any of her Austrian ladies in waiting with her and had to bid them a tearful farewell. Instead, she was presented with a number of French ladies who had been chosen for her by Louis XV. She was now French, through and through. It must have been a terrifying ordeal for one so young.

Emotion got the better of her as she stepped out on to French soil. She looked behind her in an effort to get one last look at the Austrian contingent but they had already disappeared from sight. She burst into tears and ran into the arms of the first lady she saw – the Comtesse de Noailles. Once the tears had passed, the very same Comtesse introduced her to the contingent who had come to welcome their new dauphine. They then began their journey to the capital with various stops where she was greeted by throngs of people. Eventually they arrived at the Château de Compiègne where they were met by the king, her new husband the dauphin and the entire court. The king and dauphin waited by the Berne bridge as the contingent

approached. The coach pulled to a stop and the dauphine got out – protocol demanded that she conduct herself properly but, caught in the moment, she rushed forward towards the king and threw herself into a deep curtsey. Louis, overwhelmed by her spontaneity and youthful behaviour, raised her to her feet and introduced her properly to her new husband. In portraits that had been shown to her, Louis Auguste had looked to be a handsome young man. But the reality was far different. Before her stood a portly 13-year-old boy who came across as rather intimidated and sulky. He did not even look at his wife properly, just gave her a brief kiss on the cheek. He would write in his diary later that evening that he had a 'meeting with Madame la Dauphine'. Such coolness surely did not bode well for their future relationship. Then came introductions to the rest of the family. Three of the elder princess aunts were there to meet her – Madame Adelaide, Madame Victoire and Madame Sophie. There was a fourth aunt, Madame Louise, but she had recently retired to a convent. Later at the Château de Compiègne, Marie Antoinette met even more of the family including the Princes and Princesses of the Blood who were all relatives of the king. These titles were a prized possession in the French Royal Court and were the top of the social hierarchy. There she was introduced to the Duc de Orléans, the Duc de Chartres and the Princesse de Lamballe. The next evening, at the Château la Muette, she also came face to face with the notorious Comtesse du Barry, mistress of the king. The rest of the surrounding court turned their noses up at her presence while the young dauphine, in her naivety, asked the Comtesse du Noilles who the woman was. The Comtesse told the young lady that she was there to please the king and Marie Antoinette smiled and said, 'Then I shall be her rival, because I too wish to give pleasure to the King'. Not exactly something to say in a court that was fuelled by gossip!

 The party then made their way to Versailles, which was to be Marie Antoinette's new home. The palace had been built by Louis XIV, the Sun King, and was a place of utter magnificence. Once she arrived, she was taken to her temporary apartments, watched by thousands of

spectators who thronged the windows of the surrounding buildings to see her arrival. There she was prepared for her wedding ceremony. She must have had stars in her eyes when she was presented with the dauphine's jewels worth a staggering 2,000 livres, as well as a necklace of pearls that was usually presented to queen consorts. This was Marie Antoinette's due as there was currently no living queen. She was then dressed in a gown of white brocade and the wedding took place. Just as he had been when he first met his bride, Louis Auguste was apprehensive at the ceremony and was seen to be nervous as he placed the wedding ring, already measured up for Marie Antoinette at the Château de Compiègne. The marriage contract was then signed by the entirety of the royal family, from the king down, but when the new dauphine went to sign her name the ink blotted over the first J in her full name – Marie Antoinette Joseph Jeanne – and the signature even sloped downwards. But despite this, the celebrations following the ceremony were magnificent even before the main event of the whole thing – the bedding ceremony. With this, whilst the couple were escorted to the marriage bed, their union was left unconsummated. At least that was what was whispered the following morning.

The couple's sex life was a source of constant study and speculation particularly from the point of view of a gossiping court. They watched with hawk like eyes as the young dauphin made his way to his wife's bed chamber, watchers who whispered openly their speculation over whether he would actually be able to consummate his marriage. Constant promises were made to Marie Antoinette but each promise was left unfulfilled and eventually Louis stopped visiting her bed, so humiliated was he over his failure. The Empress of Austria grew increasingly annoyed over the situation – an unconsummated marriage meant no heir. It also meant that the marriage could potentially be annulled. So the sooner the two could do the deed, the better. It was well known how shy the dauphin was – was it this that was affecting his ability to sleep with his wife, or was it something more? Indeed, he seemed unwilling to show his wife much in the way of affection, despite telling others that he found her delightful. It would take the

couple some years to consummate their marriage and the two would not have children until a while after they had become rulers of France. The deed was finally done by summer, 1773 – the dauphine wrote to her mother and jubilantly told her the news. The empress was told the news even before the king was, though the letter would certainly have arrived after the fact. The king, just like the empress, was overjoyed.

Louis XV died on 10 May 1774 following a bout of smallpox and ongoing ill health. The news was broken with a simple sign – a candle in the window of the King's room was extinguished. A throng of courtiers had been waiting around to see when the King would breathe his last and, all of a sudden, they rushed to the dauphine's apartments where the couple had been waiting. Presented with the news, the new king and queen of France fell to their knees and cried out, 'Dear God, help us and protect us. We are too young to reign.'. A huge number of the royal court then packed up and left Versailles due to the threat of being infected with smallpox, including the king and queen. For King Louis XVI, as he was now known, his Queen's safety was paramount. While the dead king was rushed to his resting place, sealed in a lead coffin, at the Cathedral of Saint Denis, the royal party made their way to the safety of the palace of Choisy. They stayed away from Versailles for six months, moving from Choisy to Marly and then Fontainebleau before returning to the main palace.

As queen, Marie Antoinette was supposed to be submissive to her husband. From her place at the top of the tree she was supposed to be all virtue, a beacon for other women to show them how to behave for their husbands. It was her job to provide heirs not to get herself involved with any sort of politics or meddle. She was, for all intents and purposes (just like women at the time generally), to be seen and not heard. Instead, the young queen was swept up in the grandeur of her new position. She spent a good amount of time using her position to live the life that she pleased, rather than acting as the perfect queen consort – the opera was one of her favourite past-times and she was often seen in the royal box. And then there was the fashion. Marie Antoinette is known today as a woman who loved fashion;

she dedicated herself to it and spent a ridiculous amount of money on clothes and jewellery – the yearly budget that she was supposed to stick to was 120,000 livres for clothes but she often overspent; in 1776 she spent 100,000 livres on accessories! She was also into gambling and spent evening after evening at the gambling table with her friends – Louis hated gambling and so the two began to spend more time apart. Whispers abounded that their marriage was heading for disaster, more so given that many of her gambling partners were handsome young men who were notorious womanisers. One of them, the Swedish count Axel Fersen, was even rumoured to be having an affair with the queen. When the King, in 1775, gave her the estate of the Petit Trianon on the edge of the sprawling Versailles estate, she began to retreat there and spent more time holed up in her little home than she did at the main palace. It became her escape and she built a tiny working hamlet there that included a working dairy farm, a number of cottages, a dovecote and more. The whole area was planted with stunning flowers and fruit trees. Unfortunately, her pet project began to turn the tide of public opinion. How could she spend all this money on a little hamlet and her own personal escape palace, when her subjects were suffering? It mattered little that she had worked closely to help after a nasty firework accident and had donated a large sum of money to help the families of the 130 victims.

In 1778, Marie Antoinette finally fell pregnant. This was the moment that she had been waiting for and both the king and her mother were overjoyed. Many in the court, however, whispered that the child could not be the king's and it had to be the progeny of one of her many supposed lovers. The rumours that stemmed from members of the court who were jealous they were not part of her circle didn't really matter at this point – what mattered was that she was pregnant with what the couple hoped would be the heir to the throne and that she had solidified her place as queen of France.

The birth of the child was, like everything at the French court, a huge public event. Nobles came from all around the country to stay at the palace for the long-awaited spectacle and on 19 December

1778, the show began for the spectators. Whilst the queen did not protest against giving birth in public, as she knew just how important it was for the birth of her child to be witnessed as legitimate, it must have been a humiliating experience. The child was, however, not the hoped for boy. When she was told that she had given birth to a daughter, Queen Marie Antoinette burst into tears. Straight after the new-born was carried off to be washed, the queen lost consciousness and had to be bled – her doctors were briefly worried for her life, but she soon rallied. The king only learned of what happened later, after he had been to a mass to celebrate the birth of his little girl. He rushed to her side and told her how overjoyed he was that they had a little daughter – the baby was then brought into the room to see her mother. She cooed over her child and stated that the child would be hers, rather than the belonging to the state as a boy would have. The little girl would be her favourite companion, almost a little doll. She was named Marie-Therese and given the title of Madame Royale.

Yet the birth of the new princess didn't please the French people. That became very clear when the king and queen attended a celebratory mass. It was, of course, a magnificent occasion with wine flowing from fountains and money doled out to the gathered crowds, but the Austrian queen was not warmly welcomed in the capital. The new parents did not seem to notice, they were so swept up in their happiness over the birth of their daughter. They were caught in a bubble and either did not know, or care, that their people were starting to turn on them.

Marie Antoinette's joy was not to last. Less than a year later, on 29 November 1780, her mother died. Her health had been declining for a while and she had been complaining of rheumatism. Her doctors also diagnosed her with 'hardening of the lungs'. She worked right up until her last moments and had been pressing her daughter on the need to provide France with a dauphin. The aging Empress pressed her daughter to share her husband's bed, after Marie Antoinette admitted that she and her husband had not had sexual relations in a while. She told her daughter that the German way of doing things

was much better and that the two of them should physically share a bed every night. It was Louis who found out first about the empress's death and he did not want to break the news to his wife so he asked the Abbé de Vermond, a churchman who was close to his wife to do it. Marie Antoinette was overcome with grief and in a rare show of support, Louis stayed by her side. Joy returned though when it was discovered that the queen was once again pregnant, in the early months of 1781.

Protocol was changed for the birth of her next child. Louis recalled the ordeal that she had gone through with the birth of Marie-Therese and so going forward, only the closest members of the family, the Lord Chancellor and a few of the queen's ladies were allowed in the room. Everyone else had to wait outside, offering the queen much more privacy than she had before. On 22 October she went into labour and within just an hour and a half, the child was born. It was whisked away to be washed without anyone even telling the queen of her baby's sex and it was only when Louis proudly said to her, 'Monsieur le Dauphin begs permission to enter,' that she learned the happy news. Finally she had given her husband and France, the longed for heir to the throne.

Following the birth of her son, the Queen of France was happy. It didn't matter, at least in that moment, that the people of France still laughed about her and her husband. But when people began to whisper that the dauphin wasn't the king's child, her happiness faded. Her reputation was sullied by these vicious rumours, and it did not recover even a little even following the investigation ordered by the king, that aimed to find out who started such vicious diatribes. All the while, Marie Antoinette kept trying to convince her husband to side with Austrian interests – it was something that she had done from her earliest days in France. Back then it was at the order of her mother. Now it was at the order of her brother, the Emperor. He was planning to invade and totally dismantle the Ottoman Empire with the Tsarina of Russia but Louis XVI and his advisors insisted on refusing the Emperor's request to remain neutral. Whilst there was the promise of

massive amounts of land in Egypt should Louis agree to work with Austria, France and the Ottoman Empire were long-time allies. The queen tried desperately to have her husband change his mind but to no avail.

When the queen once again found herself pregnant, whispers began again that the child could not be the king's. It was well known just how much she adored the handsome Count Axel Fersen of Sweden, just how much she was in love with him and wanted to be in his presence as much as possible, It is impossible to state with certainty whether or not Marie Antoinette and Fersen's love turned sexual but what matters here is that the people of France believed that the two were having an illicit affair right under the king's nose. It was noted, somewhat tellingly in the eyes of the court, that she fell pregnant just after Fersen had been at court for a visit. She gave birth to a second son on 27 March 1785 and, when she was churched in Paris just a short time later, she was greeted by a quiet and incredible icy atmosphere. The people remained silent as she passed, causing her to throw herself into the king's arms and beg to know what she had done to upset them so.

A number of supposed crimes began to rack up against the queen. To many it seemed rather suspicious that the king brought her the estate of Saint Cloud right at a time when she was once again pushing the Austrian interests on him. Parliament, in particular, turned their noses up at the property being acquired both for the queen and in her own name – they said it was unseemly for a queen to own her own palace. At this point though, the grumbling did not seem to bother her all that much. She was happy enough to have her little palace and demand that the court settle there on her whims. Soon things were to take a further turn. The queen loved jewels and often brought jewels behind her husband's back and often paid her jeweller, a man named Bohmer, out of her own pocket. In the run up to her thirtieth birthday, Bohmer paid a visit to the Queen to deliver a piece that she had brought as a present for her son. The jeweller made an offhand comment congratulating her about the new diamonds in her collection

and then left her a mysterious note. Her mind was elsewhere so she paid little attention to the comment but when she found the note which congratulated her on the purchase of a beautiful diamond necklace, she burned the note. Bohmer then commented to Madame Campan that he would be ruined if the Queen did not pay for the necklace – though confused and sure the Queen had not brought any personal jewellery from him lately, she allowed herself to be convinced by the tale that he spun. The story went that the Cardinal de Rohan had ended up buying the necklace on behalf of the Queen – bearing in mind that the necklace had already been turned down by the Queen, so why would she then go behind everyone's backs and buy it in secret? More importantly, why would she task someone who she so despised, to buy it for her? The two had butted heads in the past and she had not forgiven him for making unkind comments about her family. She was shocked when the story was repeated to her, not only by Madame Campan but by the jeweller himself, and the matter was reported to the King who ordered an investigation. It was discovered that Rohan had shown the jewellers a forged contract of sale agreement, signed by Marie Antoinette de France. This should have been the first clue that something was off. Queens only ever signed things using their first names. The jeweller, however, believed the forgery and believed that he had got rid of a necklace that he had been unable to sell up until that point. So off he went with the promise that the cost of the necklace would be paid in instalments. The investigation watched Rohan in particular, and Bohmer was told to carry on about his business as usual. On 15 August, Rohan found himself summoned in front of the king and his advisors where he was to answer for what he had done. He insisted before the king that he had acquired the necklace on the queen's orders and had the documents to prove it. She cried out that it was a forgery and the cardinal gave her a look so full of absolute disrespect that when he was taken from the room she burst into tears. The cardinal ended up being acquitted following an investigation but the people, of course, began to talk. In their eyes, the queen was the one who had

pushed for the cardinal's banishment and had been the power behind his downfall all along. All he had to do was spend one night in the Bastille. Others who had been involved in the ordeal were sentenced far more harshly. The Queen had indeed demanded that Rohan be found guilty and charged appropriately so when she found out he had been acquitted she again burst into tears. The king meted out his own punishment and demanded that Rohan relinquish his post of Grand Almoner and permanently exiled him from the court. Parliament was furious with this decision as the cardinal had been found not guilty – this was another thorn and they began to criticise the royal family more. Not only that, but the queen's image had been well and truly tarnished, and it was permanent. There was never any solid proof that she had done anything that she was accused of, nor that she had any role in the scandal. She had, unfortunately, years of frivolity and buying jewels in secret. In the minds of the people, this just proved to them that she was happy swindling the king out of money. All she cared about was her own happiness and the interests of her homeland, Austria.

By August 1788, the treasury was close to complete bankruptcy. Yet still the daily ceremonial events at Versailles did not cease. Expensive state visits still happened. The Third Estate – in other words, the rest of the population not in the Church or the aristocracy – was called in order to try to make sense of things, and the queen herself recalled Jacques Necker to court – it was believed he was the one man who could sort out the financial instability that was proving to be such a problem. Out in public, politics took a front seat for everyone and the idea of 'progress' was openly discussed. In April a riot broke out in the centre of Paris when workers rose up against wages being cut. It didn't help that, at the time of the riot, prices were rising massively. In the carnage, 300 people were killed. Following this, just six days later, the whole royal family went on a procession to Notre Dame. The queen, by this point so hated by the people, was greeted with silence. During the service it became astoundingly clear how much the royal family had gone down in the people's estimation. The bishop who

gave the sermon spoke openly about how the royals were living in opulence while the common people were suffering and struggling to eat. In fact, the people started to care less and less about the royal family or their problems. For instance, when the dauphin, Louis Joseph, died on 4 June 1789, the coffee houses of Paris were packed while political pamphlets were being issued not only in the streets but also in the Duc d'Orleans' gardens. They were in a delirium over the changes that they could see happening while the king and queen were mourning the death of their child. Even the Third Estate, the movers and shakers behind the changing political scenes in France, gave little thought to the passing of the dauphin. They even tried to visit the king on the day of his son's death. The court moved to Marley on 14 June 1789 for a week of official mourning. There the parents grieved the loss of their child while politics continued to shift.

Despite the fact that they were grieving, Marie Antoinette was still targeted by the people and the satirists that wanted to completely tarnish her name. They painted a story of a woman who would be happy to bathe in the blood of her people, so much did she hate the citizens of France. Graphic pornographic pamphlets were also published. Of course she must have been aware that such vile things were being written and spread around about her and it must have knocked her confidence. At one stage in her life she was the darling of France and now she was hated.

Revolution was just a short jaunt away. On 9 July a Constituent National Assembly was formed, and this group gave themselves the power to make and pass laws. The people's disdain of the royal family only grew when the king made the move to dismiss Necker who had been incredibly popular with the citizens. When the news broke that Necker had been removed, riots broke out. On 13 July things turned violent when the Royal German troops were mobbed and pelted with stones – the troops, led by the Prince de Lambesc responded and it was said that he and his troops cut down both rioters and the innocent alike. While in private the queen sided with him, she could not speak out publicly as she believed it would only show

that she believed that he was guilty. Perhaps she was right, but either way it cemented in the minds of the people that the Royals were okay with their troops assaulting them. It was just another nail in the coffin. The very next day would be a day that would go down in history. Incensed by the violence caused by Lambesc and his troops, a crowd of citizens stormed the fortress of the Bastille in order to take possession of the weapons that were stored there, so they could protect themselves against royal troops The Bastille was famed as a prison which held some of the most well-known prisoners in French history – including the infamous Marquis de Sade. A number of people were killed during the assault including the governor of the prison as well as other officials and staff members. Morbidly, their heads were severed and paraded through the streets following the fall of the fortress. The king and queen spent the day in total ignorance of what was happening and the king was only informed that night, when he was tucked up safely in bed. He asked, when the news was broken, whether it was simply just a revolt. The reply was telling, 'No, Sire. It is a revolution'

As the unrest grew, many members of the nobility started to flee the country. These included the Comte d'Artois who would later become King Charles X, and members of the Polignac family. Meanwhile the citizens formed a militia using the tricolour as its badge. This tricolour would go on to become the symbol of both revolutions in France.

At 10 o'clock in the morning on 1 October 1789, a number of market women marched on Versailles. Their aim was to demand that the king and queen give them grain to help assuage the hunger of the people as well as force them to agree to a number of changes that the National Assembly had put forward. As the invasion approached it was argued that Marie Antoinette and the children should be spirited away from the palace for their safety, but the queen refused. The first group of women reached Versailles at around 4 in the afternoon and by around 6pm they had all congregated before the palace. The king allowed one woman inside – during their talk, he offered to open up two

grain stores and she demanded that agreement in writing. Despite this the women were restless and among them were a number who were armed, shouting threats against the queen in particular. They attacked at around 4 in the morning, many with the aim of assassinating their queen. She escaped her chambers through a secret door and into the king's bedroom. A royal appearance was then demanded so that the attackers could see that the royals had not been killed. They were then transported to Paris, their carriage surrounded by a raging mob. It must have been a terrifying experience. It would be the last time that either the king or queen would see Versailles.

From that point on, they were prisoners. They were taken to the palace of the Tuileries which had been left to fall into a state of disrepair – it was only used occasionally if the queen was visiting the capital, but even then only for flying visits. Now it was dark and depressing, covered in dust and cobwebs with a general air of being run down. It was a far cry from the splendour of Versailles. From there an escape was planned and on Tuesday, 21 June 1791, it was discovered that the sovereign and his wife was missing. They had escaped under the cover of darkness with the help of the queen's beloved Count Fersen. But they did not make it far – they were stopped at Varennes after almost a day of travelling. When they returned to Paris they were greeted with silence. Orders had been given that the king was not to be shown respect and that anyone applauding the king and his wife would be flogged. They were returned to the Tuileries. They were all now prisoners in every sense of the word, albeit in a somewhat gilded cage.

On 14 September, Louis XVI officially accepted the new constitution of France, becoming a constitutional monarch and thus little more than a figurehead and even then, a figurehead that no one really wanted. He had powers but they were exceptionally limited. But even these limited powers were too much for some. From the Tuileries, the queen began to try other ways to save her family and began to send letters to her brother, the emperor, asking for Austria to step in. Nothing came of it, however, and the royals were on track

to destruction. The revolutionaries were by now calling for the fall of the monarchy.

On 10 August 1792 more violence broke out. The Tuileries palace was stormed by armed revolutionaries. The decision was made that the king and queen should take shelter with their enemy, the National Assembly. At that point it seemed to be the lesser of two evils. While the family were offered asylum, battle raged at the Tuileries. Many who had been left behind were slaughtered. As this was going on, new accommodation was given to the royal family. That first night they were housed in the convent of Feuillants. They were then moved to the Temple. This, or at least part of it, had once been home to the Prince de Conde, while there was another part that the queen in particular feared. Part of it was made up of a large medieval tower which had once made up part of the Templar structure that had previously been there

Life wasn't easy in the Temple for the family, yet things would only get worse in the months and years to come. They were, for want of a better word, prisoners and security was tight. The women also had none of their usual royal attendants, instead they were provided with local women to do the job of looking after them. And these women were disliked by Marie Antoinette and her daughters, especially bearing in mind that their usual attendants were taken for interrogation. One of these, the Princess de Lamballe, was taken and locked in the La Force prison and she unfortunately lost her life during massive riots on 2 September – prisons across the cities were ransacked and the people held within slaughtered. The princess was dragged from her cell and taken before a tribunal where she refused to denounce the king and queen. Her fate was gruesome – taken into the courtyard of the prison she was attacked with a hammer. The stories about her fate are particularly morbid – it is said that she was raped both while she was alive and dead, her breasts cut off and her heart removed, cooked and eaten. These rumours spread like wildfire but what we do know for certain is that she was beheaded. Her head was then placed on the end of a pike while her body, its viscera having

been removed, was placed on another and then both body parts were paraded through the streets. They were taken to the Temple then and the princess's head was paraded by the window of the dining room. The queen, thankfully, did not see this but her women did. But when she found out about her dear friend's fate she was in shock, frozen in terror before fainting. Those who brought the head to the Temple clearly wished to do the same to Marie Antoinette, but the governor of the Temple put a stop to it.

Shortly after this violence, the monarchy of France was officially abolished. On 21 September they heard the proclamations from outside their windows. It soon became clear that they wouldn't stop at simply the abolition of the monarchy. On 11 December, a number of soldiers arrived at the Temple and took the king into custody – except they named him 'Louis Capet'. Taken before the Convention where he was formally accused of treason, he was then subject to a trial. He was found guilty, but no one could agree on his punishment. Arguments were made for banishment or confinement but on 16 January 1793 the sentence of death was passed, though only by a very small majority. The king was advised of his fate on 20 January that he would be put to death the following day. That evening, Marie Antoinette was allowed to see her husband for the final time along with her children. When he told her that he would be guillotined the following day, she and the children threw themselves into his arms with sobs of complete anguish. Louis promised his wife that he would see her the following morning in order to say his goodbyes – but his visit never came. He wished to spare her the heartache. Instead, he had a servant take her a message of farewell, along with a lock of his hair.

On 21 January, at just gone nine o clock in the morning, King Louis XVI of France ascended the scaffold that had been erected in the Place de la Revolution. At 10.22 that morning, just after breakfast, the family were greeted with drumrolls that told them the deed had been done. The one-time King of France was no more, his head having been separated from his body by guillotine. The guillotine

was a device that has come to almost be the poster child of the French Revolution, probably more so than even the tricolour badge. Not surprisingly, following the death of her husband, Marie Antoinette fell into a depression. She refused to eat or to go outside and suffered from frequent ill health. She became old before her time, looking far older than her 37 years.

Her own fate was practically a foregone conclusion at this point. She hoped that her family would step in and save her but in truth they cared little for her plight. As time passed, those who headed the revolutionaries became more and more outspoken – Maximillian Robespierre was the most vocal, crying out that one tyrant had been overthrown and it was time for another. In August 1793, Marie Antoinette – or the Widow Capet as she had come to be known since the overthrow of the monarchy and the death of her husband – was taken from the Temple to the prison of the Conciergerie. There she would be locked up while awaiting trial and her inevitable execution. There she was forbidden from leaving her tiny cell, although other prisoners were allowed to take exercise in the small courtyard. She was also watched day and night by two guards who were stationed in her cell, separated only by a screen for her privacy.

Her trial began on 14 October 1793, and she was questioned intently by the Convention, her supposed crimes fired at her one after another. She held herself well against these accusations yet in the end it was all for naught. In essence it was little more than a kangaroo court. She was accused of bleeding the nation's coffers dry for clothes and jewellery and the diamond necklace affair was, of course, brought up. One particularly heinous accusation was that she had sexually abused her son. She argued each and every accusation well, holding herself with complete and utter dignity. But whereas her husband's fate was in the air, her own was written in stone. She was accused of high treason and would be executed, publicly, by guillotine.

Her death came on 16 October. Her hair was cropped completely and she wore white, carried to the place of execution on the back of a wooden cart. The people turned out in their thousands, jeering

at the woman who had once ruled over them as she was driven by. Yet she held her head high and remained calm. Her composure only broke when she accidentally stood on a guard's foot. A priest on the scaffold urged that she hold herself with courage and she dismissed him, saying that it took far more courage to live than to die. She then lay down and was strapped in, her life taken in a swift swish of the blade. She was buried that very same day in the tiny cemetery of Madeleine, thrown alongside the bones of her husband. It was only later that the bodies of the king and queen were exhumed and moved to the cathedral at Saint Denis.

During her life Marie Antoinette went from loved to hated. When she first came to France she was seen as the future of the country but soon the people turned on her. She was a foreigner who cared nothing for the plight of the French people, or so it seemed. She squandered money and committed adultery without a thought. At least that was what was thought of her. She became a legendary villain to many, the worst of the worst who deserved to be put to death for keeping the people of France from their freedom. But in reality, she was little more than a victim of circumstance, a woman who had a tragic life in many ways despite living in all the pomp and circumstance of Europe's richest court. The black myth of Marie Antoinette has since become a martyr who inspires compassion. Today we seek to understand her life and legend, to dig through the dark legend of the frivolous princess who cared only for jewels, fashion and lovers, and she has become the heroine of films and novels alike. Visitors flock to Versailles to see her bedroom and the conciergerie where she was held in her last days, in order to be close to a woman, a queen, who was put to death by her own people.

Chapter 9

Lizzie Borden
1860–1927

> 'Lizzie Borden took an axe
> And gave her mother forty whacks
> And when she saw what she had done
> She gave her father forty-one'

On August 4, 1892, the small town of Fall River in Massachusetts was rocked by a gruesome discovery that would end up turning into one of the greatest true crime mysteries in American history. When Lizzie Borden returned home, she discovered the body of her father. Andrew Borden, who was lying dead on the sofa with his face and head covered in axe wounds. When she had left, just a short period beforehand to visit the barn, he had been asleep on that same sofa. Shocked at the scene, she stumbled to the stairs and cried out for the maid to come down as someone had murdered her father. The maid ran across the road to fetch the doctor and when she returned, without the doctor as he was out on house calls, she found Lizzie standing in the doorway of the kitchen in a trance – Lizzie sent the maid to fetch her friend Alice, saying that she couldn't be alone. Of course she couldn't – she had just discovered her father had been murdered. As the maid, who had changed into a fresh dress, ran out to fetch Alice, a widow from across the street, Mrs Churchill, noticed Lizzie standing by the screen door and called out to see if everything was okay. Lizzie called out to the widow 'Oh Addie, do come over; somebody has killed father.' Mrs Churchill rushed on over and asked Lizzie about what had happened and where her

stepmother was – according to Lizzie, her stepmother had gone out to see someone who was unwell.

The police were called and a local painter was stationed by the kitchen door with direct orders not to let anyone in except for policemen. Doctor Bowen, who the maid had tried to get earlier on, finally arrived between 11.15 and 11.30am and he set about examining the body which he described:

> The blows extended from the eye and nose around the ear. In that small span there were 11 distinct cuts of about the same depth…one of them had severed the eyeball and socket. I could not inflict upon a dead dog the additional blows that were driven in Andrew Borden's head.

The doctor then went off to send a telegraph to Lizzie's sister, Emma, who was out of town visiting friends. By the time he returned, a second body had been found. Mrs Churchill and Bridget Sullivan, the maid, had discovered the corpse of Abby Borden laying on the floor of the guest room. Somewhat strangely it had been Lizzie who had directed them to go upstairs looking for her, saying that she could have sworn she heard her stepmother come in and go upstairs.ABBY, like her husband, was covered in axe wounds and again Doctor Bowen examined the body. 'There was a large pool of blood under the dead woman's head as she lay face downward … her head had been literally hacked to pieces … One glancing blow cut off nearly two square inches of flesh from the side of her head.'

Both victims showed no sign of a struggle and with Andrew, in particular, it looked as if he hadn't moved from the position in which he was sleeping. The doctor came to the conclusion that both victims died almost instantaneously. Suspicion did not immediately fall on to Lizzie, the poor shocked young woman who had found the body of her father. There were other people staying in the house at the time of the two gruesome murders, four of whom were already accounted for with two of them already dead, so they all had to be considered.

One acted the most strangely out of all of them. His name was John Morse who was Andrew's brother-in-law – he had arrived from out of town the day before without any prior warning and with no luggage. On the day of the murders, he had spent most of the morning visiting a niece who lived close by and then returned, apparently to accept a dinner invitation from Andrew. Yet as he arrived, having stopped to eat a couple of pears on the way, he had apparently not noticed the growing crowd outside the Borden residence.

If that didn't seem suspicious, then what did? And more importantly how did the now orphaned Lizzie Borden come to be accused of the murder of her parents? In the years since the vicious murders, children have repeated the same rhyme about Lizzie, whilst on the playground. Everyone associates her name with that of a murderess who got away, literally, with the crime of which she was accused.

But was she guilty? The jury who tried her certainly didn't think so and she was acquitted. Yet there are those out there today who still believe wholeheartedly that she was guilty, with even paranormal investigators visiting her home to 'ask' her spirit why she murdered her father and stepmother. One particularly popular ghost hunting show states that they uncovered the truth during their investigation with a damning electronic voice recording. Of course, one must be careful with such evidence as paranormal events can usually be explained with science. The question is then usually asked – if Lizzie Borden didn't kill her parents, then who did? Media spin and bias towards a young woman acting out of sorts cemented the so-called truth in the minds of many both at the time, and beyond.

Innocent or guilty, the name of Lizzie Borden has gone down in history as part of an incredibly brutal murder – the story has been told time and again in novels and visual media. Here we will look at the circumstances surrounding the murder and what happened during the trial that ended with her acquittal. More importantly we will look at who, if not Lizzie, may have committed such a heinous crime and investigate whether or not Lizzie Borden deserves to be labelled as a murderess.

Lizzie wasn't thought of as a suspect to start with. Rather it was assumed and even reported by the local paper that the most likely perpetrator was a foreigner. The *Fall River Herald* pointed the finger at a Portuguese labourer who had gone to the Borden home earlier that day in order to ask for the wages that were due to him. They speculated that when Andrew Borden told the labourer that he had no money and to come back later, the man murdered him. They also speculated that the medical evidence suggested that Abby Borden in particular was murdered by 'a tall man, who struck the woman from behind.' The Portuguese man was arrested and questioned – not particularly surprising given the xenophobia that was rampant in 1892, not just in Fall River. It should be noted that there were also a number of Irish immigrants in the town which were looked down on. One of them, a doctor, lived practically next door to the Borden house. Yet Lizzie opted to ask the maid to go and fetch Doctor Bowen instead. No one, let alone the media, could imagine that a woman would commit such a vile and unspeakable act, even less so a woman who taught Sunday school.

But suspicion soon shifted. Just a few days later it was discovered by police that Lizzie had been shopping in S.R. Smith's drug store in Fall River. A sales clerk, named Eli Bence, told the police that she had been in the store the day before the murder was committed. More suspiciously she had attempted to buy the deadly poison prussic acid. Suspicion only grew as during questioning it seemed that Lizzie knew so little of her stepmother's whereabouts after 9am when she had already stated the woman had gone upstairs to deal with household issues. And then there was the even stranger assertion that during the time of her father's murder she had been in the family barn out in the back yard looking for 'irons'. She had stated that she had looked for these irons, to take on an upcoming fishing trip, in the upper floor of the barn. The police followed up – no footprints were found in the dusty loft and the heat in there was so bad that they concluded it would be nigh on impossible for anyone to spend long up there. As suspicion grew, the media started changing their tune. They reported

that a leading physician explained that the perpetrator could not have been a tall man as 'hacking is almost a positive sign of a deed by a woman who is unconscious of what she is doing'.

The double funeral of Andrew and Abby Borden took place on Saturday, 6 August and was held in the very room where Andrew had been found hacked to death. Seventy-five people were present for the funeral inside the house but of course, interest in the case was rife. Thousands flocked to the house and waited outside, hoping to catch a glimpse of the funeral cortege. Following the funeral service, which omitted any sort of eulogy (Andrew seems to have been universally disliked), the mourners accompanied the coffins to Oak Grove Cemetery. It was there that the Borden family plot was located, but the deceased would not be interred. At the orders of the Medical Examiner they were placed in a receiving vault to await further investigation. Following the funeral, the police continued to investigate the house – previous searches had found little. They searched everywhere with the total cooperation of Lizzie and her sister, Emma. The girls' closet was searched and their dresses looked at closely for any sort of blood stains. Every single dress was looked at and nothing was found. Nothing was found that day and so the search continued on Monday – previously a handle-less hatchet had been discovered in the basement, in a box on the top of a shelf. When it was first discovered it was put back and promptly forgotten about. It was rediscovered on the Monday and promptly sent to the police station. Nothing further was discovered.

Other blades had previously been found. During the initial search of the house on the day of the murders, the police found a blade in the cellar that was covered in blood with clumps of hair stuck to it. As well as this a bucket of bloody rags was discovered – the maid, Maggie, who had taken the police down to the basement seemed surprised to see it and said she had never seen it before. When Lizzie was questioned about the bucket, Dr Bowen answered and told them what the bucket was used for. Though no explicit reason was given it has since been argued that there were sanitary rags being cleaned as Lizzie was currently having her period.

By that point, however, the police had firmly settled on Lizzie as their main suspect. During questioning she had appeared to be far too calm for someone who had just discovered her father and step mother murdered, nor did they believe the story that she had told them about Abby getting a note that morning to go out and visit a sick friend on the morning of the murders. Investigation into that came to nothing – no one they spoke to had sent a note, and the note itself was never found. And then there was the prussic acid. In their minds it all added up. It had to have been Lizzie Borden who committed the deed. Other suspects had been investigated but ruled out.

An inquest into the deaths was begun on August 10 with involvement from the Massachusetts district attorney, Hosea Knowlton. As the D.A travelled to Fall River, Police Captain Hilliard requested an arrest warrant for Lizzie. He received it but kept it secret, though it wasn't long before Lizzie found out that she was the prime suspect, and she requested for her lawyer to be present at the inquest. The request was denied. Unfortunately, Lizzie's full testimony has been lost though excerpts and transcripts were published in local papers, the largest transcript being in the *New Bedford Evening Standard*. This is, however, not the official court transcript, but it is the closest thing we have to what Lizzie actually said during the inquest process. During the inquest, other suspects were questioned and it was here that Andrew's brother-in-law, John Moore, cleared himself of any wrong doing. Lizzie herself testified for three days, during which the question of money was often brought up. She was asked if she knew about her father drawing up a will to which she answered, 'No, sir. I heard somebody say that there was one several years ago; that is all I ever heard.' When asked who had made the comment she answered simply 'I think it was Mr. Moore.' Money seemed to be the main source of questioning, from Andrew's will to how much property he owned – the prosecution were evidently trying to build the case against Lizzie and show that money was the reasoning behind the murders.

Lizzie's story seemed to change a lot during the questioning to the point where she became confused and flustered, When questioned

about where she was when her father came home, she said that she had been upstairs, despite telling many others that she had been downstairs.

> Q: Then you were upstairs when your father came to the house on his return?
> A: I think I was
> Q: How long had you been there?
> A: I had only been upstairs just long enough to take the clothes up and baste the little loop on the sleeve. I don't think I had been up there over five minutes
> Q: Was Maggie still engaged in washing windows when your father got back?
> A: I don't know
> Q: You remember, Miss Borden. I will call your attention to it so as to see if I have any misunderstanding, not for the purpose of confusing you: you remember that you told me several times that you were downstairs, and not upstairs when your father came home? You have forgotten, perhaps?
> A: I don't know what I have said. I have answered so many questions and I am so confused I don't know one thing from another. I am telling you just as nearly as I know.

Was this confusion a sign that she was guilty and getting her lies mixed up, or a sign that she was innocent and struggling to handle the stress of being on the stand without a lawyer? The prosecution clearly thought it was the former.

Once the inquest was over, Captain Hilliard informed the district attorney, once they had agreed that Lizzie was to be arrested, that he already had an arrest warrant for the young woman. Knowlton had Hilliard return the arrest warrant and had a new one issued – it would look bad and could easily create a legal issue if it was found

out that one had previously been issued. Lizzie's lawyer, Andrew Jennings, was handed a copy of the warrant and joined both Hilliard and Knowlton as they returned to the courtyard where they publicly served Lizzie with the warrant and had her arrested for the murders of her father and stepmother.

There are conflicting accounts to how Lizzie reacted to being arrested. Some reports say that she reacted with the same calm that she had done after finding her father's body. Others say that she fell into a fit of terror. Either way she was arrested and charged with the murders. The next day, accompanied by her lawyer, she appeared in court before Judge Blaisdell where she entered a plea of 'not guilty'. A preliminary hearing was scheduled for 22 August and Blaisdell would preside. Lizzie's lawyer objected to this as Blaisdell had been involved heavily in the inquest. He was, the lawyer said, 'acting in a double capacity and therefore … cannot be unbiased. This takes away from my client her constitutional right to be heard before a court of unprejudiced opinion.' The objection was overruled and Lizzie was taken by train to the Bristol County Jail in Taunton, just to the north of Fall River.

Lizzie found herself confined to a small jail cell with just a bed, chair and washstand. She was allowed some books and the cell was furnished with Charles Dickens novels as well as religious works. During her ten-month stay at the jail – originally she was only supposed to be held there until after her preliminary trial – she requested that she not be given the daily newspapers to read. She was accorded some special privileges while she was held in custody at the jail in Taunton, including special meals that were ordered in from a local hotel. This was probably because, as a child, she had spent time at the house of the man who looked after the jail. He and his wife had lived in Fall River and Lizzie had been known to go to their home and play with their daughter. Perhaps most surprising is the general reaction to Lizzie's arrest – many in Fall River were incredibly relieved and felt safer knowing that the vile deed had been committed by someone they knew rather than a homicidal stranger. Many locals called for

her conviction and demanded she be sentenced to death. There were of course some who believed she was innocent, but for now it seemed as if most believed she was behind bars where she belonged.

At Lizzie's preliminary hearing, Judge Blaisdell pronounced her probable guilt. The case, as per Massachusetts law was then transferred to a jury who had to decide whether there was enough evidence to bring her to trial. The grand jury came to the decision to issue an indictment – this was after initially refusing to indict Lizzie and then hearing further evidence from Alice Russell, a friend who had stayed with Lizzie and Emma following the murders. She told the grand jury that she had witnessed Lizzie burning a blue dress in the kitchen fireplace which convinced the jury.

The trial of Lizzie Andrew Borden began on 5 June 1893 at the New Bedford Courthouse just ten miles east of Fall River. The trial was so sensational that newspapers up and down the country had reporters stationed at the courthouse, jostling to be the first to report on the outcome. Lizzie's defence team was a powerful one and included the former governor of Massachusetts, Andrew Jennings. While he did not have much experience in a court of law and in cross examination, he was down to earth and affable. It made the jury feel at ease. The prosecution was made up of District Attorney Knowlton and Thomas Moody, District Attorney of Essex County. Moody would go on to have a prestigious career, rising to become an Associate Justice at the supreme court of the United States.

The jury was made up of twelve men with a realtor named Charles Richardson, aged 54, as foreman. The trial itself lasted two weeks, during which a number of witnesses were called in which they testified on what had happened during the morning of the murders. Much was made over Bridget 'Maggie' Sullivan's testimony. Sullivan claimed that Lizzie had been the only person she had seen in the house on the morning of the murders but also admitted that she had never witnessed any bad blood between Lizzie and her stepmother. Everything was, according to Sullivan, 'pleasant'. When Dr Bowen was questioned, he stated that the morphine he had prescribed to calm

Lizzie's nerves had probably caused her confusion during the inquest. Others testified that Lizzie had been seen wearing a blue dress though no blood had been seen. Lizzie's friend Alice Russell (soon to be ex-friend, considering that Alice's evidence about the blue dress had led to the indictment) also testified. She told the court that Lizzie had stated that she 'wanted to go to sleep with one eye half open for fear somebody … might hurt her father because he was so discourteous to people.' Attention then turned to the dress burning incident – on cross examination the point was made that a guilty person would be unlikely to burn evidence so openly. The note that Abby Borden had allegedly received was also brought up. Alice told the court that she had sarcastically said to Lizzie that, as the note had been unable to be found, Abby must have burned it. She then said that Lizzie had agreed that this must have been the case.

The theme of the dress came up multiple times throughout the trial. The main question was – if Lizzie did murder her parents, how was it that her dress (and her whole self) was not splattered with blood? It was generally agreed that on the morning of the murders, Lizzie was wearing a blue dress, though many could not describe it in much detail. Dr Bowen said, 'it was an ordinary, unattractive, common dress that I did not notice specially.' Maggie Sullivan mentioned that Lizzie changed into a blue dress with white embroidery. When Adelaide Churchill, the neighbour that Lizzie had called over once she had found her father's body, was shown a dark blue dress by the prosecution. She denied that it was the one Lizzie had been wearing but rather a light blue dress with a navy diamond figure on it. She was very clear that there was no blood to be seen on the dress. When Alice Russell took the stand, she repeated the story of Lizzie burning her dress as it was covered in paint. Emma Borden, Lizzie's sister, was also questioned on the burning incident. She made it very clear that burning the dress had been her idea, 'I saw it hanging in the clothes press over the front entry. I said, "You have not destroyed that old dress yet; why don't you?"'

The murder weapon was supposed to be the handle-less hatchet that had been found in the basement of the house, During questioning,

all of the police officers who had looked at the weapon said that it was covered in ashes and that there was a break on the handle that looked fresh. The break, however, could not be dated. The line of questioning on the weapon seemed to be going well for the prosecution – everything seemed to be lining up with the break and the ashes covering the blade. But then Officer Mullaney was questioned, who had been with Officer Fleet when he found the weapon. Mullaney mentioned that parts of the handle had been found in the box with the hatchet. According to Mullaney, Fleet removed the pieces. When recalled to the stand, Fleet denied any and all knowledge of these pieces.

Other lines of questioning involved whether or not an intruder could have accessed the house and committed the murders. The locks on the front door were found to be defective – whilst the bolt and mortise locks on the front door were used only at night, they were unlocked every morning by either of the Borden sisters. The spring lock, however, often wouldn't catch unless the door was slammed. However, Maggie Sullivan, when questioned, told the jury that on the morning of the murders all three locks had been in place until Andrew Borden returned home at around 10.45am. He hadn't been able to get in and had called for Maggie to open the door. The kitchen door, however, was easily accessible. The screen door there was fastened with just a simple hook – and in the run up to the murders it had been left entirely unhooked.

Other evidence brought up included the contents of both Andrew and Abby's stomachs – used to 'prove' that Abby was killed first. Dr Dolan had examined the bodies and found that there was undigested food in Abby's upper intestine, whereas Andrew had no undigested food still in his system. There was also the difference in temperature between the two bodies. According to Dolan, Abby was colder, 'I felt the body with my hand and it was much colder than that of Mr Borden.' Of course, the defence tore into Dr Dolan for this – they turned his digestion argument around completely. The Bordens had been suffering stomach upsets the night before, and upon questioning

Dolan admitted that such an illness could indeed affect digestion. Professor Wood was also questioned on the same subject and also admitted that a stomach upset could affect such things. Despite this it was still generally argued that Abby was killed around two hours before her husband – body temperature and stomach contents were not the only evidence. It had been noted also that Abby Borden's blood was much more coagulated than Andrew's and thus she must have died earlier. The defence managed to throw doubt on this one also. When asked about the coagulation and how soon coagulation happened after death, Dolan answered, 'Various authors differ on that. The time is generally put down from three to ten minutes.' He then admitted that after about fifteen minutes he wouldn't be able to express an opinion on someone's time of death based solely on how the blood looked.

By 20 June the trial was over and the jury quickly gave its verdict on the case. Before sending the jury off to deliberate, Judge Dewey delivered his charge to them. He was quite clear in his belief – Lizzie Borden was innocent. This charge was to guide their decision and reminded them that for a guilty verdict there needed to be proof beyond reasonable doubt that she had committed the crime. And there wasn't. He went through each point, delivering his guidance clearly. With the note in particularly he questioned, 'what motive had she to invent a story like this? What motive? Would it not have been more natural for her to say, simply, that her stepmother had gone out?' He then questioned whether it was reasonable that a woman such as Lizzie would have been able to use such brutal force. It was, according to Joe Howard, columnist for the *Boston Globe*:

> A plea for the innocent. Had he been the senior counsel for the defence making the closing plea in behalf of the defendant, he could not have more absolutely pointed out the folly of depending upon circumstantial evidence alone. With matchless clearness he set up the case of the prosecution point by point and in the gentlest and most ingenious manner possible knocked it down.

The jury were then dismissed. They were back in the courthouse just an hour later and Lizzie sat awaiting the verdict with courage. The foreman was asked for the verdict but stood quickly and interrupted the question, declaring that Lizzie Borden had been found 'Not guilty!' As Lizzie sank into her chair with relief, as if a weight had been lifted from her shoulders, the rest of the jury were asked to confirm that they had found the prisoner to be not guilty. They had, it was answered. And they had been unanimous.

Following the trial, Lizzie Borden found herself ostracised by the people of Fall River. She even found herself separated from her sister, probably after a rather raucous party at the new house they had purchased following the trial. The party allegedly involved the actress Nance O'Neil and a number of her actor friends. Such hedonism would surely have caused Emma to leave, she who wanted to fade away into nothingness following the shame of the trial. The people of Fall River did not like to talk about what had happened – the whole thing had been shameful and the citizens wanted to bury their heads in the sand. In her later years Lizzie found herself more often than not entirely alone. At church the pews surrounding her were empty and she had very few friends. She died in 1927 at the age of 66, not long after undergoing gallbladder surgery.

In the years since, Lizzie Borden has become synonymous with axe murder. Her story has become so famous that children sing rhymes about her in the playground, movies and TV shows have been created showing her committing the crime she was accused of and the house where the murders took place has been turned into a bed and breakfast with ghost hunters often turning up to see what they can find. Despite the findings of the court, it seems to be generally accepted that Lizzie Borden was guilty. After all, she was the only one who could have done it. Wasn't she? To many she is a murderess who got off scot free and who ended up coming into a large inheritance, which must have been just what she was after. No matter that the supposed evidence that shows her guilt is

circumstantial, and no matter that the evidence has been looked at again in modern day mock trials and the same verdict reached.

Did Lizzie Borden murder her father and stepmother? We will never know the true answer to this question. But as with anything, the story of vicious murder captures the imagination more than someone wrongfully accused. The history of the murder is dark and macabre and what better than a villainess who was close to the victims, who viciously slaughtered her own parents, being allowed to walk free. It is certainly much more exciting than an innocent woman. So what better way to keep the public imagination than continuing the tale going that 'Lizzie Borden took an axe …'

Chapter 10

Empress Dowager Cixi
1835–1908

Comparisons are often drawn between Empress Wu and the woman who would go on to rule China as Empress Dowager for over fifty years. Both women are universally disliked, their names besmirched by whispers and hatred – Wu is spoken of as a woman who used sex and sexuality to rise to power whereas the woman we will be looking at in this chapter, Tsu-hsi (or Cixi, the anglicized version of her name which we will use going forward) was ruthless and politically minded. She used her intelligence to make her way up the ladder. Cixi, like many of the women we have covered thus far, did many good things – just some of her accomplishments include the banning of foot binding, bringing modernisation to China and a total reform of the education system. But why is she so disliked? She was seen as manipulative, mishandled international relations and most importantly she spent huge amounts of money. This chapter covers the life and times of Empress Dowager Cixi, the last ruler of the Qing dynasty and the woman who introduced China to modernity yet, to many, oversaw the downfall of the Qing dynasty.

Cixi was born on 29 November 1835. China at the time was a superpower with Beijing as its capital city. We don't know precisely where she was born but we do know that she spent much of her childhood in the city. Her family were not rich, and her father was a low level government official, working mostly as a clerk. He vanishes from the historical record when Cixi was around 18 years old, after going AWOL from his job at the beginning of the Taiping Rebellion.

The Taiping Rebellion began in 1850 and lasted through until 1864. It was, simply put, a rebellion against the ruling Qing dynasty that was fought with overly religious conviction. The leader of the revolt, Hong Xiuquan, was a self-proclaimed prophet. Whilst ill he had lain in a feverish state and dreamed that he travelled to a heavenly kingdom where he was told mankind was under threat from demons. In the dream he battled the demons and won, but as he lay in a fever he screamed about the demons. When he woke, he told his family of the dream – they believed the fever had caused him to go insane. But it was when he failed his governmental exams that he started to play on the dream he had, starting what eventually became a cult – the God Worshipping Society. And the peasants who rebelled were convinced to join this society. Under his leadership, the rebels, who were already on edge due to long standing famine, swept into the city on Nanjing which was held as an opposing state. It erupted into a brutal civil war with a death toll of around 20 million people.

Cixi had been close to her father and his passing made her realise that she had to do something to help the empire and that she should concentrate on making sure she rose in status at the royal court. As she was descended from a powerful Manchurian family and her father was part of the Blue Banner Military Company her name would automatically be put forward as a potential concubine for the Emperor. She was selected at just 16 years of age and was entered in the court annals as just a 'woman of the Nala family'. At this stage in her life she wasn't even important enough to warrant having her name written down. Her birth name has been lost though it is assumed by many that at birth she was given the name Lan Kuei which means 'Little Orchid'. This was in fact the name that was given to her when she entered the royal court

The Manchu people had originally lived beyond the Great Wall. They took the opportunity to invade in 1644 after the Ming dynasty had been overthrown by a peasant rebellion. The Manchu invaders defeated the peasant rebellion and set themselves up as a brand new dynasty – the Great Qing. The Manchus outnumbered the local

Chinese population by 100:1 and imposed strict rules on them – the men were forced to wear the Manchu braid in their hair. Anyone who refused to do so was executed. Yet the Manchurian people took on much of the Chinese culture such as the political and administrative systems. The two groups were segregated and intermarriage was banned, but the Manchus came to think of themselves as Chinese through and through. This was the group that Cixi was born into.

The selection process for the Emperor's concubines was the same as it had been for centuries so Cixi would have gone through a similar procedure as Empress Wu had done over a thousand years previously. The day before the selection she would have been taken to the palace on a cart that had been hired by her family. She would have sat inside a cabin on the back of the cart that would have been filled with cushions, the windows covered with blue curtains. Despite the cushions the cart would have been incredibly uncomfortable. She would have been dropped off at a back entrance of the royal city along with the other candidates up for selection. Why the back entrance? The front entrance of the Forbidden City was off limits to women. In fact, the back of the City was the only area where women were allowed – only men were allowed in the whole front section of the city. The girls spent the night at the back entrance, camped out in their little caravans which can't have been comfortable. Then, when the gates opened at dawn the girls were escorted into the compound by a group of eunuchs who took them to the great hall where they would be lined up and inspected by the emperor. Their looks were not the most important thing when it came to the candidates, though they did of course play a part. Rather a good family name and the way they held themselves were far, far more important. Dignity, bearing and graciousness were the top priorities. They also had to prove themselves to be pure (which to our modern eyes may seem strange given that they were to be concubines) and in order to show this to the best of their abilities were required to wear simple dresses as well as high heeled shoes that had the heel in the centre of the sole at a height of up to fourteen centimetres – a nightmare to balance on!

Yet it forced them to stand upright and walk daintily so they didn't topple over.

Cixi caught the emperor's eye, not with her looks (though her eyes were said to be fearsomely expressive) but through her gracious poise. When the emperor made it clear that he was interested in her, officials took her identification card from her which was kept until she finished going through the shortlisting process and was chosen to become one of the emperor's women. This was the path to influence and power not only for the girls but for their families also. And just like it had done for Empress Wu before her, it set Cixi on a path to the heights of Imperial power.

Her new life was certainly comfortable and she occupied a small suite of rooms. The rooms were beautifully decorated but the chosen girls had to follow a strict set of rules. For instance, daily allowances of food had to be adhered to as well as the sort of fabric that was allowed to be used for clothing. And as Cixi was only a low-level concubine, the rules she had to follow were even more strict and she was entitled to much less in the way of personal servants than the Empress was. The Empress was the top rank of the concubines – the empress that Cixi knew was a girl who had entered the court at the very same time she had. Her name was Zhen and she was elevated to the top rank because she was able to both manage and get on well with the rest of her husband's women. Cixi remained at her rank (rank 6) for well over two years and her husband the emperor did not seem particularly interested in spending any time with her. His interest in her only lessened when, during the Taiping rebellion, Cixi tried to give him suggestions over what he could do to make things better with all his personal woes and the upheaval caused by the rebellion. It was a mistake that could have proven deadly to the young woman.

It was Empress Zheng who helped Cixi regain the emperor's good graces, putting in a good word for the low-level concubine. Zheng proved herself to be a friend and protector to the young Cixi and the two would remain lifelong friends because of this.

Cixi was promoted up to the 5th rank in 1854 meaning that she was no longer scraping the bottom of the barrel. At the same time as the promotion, perhaps helped by the good words of the empress, Cixi was granted a new name in an edict personally stamped by her husband. She was now known as Yi, which meant 'exemplary'. It was after this that the young woman started making waves among the royal harem, and it was a shared love of opera that brought her fully to the Emperor's notice. On 27 April 1856, Cixi gave birth to a little boy – the firstborn son of Emperor Xianfeng. It raised Cixi in his estimation and would change her place in Chinese history forever.

The emperor's health was beginning to wane. At the age of just 29, following a bitter humiliation following the destruction of a number of his estates during the ongoing Taiping rebellion, he was dying. This was mostly self-induced. Thrown into a depression after this he spent his time sleeping with women, drinking incredible amounts of alcohol and taking drugs until he got to the point that he was nigh on bed ridden. As he languished, so did his popularity with his people as well as the upkeep of his remaining palaces. As his life faded, his palaces fell into disrepair. By his 30th birthday in 1861 he still had not named his successor so Cixi took her young son to his bedside and asked what would happen with the succession but it was only when she spoke directly to the emperor and told him his son was being held before him that he opened his eyes and said the words, 'Of course he will succeed to the throne.' He died on 22 August and the previous night he established a number of regents to oversee the throne while his young son was growing up. It is likely that both Empress Zheng and Cixi (known as Yi, at the time) were given special seals in order to stop the regents from gaining too much power – these seals were used on official court documents in place of signatures and for a document to be considered as final, it had to have 25 seals on it. So if either Zheng or Cixi wished to scupper the plans of the other regents then all they had to do was refuse to put their seals to the paper. Some of the regents tried their best to ignore these restraints but others of them had far too much respect for the royal family than to go against

their word – when the first few documents appeared without the seals of Zheng and Cixi there was an uproar. So an edict was issued raising both women to Empress Dowager. Following this they spoke with one voice to confer more authority and they both worked closely with one another. More importantly, for Cixi, she was able to persuade Zheng to side with her on many important matters. She formally assumed the name of Cixi at this time which meant 'motherly as auspicious'.

Next came an event, or rather a coup, that would truly cement Cixi's place. Plans had been made in secret prior to the dead emperor's funeral that came to a head on 1 November – the two empresses and the infant emperor returned to Beijing where they took up residence in the Forbidden City. Shortly after, the empresses and Prince Kung confronted the rest of the regents with an edict that stripped the regents of their power. Knowing that they could not fight back as they were arrested, the regents submitted. The two women were then officially granted the regency though they argued that they did not actually want the role. At this stage the two women worked together and Cixi bided her time, proving that she was intelligent and capable when compared to Zheng who was malleable and almost illiterate.

In 1865, the Taiping rebellion came to an end. The armies under the Empress did what the late emperor could not. In the years following, other rebellions bubbled through the cracks until peace was finally achieved fully in around 1873. Much had been destroyed and it was suggested that perhaps, to help rebuild, China should look towards the West and open up trading routes which would bolster the economy. This idea was wholeheartedly rejected by Cixi in particular – China was a Confucian society and that meant that they were self-serving and frugal. Further ideas of modernisation were also rejected including the building of railways and telegraphs – these ideas went completely against the traditional ideals of Chinese society. The only good thing about the West was their military strength and the Imperial court ended up hiring a number of foreign engineers to start building up a Chinese navy. With foreign engineers, particularly French, being in China it also meant that missionaries

started to show up. They tried to push their Christian ideals on to the local populace. Ministers in Beijing tried desperately to stop the missionaries from spreading. Suffice to say this could not be done without arguments – it was threatened that if the Chinese tried to ban the spreading of the Christian word, then all foreign engineers should leave the country also. The Chinese needed the engineers and so the missionaries had their protection. Religious change could not be stopped and even ended up with traditional Chinese temples being changed into Christian churches and conversions were all but forced – in exchange for food and shelter, local Chinese people were forced to convert to Christianity. And so the religion spread, much to the chagrin of traditionalists who began to spread anti-Christian literature. Suspicion of the foreign religion grew until tragedy struck. Unrest at a monastery following an epidemic that saw the deaths of a number of Chinese children (the locals believed that they had been murdered by witchcraft) led to violence. The buildings were set alight and nuns massacred and there was the worry that the West would reciprocate. Still, Cixi tried to calm the situation down by admitting that fault for the unrest lay on both sides. But this only cemented the fact that China would need to learn to protect herself against any further unrest and potential invasion.

It became very clear even in the early days of her regency that Cixi was prepared to take the bull by the horns and prove that she was the one in power. Anyone else could very easily be got rid of. She gave a real show of the power that she truly wielded when she decided it was time for her to throw off the shackles of pupil to Prince Kung, who she had been learning from in the earliest years of her regency. In the April of 1865, during an audience with the Prince, she suddenly cried out for help and demanded that Kung be taken directly from her presence. His crime? She claimed that he had approached the throne and made to attack her, ordering that he immediately be stripped of all his titles. It was all false, of course, and done to prove that she was the one who held every string of power – no one else could match her. Kung had been instrumental in her taking power and she made

it very clear that she could easily topple him should she so wish. His position, and indeed his life, was in her hands. She let him fester for a week before declaring to the court,

> The punishment which we were compelled to inflict upon him was necessarily severe…he has now repented him of the evil and acknowledged his sins. For our part we had no prejudice in this matter, and were animated only by a strict impartiality…we therefore restore him to the Grand Council, but in order that his authority may be reduced, we do not propose to reinstate him in his position as 'Advisor to the Government'.

Her taste for power only grew after this – striking down one of the most powerful men in China was only the beginning. As with any ruler, she began raising members of her family to important positions in government – her brother-in-law was appointed supervisor to the young emperor's education which was a much sought after position at court which gave both status and power.

When Cixi's son, the Emperor Tongzhi, reached his majority at the age of 17, she relinquished the title of regent and power formally moved into his hands. Yet the young man was not suited to ruling and was accused of being childish and arrogant, preferring to spend his time drinking with his eunuchs than actually ruling the country. His proclivities took their toll, however. In 1874 the emperor caught smallpox and became incredibly ill, already weak from his heavy drinking and smoking habits. He rallied some, but on 12 January 1875 he died at the age of just 19. Of course, Cixi immediately called a meeting of the Grand Council and made sure that the army was surrounding the palace in case of revolt once the news filtered out. Tongzhi had left no heir and so the succession needed to be discussed, though his wife was apparently pregnant at the time. Cixi was quite clear and put forward her nephew who became the Emperor Guangxu. He was just three years old and the choice for regent was

obvious – the Empress Dowager herself. In fact, Cixi adopted the child as her own. Tongzhi's wife, Alute, chose to accompany her husband in death. The tale was told amongst the eunuchs of the palace that her father had delivered a food box to the young woman following her husband's death. She opened it, discovered it was empty and knew what her father meant – she was to starve herself to death. She died on 27 March, 70 days after her husband. Cixi has, of course, been blamed for her death and has been accused of driving Alute to suicide when she was pregnant. Why? So she could secure power for herself. Whilst this makes sense if you believe that Cixi to be pure evil, it should be noted that these accusations have come from Westerners, who Cixi despised during her lifetime. It was the sign of utmost loyalty for a wife or concubine to take her own life following the death of her man and so would have been, at the time, the most virtuous thing for Alute to do. The young widow's official cause of death was put down as a long standing and serious illness and Cixi kept up this guise for the remainder of her life, even going so far as to rebuke individuals who wanted to posthumously memorialise Alute as believing in pure and unsubstantiated rumour. It has also been charged that Cixi rejoiced at the death of her son – though she was far from the most maternal of women, she stated after his death, 'I thought I could be happy with my son as the Emperor Tongzhi, but unfortunately he died before he was twenty years of age. Since that time I have been a changed woman, as all happiness was over as far as I was concerned when he died.' Does that really sound like the words of a woman who was happy about the death of her child?

The child was placed in the charge of eunuchs after being forcibly taken from his parents. Cixi taught the child to call her 'Papa dearest'. It was obvious that she wanted to show herself as a more domineering, male character within the court than the typical weak female who was to be kept hidden away behind the curtain. Empress Zheng was the one who was more of a maternal figure to the young ruler, but she died when he was just nine years old. It is likely that she died of a brain haemorrhage after suffering a stroke, yet many have

since accused Cixi of poisoning her. But Cixi mourned Zheng – the two had been friends and had worked closely together, after all. She extended the period of mourning from twenty-seven days to 100 and even put a twenty-seven month ban on music. Cixi respected Zheng immensely so would she really have poisoned her?

Guangxu was brought up by his teachers and his 'Papa Dearest' to be a wise ruler and he enjoyed his studies, unlike his recently departed cousin. The boy was exceptionally intelligent and able to write fluently from an early age as well as speak fluent Chinese and Manchurian as well as a little bit of Mongolian. By the age of ten, the boy emperor was able to give audiences and step in to hold court if Cixi ever fell ill. Yet he grew up mired in the religion of Confucianism, stuck in the past while the rest of the world modernised around China. He was a purist who regarded any sort of fun as a sin – unlike his cousin who had enjoyed the vices of smoking and drinking and possibly the use of opium. The boy even hatred opera which was a popular pastime among the court. He was not a strong child, and the idea of fighting would have struck fear into his heart. He preferred his lessons and enjoyed taking apart and fixing clothes, and only learned to ride a horse out of duty. Even more so he was scared of the sounds of thunder, making his eunuchs surround him for safety whenever a storm raged. Travel was something he avoided at all costs, and he preferred the safety and isolation of his rooms inside the complex of the Forbidden City.

When Guangxu turned 15 and had completed his studies, it was deemed that the boy was ready to fully take the throne. Cixi's supporters began to panic at the news – she had started a number of projects that would go on to modernise China and the people were scared. If Guangxu took over, what would happen? Would the young emperor force China into back peddling? So court officials began a petition to have Cixi act as the young emperor's regent for a few more years, in order for Guangxu to learn a little bit more about how to rule. According to Cixi, the boy even begged her to stay on and when the emperor's tutor was asked if the boy was really

ready to take over the throne from his 'papa dearest' he replied that 'the interests of the dynasty overrides all'. Guangxu wasn't happy about the situation yet, stuck in his Confucian ways, refused to say anything to Cixi. He became unwell and sank into a depression until one day, just after his sixteenth birthday he finally blew up at his adopted mother, refusing to go to his lessons and smashing windows. He was now of an age to marry and frustrated at how (deliberately) long the whole process was taking for a wife to be found for him. Cixi, shocked by Guangxu's outburst, announced that he would be married the following year. And then she made a decree that shocked everyone – she would finally retire as tradition demanded. Just a few short days later she moved out of the Forbidden City and into the Sea Palace.

Guangxu, as feared, let Cixi's reforms fall by the wayside. The western world had been hopeful that China would continue to adopt a more modern way of living under the new Emperor, yet nothing happened at all. Guangxu and his court lived in the past – he preferred the concubine Pearl over his own wife and carried on with his lessons, dutifully fulfilling all of his royal duties and just carrying on. Things were peaceful and he was free of his adopted mother's control.

Meanwhile Cixi retired and began to oversee the reconstruction of the Summer Palace, although there was huge opposition to doing so as it would cost a fortune. In fact, she had been diligently saving to finance this project. Her reconstructing of the summer palaces is one of the events that have had people condemn Cixi as corrupt and accusing her of spending millions while the people of China suffered. Many say that she stole the money for the work from the navy and bankrupted it which had a knock-on effect for later conflicts. In truth she financed 3 million taels of the restoration from her own savings. Whilst the renovations were happening, Cixi began her retirement at the Sea Palace which was close to the Forbidden City. She was ordered to stay away from politics and agreed that she would have nothing to do with any of the emperor's decisions. This must have been hard for a woman who had, for so long, been the one to decide

everything. She tried to get herself involved, announcing the launch of a new railway. It was quickly quashed. When she formally moved into the Summer Palace in June 1891, however, she was so far away from the centre of things that she physically could not get involved. A huge deal was made of her formal departure, with Guangxu even organising a ceremony that had him and members of the court kneeling both when she left the Sea Palace and when she arrived at her new home. And in her retirement, she had little power, her roles being purely symbolic.

Her retirement, once away from the political centre of the Forbidden City, was peaceful. After getting up she would clean her teeth and rinse her mouth out before having her hair dressed by one of her faithful eunuchs. A selection of jewels was then placed in the elaborate hairstyle, along with fresh flowers. She wore minimal makeup, just a little bit of rouge on her cheeks and lips and then she would dress, absolutely immaculately. Once dressed she put on her jewellery and then regarded herself in the mirror – looks were important to the Empress Dowager and she made sure she was always up to par. Once dressed and made up for the day she would take walks, smoke a pipe or two, play kick shuttlecock, take plenty of naps and eat plenty of good food. But retirement was not to last for long.

In 1894, war broke out with Japan. Japan had its eye on Korea and for a long time had been trying to undermine China's place there and take over control. This was particularly important for Cixi as Korea shared a border with Manchuria, her homeland. War broke out in the aftermath of a pro-Japanese riot (in 1882) in which Queen Min of Korea was attacked and barely escaped, while a number of courtiers were slaughtered. China intervened here, sending a number of soldiers to be stationed there to keep order. But in 1884, a coup broke out which was entirely funded by Japan. It may have been put down quickly but now it was important to stop something similar happening again, and the unrest developing into full scale violence. Yet violence happened and when Kim Ok-kium, one of the coup leaders, was assassinated – an event that had been arranged between

China and Korea. Kim had links to a secret society in Japan known as the Genyosha, a group who pushed for Japanese conquest – this group began to agitate for war in an aim to get revenge for Kim's murder, and to take full control of Korea. China held back and waited to see whether the West would intervene but, unbeknownst to them, Japan had already extracted promise from Britain that they wouldn't get involved. The war was a disaster for China, and they suffered one of the greatest military defeats that the country had ever known. Cixi, still officially retired, was expected to mediate between the two sides and to bring peace back. But as Guangxu knew nothing of war and his advisor (previously tutor) Weng knew even less, most went to her for decisions on important war matters.

China's navy were hopelessly outnumbered and unprepared when compared to Japan's fleet. It didn't help that Viceroy Li, commander of the Navy, had sent many of the ships – nine of which were modern warships – on goodwill voyages including a trip to Japan. A foolish move, as the Japanese planted spies within and it meant they were able to get a good look at just what sort of technology the Chinese had. It was believed that with these warships, the fleet could take on anything. They were wrong. A naval battle on 17 September ended up with well over half of China's fleet destroyed in a single afternoon – the opposing side suffering little damage.

As expected, Emperor Guangxu was furious at the defeat and tried to place the blame on Viceroy Li, stripping him of all of his honours. Cixi was highly aware however that Li was a dangerous man and managed to convince the emperor not to get too carried away. Prince Kang was brought out of retirement to replace Li, but nothing could be done. A number of fortresses were captured by the Japanese in late 1894 and they were in total control of Korea by February 1895. Hugely defeated, China aimed now for peace. Li headed the peace talks after Tokyo refused to negotiate with anyone else – but when Li arrived in Japan an assassination was attempted on Li. He was shot in the face – thankfully the wound was not fatal. Nevertheless, the attempt on his life meant that Japan had to pull back from some of

their demands. It was agreed that China would hand over Taiwan as well as opening up a number of ports to Japanese trade. Things could have been much, much worse.

The defeat meant that confidence had been completely lost in Emperor Guangxu. The young ruler fell into a deep depression and announced that he wanted to abdicate, so deep was his shame. The taste for a coup was in the air and it was only a matter of time until those around Guangxu made their move. A conspiracy was born headed by Prince Tuan, a man who was guided by little more than vengeance when his father was passed over as emperor some years before. His aim was to have Guangxu either abdicate or removed and his own son, Pu Chun installed as emperor. So he began to seek out Cixi and try to bend her to his will, He eventually managed to convince her that his personal army could protect her.

Things came to a head in September 1898. A secret message had been intercepted from Guangxu stating that Cixi was standing in the way of the reforms that he was proposing and that the Empress Dowager was to be held prisoner. Guangxu had also been involved in a plot to have her killed. Cixi was furious at this treachery and immediately made her move. Her soldiers were sent to the capital and she burst into the Emperor's apartments. She slapped the young ruler and screamed at him, 'Do you know the law of the Imperial Household for one who raises his hand against his mother?' Legend states that the slap was the only violence that took place before she took over. Guangxu was then arrested and placed under house arrest after releasing a decree. It was written in red ink and stated that he was stepping back and Cixi would once again be his guardian. And so Cixi stepped out from behind the scenes and took up the true power and Guangxu was used only to sign edicts and decrees on her behalf. He no longer had the power to make any sort of decision on his own and she was at his side whenever he saw any formal visitors. She was, for all intents and purposes, his puppet master.

Her first job was to strike down those who had been involved in the plot to overthrow her. Her main target was Kang, the 'Grey Fox'

who had been the one behind the plot and who had whispered poison in the young Emperor's ear. Unfortunately, he slipped through her fingers. Instead, she arrested others, all very quietly, put them on trial and had them executed. Sadly some were executed who had little to no involvement in the plot. Eventually, she covered up the plot, probably out of fear that the Fox would end up convincing foreign powers to get involved and bring Guangxu back to power. It was the Grey Fox who first planted the seed of hatred when it came to Cixi – he was the first to state that she had a number of lovers and engaged in licentious orgies. These ideas would take hold in the public imagination and stay, festering there until Cixi became a figure so disliked in Chinese history that she would often be held up against Empress Wu. The Fox was already giving interviews in Shanghai about how deplorable Cixi was. She could not risk any more blows to her reputation. This way, she kept the people on her side. Others who had been involved were exiled including Sir Yinhuan, who had twisted the malleable emperor into working with the Grey Fox, and also for working with the Japanese.

Kept imprisoned, Guangxu's health began to fail. He had never been in the best of health, but this was a new level of illness. He suffered with severe vomiting and shortness of breath, could not stand properly and had severe pain in his kidneys. Examined by doctors they diagnosed him with acute kidney failure. The young ruler did not have long left. This was perfect for Cixi – she would not have to resort to murder and risk her soul. Instead, his death would dethrone him, leaving things open for her. Eventually the Emperor released an edict stating that as his health was too poor for him to father an heir, he had granted Cixi permission to choose an heir on his behalf. She chose the young Pujun, son of Prince Duan who was a half-brother of her deceased husband.

In the remaining years of her life, Cixi oversaw the downfall of Imperial China. In 1900 the Boxer Rebellion broke out and the Empress stood back and let it happen. The Boxers stood against all foreigners in China and all Christians and she allowed them to run

riot – though she argued that she had little control over the matter. If she stood against them, she argued that they would all be plunged into much worse peril and violence. Violence happened anyway and Beijing was besieged, with a number of Westerners and Christians killed. The Boxers, though, suffered far more. Although eventually put down, the fact that the Boxers had caused such chaos under Cixi's rule had people losing faith in her

In 1900, as Western allies were making their way closer to the walls of the Forbidden City (Britain and Germany, in particular), Cixi left the palace. She took Guangxu with her as well as one of his concubines. She ordered that his favourite concubine, Pearl, commit suicide. The concubine refused to obey and when ordered, none of the eunuchs stepped forward to push the girl into a well. So, the story goes, Cixi did the deed herself.

And so they fled northwest travelling hundreds and hundreds of miles to escape the Western allies and their invasion. Eventually they reached Siam which was under the control of General Tung and so nothing Cixi did or said could be hidden. Her words were reported back to the general. By this point she was 70 and been forced away from her home, she teared up whenever the situation behind her exile was mentioned. She found herself sharing a fate with the emperor who she had dethroned, and who had annoyed her greatly, and she ended up growing more kind towards her adopted son. Perhaps it was because of the shared, terrible situation that they found themselves in, that caused her to U-turn on her dislike of that young man.

In September 1901, a peace treaty was agreed and signed. Apologies were to be given to both Germany and Japan for murders that had been committed, allies were to be allowed to occupy spaces along the coast and a huge sum of money was to be paid in reparations to the allies for the cost of personal property and military expeditions during the violent uprisings that had taken place.

Cixi had been against westernisation for so long, but in the wake of the huge upheaval from the Boxers she issued a decree in which she stated the country would be taking note of what made the West so

successful in an effort to turn things around for China. These reforms garnered much support – what the West had was desirable and it would help reform much of the poverty that had been an issue in the cities – the streets began to be cleaned, electricity and public toilets popped up. China was truly on its way to modernisation. Cixi's reform ideas also received support from the West and, once she returned to the Forbidden City, she would end up overseeing what would end up being both a modern revolution, and a downfall of a dynasty.

Cixi and her exiled court returned to Beijing once the peace treaty was signed. En route she saw the devastation that the Boxers had wrought and that the people were starving, so she gave them food from the baggage train. She even made sure to be seen on the journey back – just like rulers in the west, if she was seen by the people then she would seem more human, more personable. The journey back was a long one, well over 700 miles, so it took them some time to reach their final destination. Along the way, the decision was made to remove the heir apparent – the child was disliked and preferred to spend his time looking after animals than learning how to rule. The very last part of the journey was taken by train, and it was the first time that Cixi had ever travelled by such a modern marvel. They reached the Forbidden City on 7 January 1902 and entered in style. One of the very first things she did upon her return was to honour and pray for the murdered concubine Pearl. This was an act of penitence on Cixi's part. She wished to show the West, who had been shocked at the violent drowning of the young woman, that she had changed and was worthy of their support.

The aging dowager certainly seemed keen to show friendship towards the West following everything that had happened. She greeted visiting Westerners to her court and even told Sarah Conger, a visiting lady and pious Christian, that she wished to be friends with Westerners and that her previous attitude had been a mistake. She showed visitors around the Forbidden Palace and entertained them without complaint, lavishing them with gifts. In fact, Sarah Conger and Cixi grew to have a close friendship so much so that when Sarah

had to leave in 1905 Cixi impulsively presented her with a small, jade stone from her personal collection.

What Cixi did in the following years can be described as no less than a revolution. Old laws were repealed and bans were issued on awful practices such as foot binding. This ban was brought about gradually however, as the practice had been in place for well over a thousand years. Forcing the issue would do no good. The segregation of women and men was also stopped and women were allowed to appear in public fully for the first time – many had never had the opportunity to visit the opera until this incredible moment. And then there was education. Schools were opened for women across the country. Due to Cixi's reforms, the women of China, particularly aristocrats and prominent women to start with, were able to spread their wings and take on new and exciting opportunities. Without Cixi there would not have been the first woman editor of a newspaper or even the first women's magazine, probably for many years. The legal system was also shaken up in order to fall into line with Western ideals and in April 1905, the execution method of 'death by a thousand cuts' was finally outlawed after centuries of use. Torture was also forbidden unless there was sufficient evidence to allow it and the prisoner was to be executed anyway. Other changes included the introduction of a state bank, the introduction of national currency and the military was given brand new buildings. Opium smoking also declined. There were so many new and exciting breakthroughs in these years including the first ever photographs of the royal family – we know how Cixi looked in her declining years thanks to the famous photograph of her seated upon her throne, though it must be noticed that these photographs were touched up before being presented to her. In a very early version of airbrushing, Cixi's wrinkles were removed.

Cixi's end came in 1908. Her own demise followed a grievous illness and the swift end of Emperor Guangxu. He died on the evening of November 14 after complaining of severe pain below his waist, which many put down to his previous kidney issues. Cixi died the following afternoon. In the run up to her death she had been struggling

yet tried to keep going, though she cancelled a number of meetings as she had been feeling so unwell, including a meeting with the Dalai Lama. As Guangxu lay dying and Cixi felt her own life slipping away, she worried that if he outlived her then China would fall into Japanese hands. Unwilling to allow this, she ordered one last murder – that of her adopted son. In 2008 Guangxu's remains were examined and it was confirmed that his death was due to arsenic poisoning. The Empress Dowager worked through the hours following Guangxu's death. She finally stopped working at 11am on 15 November. Three hours later she was dead and her official will was drawn up a secretary of the Grand Council. With her death, Guangxu's wife was made Empress Dowager – it was almost as if Cixi knew the dynasty was on its knees and that the new Empress Dowager would hand over the dynasty in order to survive. In 1911, uprisings took place that demanded China be made a republic. Just as Cixi predicted, the Empress Dowager formally abdicated and the Qing dynasty came to an end. China was now a republic and thousands of years of imperial history was suddenly just that ... history.

In the years since her death, Cixi is mainly remembered for all the 'evil' that she supposedly did. Of course it cannot be denied that much of what she did in her life deserves derision – she was corrupt, ordered murders and spent vast sums of money when her people suffered. Yet she did so much good also and towards the end of her life realised that she could not stop modernisation. Thanks to her, outdated practices such as foot binding were got rid of, education was totally reformed and electricity was brought in as well as freedom of travel and women's rights. However, as with many women throughout history, the idea of a woman with power just turns so many off. A woman in those days must have done completely nefarious deeds to get her power and it didn't matter whether or not she actually did good. Cixi suffered for this even in death – her tomb, which was supposed to be a place of total sanctity, was looted twenty years after her death. Her coffin was forced open and the jewels she was buried

with were stolen, whilst her body was left completely exposed. But in more modern times Empress Dowager Cixi has been described as a tyrant who used viciousness to cover up her inability to rule with any sort of competence. What good she did is often attributed to the men of her court who served her. Why? Because she was a woman and a woman could not rule. Not only that, but a woman could not rule competently and have any sort of power without misusing it. It is a pattern we see throughout the centuries from Empress Wu to Anne Boleyn and Elizabeth Báthory. These outdated mindsets have stuck fast and malicious rumours continue to swirl about these women – never mind what Empress Dowager Cixi achieved, most would rather believe the bad. Corruption and murder make for a better story than a woman who helped bring modernisation to China, after all. Doesn't it?

Chapter 11

Iva Toguri – 'Tokyo Rose'
1916–2006

Myth and legend often permeate the stories of women throughout history and none more so than with Iva Toguri, who was believed to be the infamous 'Tokyo Rose', a Japanese American who had turned on her country during the Second World War and demoralised American troops via radio by highlighting their losses and sacrifices. This was, in the eyes of the American government and armed forces, tantamount to treason and in the aftermath of Japan's surrender in September 1945, the Americans began to search for any Japanese person – military or otherwise – who had committed war crimes and treason against the United States.

Tokyo Rose, however, was not a real person. The name was first recorded by an American submariner in December 1941 after he picked up Radio Tokyo. He spoke of a woman who spoke excellent English and who taunted and gave hints about the location of American ships. The submariner wrote, '"Where is the United States fleet?" jeered Tokyo Rose... "I'll tell you where it is, boys. It's lying at the bottom of Pearl Harbor".'

After this first mention, the myth of Tokyo Rose only grew and rumours abounded about who exactly she was. Some whispered that it was Amelia Earhart, the pilot who had disappeared during her round the world flight in 1937 – according to the rumours she had been taken prisoner by the Japanese and was being forced to disc jockey on Radio Tokyo. The theory sounds ridiculous and there were much more believable theories circulating about what had happened to her. Eventually it was postulated that Tokyo Rose must be an

American traitor – what other explanation could there be when she knew everything about American troop movement? She became the voice of the American troops' fears – everything she said came true. But as the tide of war turned in America's favour, it was decided to find out exactly who this mysterious disc jockey was.

Surveillance began and it was discovered that she was a young woman who disguised herself at weekends to search for food, wore jeans and spoke little Japanese. She was very slight of build. She was found to live in a house in Setaga-ku and her landlady was questioned – it was then discovered that the woman spoke English and refused to change her citizenship to Japanese. She would refuse even to show respect in the Japanese manner and would not bow as she passed the Emperor's palace. And most tellingly she was seen lugging a Christmas tree into her home – something that the Japanese did not do – and decorating it in the American manner. That is to say draping the branches with popcorn. But nothing was done, at least by the Japanese authorities who were keeping an eye on the young woman – they noted things that should have had her arrested and yet did nothing. As an employee of Radio Tokyo, she was seen taking medication and food into the office in order to dispose of it. Prisoners of war, who she was known to work with, were then found to have extra food and medicines. She also had a habit of saying that Japan would lose the war – she was warned about saying such things and that even if she did believe it (after all this young woman had lived in America previously) then she should just keep it to herself. Yet nothing came to pass as by this point it was clear that Japan really was losing. But who was this woman? And how did she end up being convicted as a traitor in the American courts?

The young woman, Iva Toguri, had been born in the United States of America to Japanese parents and grown up a pure American patriot who loved the country. But she found herself stuck in the country after war broke out in December 1941, having been visiting a sick relative. Iva's uncle informed her of what had happened as she herself could not understand the news reports. She was known as an 'alien' and so the secret police often visited her Uncle's home, where she was

staying at that point in time, to try to force her to take out Japanese citizenship. She steadfastly refused this request.

When the opportunity came for her to potentially leave Japan as an American refugee, Iva, of course, applied. Yet her application was refused and she was told that her American citizenship was in doubt. In fact, every Japanese American had their citizenship in doubt. This was just the beginning of a huge wave of discrimination that would see a huge number of Japanese American citizens interned in prison camps. Iva had saved up money for the trip home but after being denied passage she ended up having to live off that money – her search for work proved to be fruitless as her spoken and written Japanese was so poor. Eventually she saw an advert for a typist who could work in the English language. The job was to monitor American and Allied radio for five hours a day and type up what she heard – it was, for all intents and purposes, a spying job. But Iva was desperate. The salary would cover her room and board with a little to spare, so who was she to pass up the opportunity?

It was at this job that Iva met her future husband – Felipe d'Aquino, a Portuguese national. He helped her secure food after she had been refused a ration card, a punishment for refusing to take out the Japanese citizenship that she was being advised to take out by the secret police who were constantly visiting her. She kept working, using her job to keep her finger on what was happening in the war. What she was listening to on a daily basis was certainly telling her a different story than what was being fed to the Japanese people. Whilst the Japanese media were reporting great naval victories, they were not giving any specific names of vessels that they had managed to destroy. But in the Allied reports she was constantly hearing specific names of Japanese vessels that had been hit. Toguri was convinced that the Japanese were therefore losing the war and she did not hide this fact, often getting into arguments with friends of hers and Aquino's. One of them, Nagamoto, threatened to report her to the Kempa-Tai (secret police) for what she was saying. The threat ended up in a fist fight between Aquino and Nagamoto.

On 23 August 1943, Iva started a new job at Radio Tokyo. The very next day she saw two emaciated white men – prisoners of war – being escorted into another section of the office. She resolved to talk to them, despite having promised herself that she would do her best to stay out of trouble and not mention anything at all about her views on the war. It was here that the story of Iva Toguri as 'Tokyo Rose' truly began.

In November 1943, Toguri was invited to join a panel of propaganda broadcasters which was under the direction of a number of POWs. These broadcasts were aimed at any American listeners in order to affect them psychologically – after all, there were a number of American troops in the area following the attack on Pearl Harbour and the Japanese wanted to use any methods at their disposal to win. Of course these troops would be listening to radio, so why not take advantage of their mental state by using English speakers who understood how to play on American colloquialisms? Even better, bring in female announcers to soften the American resolve. And that was to be Toguri's role. Except she was an American through and through, having grown up there and attended college there. Her aim here would not be to undermine American interests, as was the role. It was the programme's producer, Major Charles Hughes Cousens, who requested Toguri for the role. This Australian PoW, a well-known media personality back in his home country, had his own interests when it came to these programmes – whilst his official 'job' was to head propaganda broadcasts on behalf of the Japanese government, his own aim was to sabotage them. So he selected his own broadcasters with that aim in mind, and nearly all of the women he chose were American or Canadian. And all of the women had their own broadcasting names that they went by such as Madame Tojo.

Toguri was Cousens' secret weapon, however. Her voice was raspy and seductive, something which the other women complained about, but Cousens knew that would be the perfect way to steer the script he had been given away from the veiled threats and targeting of American troops – her job would to be to simply provide entertainment

and banter that would shore up the American resolve. Shy at first, Cousens had to coax her into agreeing to take the role but once she did, she was brilliant at it - Cousens found that her voice was perfect for what he wanted to put across; it was not the voice of someone who wanted to make American troops sad and homesick, it was not downbeat. Rather it was raspy, upbeat and perfect for comedy though it did require some work. Cousens coached her in how to use her voice better and taught her to slow down her delivery and how to maintain that upbeat diction that he so needed to get his points across. It worked like a charm and Toguri, now known as 'Orphan Annie', became the star of the show. Just as Cousens wanted, she gained such popularity that she was popular amongst American troops stationed nearby as well as the Japanese. They were playing the game and, they thought, playing it well.

By 1944, Iva was given the freedom to write the entire show script herself, so trusted was she by Cousens. Her vocal work had been light hearted before but now it became more so, with an added intimacy that made her loved among listeners on both sides. This is when she started getting clever with her greetings, also adding in a sort of fake correction: 'This is Ann of Radio Tokyo ... news and the Zero Hour for our friend – I mean our enemies! – in Australia and the South Pacific.'

She even had Zero Hour's theme song as *Strike up the Band*, which was the fight song of the university in America where she had studied – yet no one questioned it or bothered to research the meaning behind the music. It must have been quite something for the American GIs to hear the fight song of UCLA. And rather than demoralise the American troops as the Japanese hoped, it did completely the opposite – they just didn't realise! In fact, they thought she was doing such a good job they expanded the time of her episodes and encouraged her to play more American and British songs, particularly sentimental songs that would encourage homesickness.

It soon became clear to the Japanese that something was amiss and so changes were made at the radio station – they took creativity

away from Cousens and his staff and made sure that they sounded monotonous on the shows, Although the staff obeyed in order to keep the peace, the changes were not popular. When Cousens suffered a debilitating heart attack and was forced to take a leave of absence, Toguri's confidence took a real knock as she was unsure of how to keep the resistance going. She ended up disappearing from her slot on the radio for weeks and weeks at a time but none of her colleagues really seemed that bothered. She was covered easily by other announcers.

In August 1945, America dropped atomic bombs on Hiroshima and Nagasaki which effectively brought an end to the war and so Toguri began to allow her radio career to slip into obscurity. American forces occupied Japan following the dropping of the bombs and the war office announced that Tokyo Rose did not, in fact, exist. She was simply made up, a tale told by American GIs. As far as Toguri was concerned, that was the end of it – she would be able to return to the States soon and she made plans to settle down with Felipe d'Aquino, marrying him in 1945. But for the press it wasn't the end of it. They took the story of the mythical Tokyo Rose and ran with it, with American journalists offering the huge sum of $2,000 for her exclusive story. It was one of Aquino's friends who took the news to Iva. All she would have to do was go to the Imperial Hotel in Tokyo the following morning and all would be waiting for her. When she arrived at the hotel she was met by two men dressed in clothing that was similar to military garb – one was the associate editor of *Cosmopolitan* magazine, Harry T. Brundidge, and the other was Clarke Lee, a world-famous correspondent for the international news service. Suffice to say she was shocked to greeted by such esteemed media moguls, and more so of all the rumours that surrounded who she – or who 'Tokyo Rose' – actually was. They spoke at length and ended up laughing about how the team had managed to twist the Japanese propaganda machine. By the end of the interview there were 17 pages of notes and Iva left feeling positive. Yet the gentlemen left thinking that they had just been fed a fantasy. There was no way, in

their minds, that any of the story could be true. And so they wrote their story, all the while leaving Toguri convinced that all was well and she had no need of consulting a lawyer.

Lee sent his story to California by wire that very same evening and the next day it was on the front pages of all the newspapers. Iva Toguri was named. More importantly, she was publicly branded as a traitor on the front page of one of the biggest newspapers in the United States, the Los Angeles Examiner.

Brundidge then tried submitting a report to *Cosmopolitan* magazine, detailing a first person confession of Tokyo Rose. When it was rejected, he took himself off to the Eighth Army offices of General Williard Thorpe and urged that Iva Toguri be arrested as the traitor, Tokyo Rose. The soldiers took one look at the typed notes from the interview and agreed. The very next day, two soldiers arrived at Iva's tiny house in ruined Tokyo and arrested her.

This arrest seemed more like a press call than anything. Taken to a hotel in Yokohama, she was greeted by a curious crowd of journalists and then, after being held overnight, was returned to her home. Her real arrest came on 18 October. Once again soldiers arrived at her home and took her away, giving her only enough time to grab a toothbrush. She was incarcerated at the jail in Yokohama. Six weeks later, she was transferred to Sugasmo prison in Tokyo where the conditions were much better – there she could at least take a bath rather than be forced to have a sponge bath out of a bucket. She was, of course, subjected to interrogation whilst held at the prison. But just like her radio persona, Toguri responded with jokes and wise cracks which only tired those who were questioning her – all they wanted was to find a reason to bring her to trial, not to deal with a smart mouthed young woman.

She spent a year at the prison before it was ordered that Toguri be released. No evidence could be found that linked her to the infamous 'Tokyo Rose' and the justice department formally came to the conclusion that this infamous woman was in fact multiple different woman all of whom had been given the name by American

troops. Nor, in any of the recordings that were located from Toguri's programmes, was there evidence of treason. It was case closed and no further plans were made to prosecute. At least that was the initial idea. As Iva was released, Harry Brundidge decided that it wasn't about to happen on his watch and made plans to sell the story of Tokyo Rose and Toguri's so called 'admission' of treason.

Iva began once again making plans to return home to the United States but, as 1947 dawned, it became clear that some in the States openly resisted the idea of allowing her home. Journalist and radio broadcaster Walter Winchell accused the government of being 'soft on the traitors' and angrily protested live on the radio against her being granted an American passport. His angry diatribes must have worked. It was reported in December that she would not be allowed to step back on American soil and Winchell was visited personally by the District Attorney in order to smooth things over – he was even thanked by the DA for his efforts in trying to protect the American citizens from traitors such as the women collectively known as 'Tokyo Rose'.

Things started gaining speed by March 1948 – Iva was summoned to a meeting with Brundidge and a Mr Hogan, when Brundidge stated calmly that the two were working on her case. If she signed his notes from their original interview, stating that they were indeed her words then she would be able to go back to the states. Of course she hesitated, her fear growing when Mr Hogan demanded that she be asked plainly if they were the notes of the interview. So she signed, and her fate was sealed. The full signed 'confession' was printed in the Nashville Tennessean on 2 May 1948 and it was reported that her arrest was seriously being considered.

All the while, individuals were being questioned about Toguri's work on the radio and bear false witness against her. Iva was warned that it was happening, but she seemed indifferent to it, and to offers of legal help. She was in shock, it seemed, and incredibly stressed. Yet no one seemed to care that this was all a ruse – all people wanted was someone arrested for treason, proof that even Japanese-Americans

could turn against the place they partly called home. The Justice Department advised against taking Iva Toguri to trial – in a memo from May 1948, sealed until 1975, it was admitted that there was insufficient evidence to bring an indictment and that the 'confession' was gained by questionable means. But the recommendation was ignored and the US Attorney decided that Iva Toguri would go to trial. In a further twist, the lawyer who had written the recommendation against going to trial was appointed to be the Special Prosecutor for the case.

Iva Toguri got her homecoming, but not quite the one that she wished for. On 25 September 1948, she arrived in San Francisco among a ship full of men returning home from war. Although she was greeted by her father with a warm embrace, the rest of the country did not. To them, she was a traitor. All they saw was a young Japanese woman who had worked against their country – she was not one of them, despite having been born there and having completed her education there. It was xenophobia at its finest. Just after she had arrived, the charges were read against her and she was taken into custody, placed on suicide watch and made to wait to be placed on trial for something that she did not do.

The Grand Jury met on 6 October and it was agreed that Toguri would be indicted with a trial to follow. Iva continued to protest her innocence and in a short press release she made clear her belief that if the grand jury had allowed witnesses in the hearing she would have been cleared and that the trial would end in her acquittal. But still no one cared all that much – this young woman was 'Tokyo Rose', a woman who had entertained on the radio and who was now entertainment in printed media. In the same way as people follow sensational court cases today, the people of America did so in this case. Never mind that Tokyo Rose was a myth, a mishmash of different female radio personalities in Japan and never mind that this had previously been admitted. The American people had believed what had been written by Brundidge and wanted the American justice system to make this woman an example. It was to be a show trial,

a kangaroo court, and it did not take long for 'witnesses' to come crawling out of the woodwork to speak out against Toguri in order to receive some sort of payment. The defence, however, could not afford to pay for witnesses to come forward and help their case.

The trial began on 5 July 1949 at a courtroom in San Francisco. The room was packed full of spectators and press keen to catch a glimpse of this so-called traitor. Iva was brought out into the court room and her ordeal began. She faced questions from Tom DeWolfe, who was less than happy in heading the prosecution, and these questions were petty, based on little more than rumour. It was a farce, and he knew it. Yet in his opening address he seemed charged up and ready to fight, to 'prove' that the passive young woman was the traitor that she was being made out to be. Throughout the first week, various witnesses were called for the prosecution, including a man named Tsuneishi, a former boss from Radio Tokyo. As he spoke, he told how the prisoners of war who broadcast weren't forced to do so and that they were treated well. Depositions taken in Japan, however, said different. When questioned about Iva, he did not recall all that much – only that she was one of thirteen English speakers to work at Radio Tokyo, and that he had never actually spoken to her. The court however was not shown the depositions that had been taken in Japan; that meant they were not told of how the prisoners were really treated or of how he actually did give orders. Clark Lee was then called to testify. The so called 'confession' that he had written was given as an exhibit, although some pages were missing. During questioning the defence repeatedly tried to have Lee's testimony stricken. It was, they said, baseless. It was overruled. Despite the falsehoods he provided, and the fact that he had a sore throat that made his voice sound scratchy, he held up well and left a good impression on everyone in the courtroom. Other witnesses included those who had been directly involved with the Zero Hour program – supervisors George Mitsushio and Ken Oki were both called and both provided direct quotes from Toguri that had been provided in the indictment. Both repeated the exact same quotes word for word. The defence latched

on to these, asking both to repeat the American oath of allegiance and if they could remember what they had for breakfast, When they could not answer, it was clear that something here was amiss.

The defence had managed to get hold of some witnesses. Cousens was called to the stand for the defence and the main line of questioning was around how the defendant had helped the prisoners of war by providing food for them. The whole argument was thrown out, however, the prosecution objected to the line of questioning and the judge sustained it. Toguri sat there in disbelief as the whole argument was thrown out. How could such a thing happen – hadn't she helped her countrymen by getting them food and medication while they were forced to work on Radio Tokyo. Cousens had very little difficulty on the stand and made clear in his answers that Iva was the furthest thing from a traitor. More importantly she was just as American as everyone else in that courtroom – when he was asked if any other Japanese person had brought him food during his time as a PoW, he responded quickly, 'The defendant was not Japanese. She was an American.'

Other witnesses called for the defence included Ted Ince who also broke down when relating the brutality he had faced whilst being forced to work for Radio Tokyo and Norman Reyes who stated that he would trust Iva Toguri with his life as she was that loyal to the United States and that, he too, had broadcast under total duress. Unfortunately for Reyes, the prosecution produced a number of statements that he had made to the FBI which completely contradicted everything that he had just testified. All of the documents bore his signature and stated that there was no duress at all, only that he had broadcast to get himself better living quarters and, more importantly, there had never been any sort of conspiracy to sabotage the Japanese propaganda that was being broadcast from Radio Tokyo. It was a win for the prosecution, but still the defence called its witnesses. However, these were all muted and not allowed to testify about receiving aid as they had not ever received it directly from Toguri.

When a number of servicemen were called to the stand who had listened to Toguri on the radio, it should have become more than clear

that Toguri was no traitor. None of these men had been damaged by the broadcasts. In fact, they had enjoyed them!

Iva's own husband was also called to testify. He had listened to a number of Zero Hour broadcasts between October 1944 and August 1945 and had heard nothing damaging against the United States or her allies. Unfortunately, his testimony was looked upon poorly – he had only listened once a week, and sometimes not at all. He reinforced during questioning that when his wife was asked by either Lee or Brundidge during their interview if she was Tokyo Rose, she had answered that she was not. Rather, she said, Tokyo Rose was many women. Evidently by this point the Judge was so bored by the whole thing that he managed to fall asleep!

Eventually Iva Toguri herself was called to the stand. And the jury, by the time she was called in September, had been reminded that they were not to feel any sort of sympathy for her. It didn't matter that she had helped the prisoners of war, or that she had refused to renounce her American citizenship. They were not to be soft on her. In essence, they were told that they had to find her guilty. Throughout her testimony she was calm and composed and told her story from her first moments working for Radio Tokyo. The prosecution were brutal, putting to her each and every supposed quote she made that were treasonous. She denied them all. By day three of her questioning she began to show some emotion, recalling how she had been given a talking to by a senior colleague at the radio station over being the only one there who had failed to support Japan in their war effort and that she should start doing so. She had told him that she would never agree to such a thing, that she would rather quit her job and risk the consequences. Each accusation that was put to her, she denied and yet they kept on, kept pushing and trying to slip her up. Right at the end of five brutal days of questioning she reiterated that she still wanted to remain an American citizen, burst into tears and stepped down from the stand.

The jury retired on 26 September in order to make their deliberations. By 11.40pm that night no word had come from them.

By the second day they still had not come to a decision – they reported instead that they could not come to a unanimous decision. The Judge wasn't having it and made a speech telling them that they had to come to a decision so that the long and arduous trial hadn't been a waste of time and money. By the fourth day a decision was reached, but only because the jury were frazzled and had run out of patience. Up until that evening, three held out from deciding that Toguri was guilty. But that all changed when they returned from the deliberation room and announced the verdict.

Guilty.

She was sentenced a week later, on 6 October 1949 and was sentenced to ten years, fined $10,000 and her sentence was to be served at the Federal Reformatory for Women at Alderson in West Virginia.

Of course there was a buzz in the air when she arrived at the prison; she had, after all, become somewhat of a celebrity thanks to her trial. The prison itself was actually somewhat comfortable and small, housing only minor criminals for the most part. To begin with it was expected that Toguri would be trouble – after all, she was a convicted traitor – but she soon showed herself to be a model prisoner and her prison records are, for the most part, glowing. She worked hard, becoming a medical aide and X-ray assistant. In one of the earliest reports it speaks of how she was 'courteous and well mannered' and that she had 'meticulous personal habits' There is frequent mention throughout the reports of her superior intellect and how she happily took on extra duties on top of everything she was already doing. For instance, in March 1952, she volunteered to work in the dental clinic and she took it on herself to learn the ins and outs of dental nursing.

She was also friendly with many of her fellow prisoners and took part in many social activities including bridge games and movie nights. Only one instance was noted during her incarceration of an action that caused a disciplinary report to be filed. In December 1953 a report was filed against her about an incident in the previous June in which she replaced a temporary filling in another inmate's tooth and

did not record the procedure correctly in the records. However this record is slightly incorrect – the procedure was not that of a filling but rather the removal of a rotten tooth without the supervision of the Dental Officer.

Iva Toguri was granted early release after serving just over six years. But the moment she stepped out of the gates in 1956 she was handed a deportation notice that ordered her to travel straight back to Japan. Her supporters created an uproar, requesting dismissal of the proceedings and Iva's citizenship be restored. For two years of her parole the worry of being deported hung over her head like the sword of Damocles but in 1958 the warrant was finally cancelled and the following year her parole was over.

But Iva's pardon did not happen until 1977, 27 years after she had been convicted, by President Gerald Ford on his last day as President of the United States. This meant she was finally free and her beloved citizenship was finally restored to her. Public support had swayed in her favour in the years following her committal to prison – the Japanese American Citizens League took up her cause, as did many others. Articles in support of her and calling for her pardon had been printed in newspapers that had, at one point, written articles vilifying her. And when the California legislative voted for her pardon, it was unanimous. Iva Toguri was finally free to live the quiet life that she had wished for. And more importantly she was able to do so with her citizenship back in her hands.

The woman who had for so long been considered to be the legendary 'Tokyo Rose' died in 2006 at the age of 90. She had been living in Chicago since her release where she lived out of the spotlight, working quietly in her father's shop for many years. Whilst she was cleared for the crime she had been convicted of and pardoned, for many years Iva Toguri was vilified as a traitor to the United States. Xenophobia against the Japanese had been rife at the time of her conviction, following the attack on Pearl Harbour and it seemed like the American people wanted someone to be a scapegoat. What better

scapegoat than a Japanese American who had been forced to seek employment after becoming stuck in Japan during the war? What better scapegoat than a young woman who had ended up working on a radio station designed to affect the morale of American troops simply because she needed a job? It did not matter that she had done her best to simply provide entertainment and derail the propaganda attempts. It did not matter that she had helped American prisoners of war and provided them with food and medicine. Nor did it matter that crooked journalists had twisted the truth and paid people to lie in order to secure her conviction. What mattered was that they had their traitor locked up. It was a huge miscarriage of justice that, thankfully, was able to be reversed thanks to the change in the tide of public feeling.

While many of the women in this book have been consistently maligned in the years since their death, Iva Toguri can be considered one of the lucky ones. She was pardoned and the truth about the myth of Tokyo Rose has finally started to come out.

Conclusion

Throughout this work I have endeavoured to show that the women selected weren't as black as their legends have made us believe. Each woman certainly had her plus points and her minus points, but none were truly what can be called evil. If anything, their 'evil' legend has come from those with an axe to grind which has created, in many instances, an almost cartoon-like villain of them. This is the sort of pattern that has been repeated time and again throughout history and, as I mentioned right at the beginning of this book, I would have needed multiple volumes to be able to talk about them all.

Of course, some of the women in this volume can be considered to be somewhat nastier than others. It cannot be denied that Elizabeth Báthory did in fact murder young women and Empress Wu certainly did resort to murder in order to get rid of those who would cause her problems. But do they deserve to be painted as purely evil? Elizabeth Báthory is no vampire, nor is there any evidence that she bathed in blood. Nor is there evidence that Empress Wu murdered her own child. Others may have been entirely innocent of the crimes they were accused of – Anne Boleyn was no witch or adulteress, simply a woman far ahead of her time; Iva Toguri was no traitor. And for others the evidence of their supposed crimes was entirely coincidental. For nearly all of the women in this work, the driving force behind the hatred is either jealousy, power, greed or xenophobia and this is something that is seen over and over again. For women with power, or land, others wanted what she had and would go above and beyond to take it from her. For women who were of another race then they would be ostracised for it, even if they had been born and grown up in the country where they faced persecution. If a woman

showed any sort of intelligence, then she was ostracised or called a witch. Or if a woman showed any sign of mental illness, then, she too, would be ostracised.

Even in the modern day we see it happening. Whether this be a woman in politics, is royalty or a celebrity, they are often vilified on social media. Their every move is watched and criticised and, sadly, we have seen a number of high-profile individuals take their own lives through such awful treatment. It should be noted that it is not just women who face such treatment in modern day media, either.

Many of the women included in this book have long been considered as pure evil and it is my hope that I have managed to tell their stories, and to show that they certainly weren't the evil that history has made them out to be. Of course there are may more whose stories need to be told and so, the journey continues.

Further Reading

Anderson, M, *Hidden Power: The Palace Eunuchs of Imperial China* (Prometheus 1990)

Beckman, J, *How to Ruin a Queen: Marie Antoinette, the Stolen Diamonds and the Scandal that Shook the French Throne* (John Murray 2015)

Bellonci, M, *The Life & Times of Lucrezia Borgia* (Shenval Press 1953)

Bernard, G.W, *Anne Boleyn: Fatal Attractions* (Yale 2011)

Bernard, G.W, *The King's Reformation: Henry VIII and the Remaking of the English Church* (Yale 2007)

Bradford, S, *Lucrezia Borgia: Life, Love & Death in Renaissance Italy* (Penguin 2005)

Charles Rivers Editors, *Tokyo Rose: The History and Legacy of Iva Toguri and Japan's Most Famous Propaganda Campaign during World War II* (Createspace 2017)

Chang, J, *Empress Dowager Cixi* (Vintage 2013)

Clements, J, *Wu: The Chinese Empress who Schemed, Seduced and Murdered her Way to Become a Living God* (Sutton 2007)

Craft, K, *Infamous Lady: The True Story of Countess Erzsebet Báthory Second Edition* (Createspace 2014)

Cruise, M & Hoogenboom, H, (trans)*The Memoirs of Catherine the Great* (Modern Library, 2006)

Fraser, A, *Marie Antoinette: The Journey* (Phoenix 2001)

Gregorovius, F, *Lucrezia Borgia: Daughter of Alexander VI* (Histria 2020)

Grueninger, N, *The Final Year of Anne Boleyn* (Pen & Sword 2022)

Gunn, Rex, *They Called Her Tokyo Rose.* (Brent Bateman 2007)

Further Reading

Hui, R, *Anne Boleyn: An Illustrated Life of Henry VIII's Queen* (Pen & Sword 2023)
Ives, E, *The Life & Death of Anne Boleyn* (Blackwell 2010)
Kraft, K, *The Private Letters of Countess Erzsebet Báthory* (Createspace 2011)
Lever, E, *Marie Antoinette: The Last Queen of France* (Piatkus 2001)
Lipscomb, S, *1536: The Year that Changed Henry VIII* (Lion 2009)
Masterton, W, *Lizzie Didn't Do It!* (Branden 2000)
Montefiore, Simon Sebag, *Monsters: History's Most Evil Men & Women* (Quercus 2009)
Montefiore, Simon Sebag, *The Romanovs: 1613-1918* (Weidenfeld & Nicholson 2016)
Morris, Samantha, *Cesare and Lucrezia Borgia: Brother and Sister of History's Most Vilified Family,* Pen and Sword, 2020
Penrise, V & Trocci, A, *The Bloody Countess: Atrocities of Erzsebet Báthory* (Calder 1970)
Princess Der Ling, *Two Years in the Forbidden City* (Earnshaw 2011)
Robertson, C, *The Trial of Lizzie Borden: A True Story* (Simon & Schuster 2019)
Round, V, *Catherine the Great* (Arrow 2007)
Seagrave, S, *Dragon Lady: The Life & Legend of the Last Empress of China* (Macmillan 1992)
Shaw, J; Fletcher-Watson, B & Ahmadzadeh, A, (eds) *Dangerous Women: Fifty Reflections on Women, Power and Identity* (Unbound 2022)
Starkey, D, *Six Wives: The Queens of Henry VIII* (Vintage 2004)
Trow, M.J., *A Brief History of Cleopatra,* Little, Brown, 2013
Woo, X.L, *Empress Wu the Great: Tang Dynasty China* (Algora 2008)

Index

A

Actium, Battle of, 10-11
Alexander the Great, 1, 2
Alexandria, 2-7, 10, 12-14
Anne, Boleyn, Queen, 68-91
Antoinette, Marie, 107-26
Antony, Mark, 5, 7, 8, 11, 13, 14
Arc, Joan of, 30-42
Auletes, 1, 3
Austria, Margaret of, 68

B

Bastille, 119, 121
Bathory, Elizabeth, 82-95
Baudricourt, Robert de, 31-32
Beaugancy, Siege of, 34
Beneczky, Katalin, 84-85, 91-92
Blaisdell, Judge, 134-135
Boleyn, George, 76-78
Boleyn, Mary, 68-69
Borden, Abby, 128-129, 131, 134, 135, 138, 140
Borden, Andrew, 127-131, 134, 137
Borden, Emma, 128, 131, 136, 139
Borden, Lizzie, 128-140

Borgia, Cesare, 43, 45-46, 50, 52-58, 60-63
Borgia, Juan, 43, 49, 51-54
Borgia, Lucrezia, 43-66
Borgia, Rodrigo, 43-44, 46-49, 52, 55-58, 60, 62
Bowen, Dr., 128, 130-131, 135-136
Boxer Rebellion, 155-157
Brereton, Henry, 77
Brudidge, Harry T, 166-169, 172

C

Čachtice/Csejthe, 81, 85, 87, 89, 91, 94
Caesar, Julius, 4-6
Calderon, Pedro, 51-52
Cathedral of the Assumption, 97
Catherine, of Aragon, Queen, 68, 70-72, 74-75
Catherine II of Russia (the Great), 95-106
Cattanei, Vanozza, 43, 63
Chang-qian, 18
Chapuys, Eustace, 72, 74-75, 78
Chateau Vert, 69
Churchill, Adelaide, 127, 136

Cixi, Empress, 141-160
Cleopatra, 1-15
Conciergerie, 125-126
Cousens, Charles Hughes, 164-166, 171

D
D'Aquino, Felipe, 163
d'Este, Ercole, 56-57, 59-61
d'Este, Isabella, 59, 64
Darvolya, Anna, 84-85
dei Mila, Adriana, 44, 49, 60
Dolan, Dr., 137-138

E
Ecsed, 82

F
Farnese, Giulia, 44, 49
Ferrara, 52, 56-63, 65-66
Fersen, Axel 1, 14, 117, 122
Ficzko, 84, 86-87
Fontainebleau, 113
Francis I, 70
Frederick II of Prussia (the Great) 100, 104

G
Gaozong, Emperor, 19-23
Gonzaga, Francesco, 63-64

H
Henry VI, 30-31, 36-37
Henry VIII, 67, 69

Hever Castle, 68
Hiroshima, 166
Hundred Years War, 31

J
Jane, Seymour, Queen, 75-76
Jingye, Li, 25

K
Kingston, Anthony, 79-80
Kremlin, 97
Kronstadt, 101-102

L
Lancaster, John of, 37
Lee, Clarke, 166
Louis XIV, 111
Louis XVI, 107, 113, 116, 122
Luxembourg, Jean de, 36, 38

M
Magyari, Stephen, 84
Maximillian II, 83
Morse, John, 129, 132

N
Nagasaki, 166
Nagy, Ilona Jo, 84-85
Norris, Henry, 76-77

O
Octavian, 7-14
Orleans, Siege of, 31, 33-34
Orlov, Alexei, 100-103

P
Page, Richard, 77
Pearl Harbor, 164, 174
Percy, Henry, 69-70
Pesaro, 46, 49-50
Peter III, 95, 97, 100-101, 105
Peterhof, 101-102
Petit Trianon, 114
Pompey, 3-4, 6
Potemkin, Grigory, 103-105
Prussia, 95, 100-101, 104
Ptolemy XIII, 4
Ptolemy XIV, 5
Pure Concubine, 20-22

R
Raizong, 24
Reims, 34
Richard, Brother, 35
Rohan, Cardinal, 118-119
Rouen, 38, 41-42
Russell, Alice, 127, 135-136

S
Saint Cloud, 117
Saltykov, Sergei, 99
Smeaton, Mark, 77, 80
Strozzi, Ercole, 63
Sullivan, Maggie, 131, 133, 135-137
Summer Palace, 97, 151-152
Szentes, Dorrotya, 92

T
Taiping Rebellion, 141-142, 144-146
Taizong, Emperor, 17-20
Temple, 123-125
Third Estate, 119-120
Thurzo, Gyorgy, 84, 89-94
Toguri, Iva, 162-175
Tower of London, 67, 71, 77-79
Turoczi, Lászlao, 85

V
Varanno, 82
Versailles, 108, 111, 113-114, 119, 121-122, 126

W
Wang, Empress, 20-22
Wei, Empress, 24
Weston, Francis, 77
Winter Palace, 100-102, 104-105
Wu, Empress, 16-29

X
Xian, 25

Z
Zero Hour, 165, 170, 172
Zhang brothers, 27
Zheng, Empress, 144-146, 149-150
Zhi, Prince, 18-19
ZhongZhong, 23-24, 26-27